CW00747271

Outdoor
Photographer of the Year

PORTFOLIO III

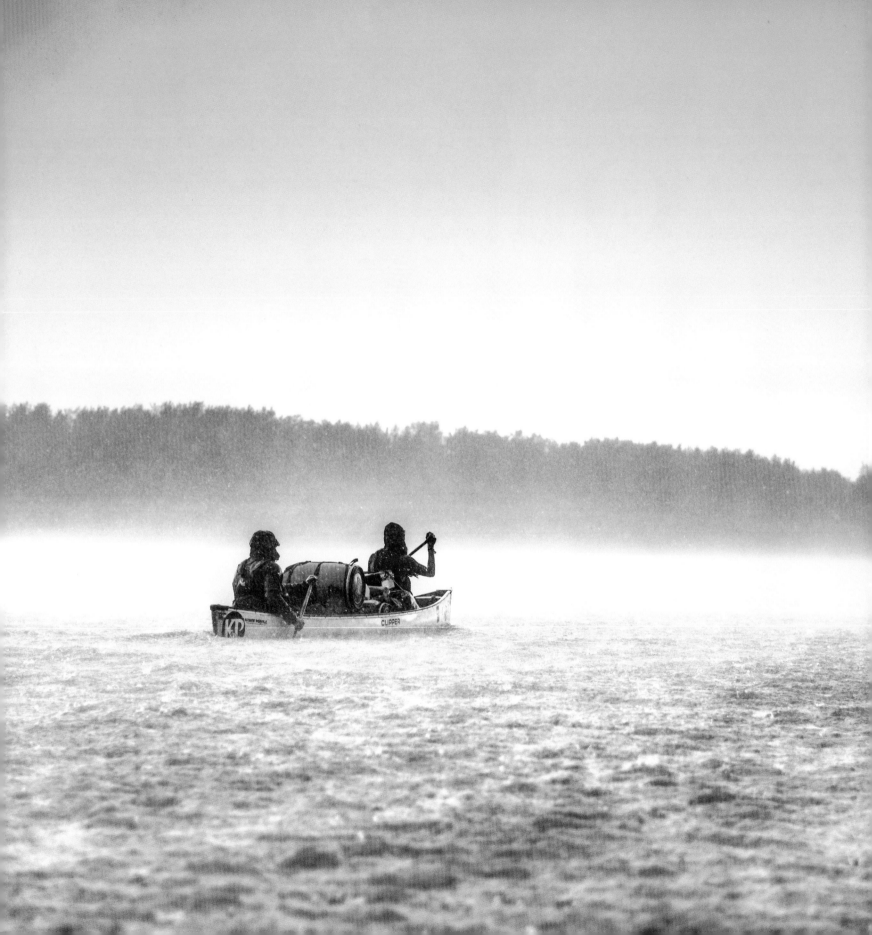

Outdoor
Photographer of the Year

PORTFOLIO III

AMMONITE
PRESS

CONTENTS

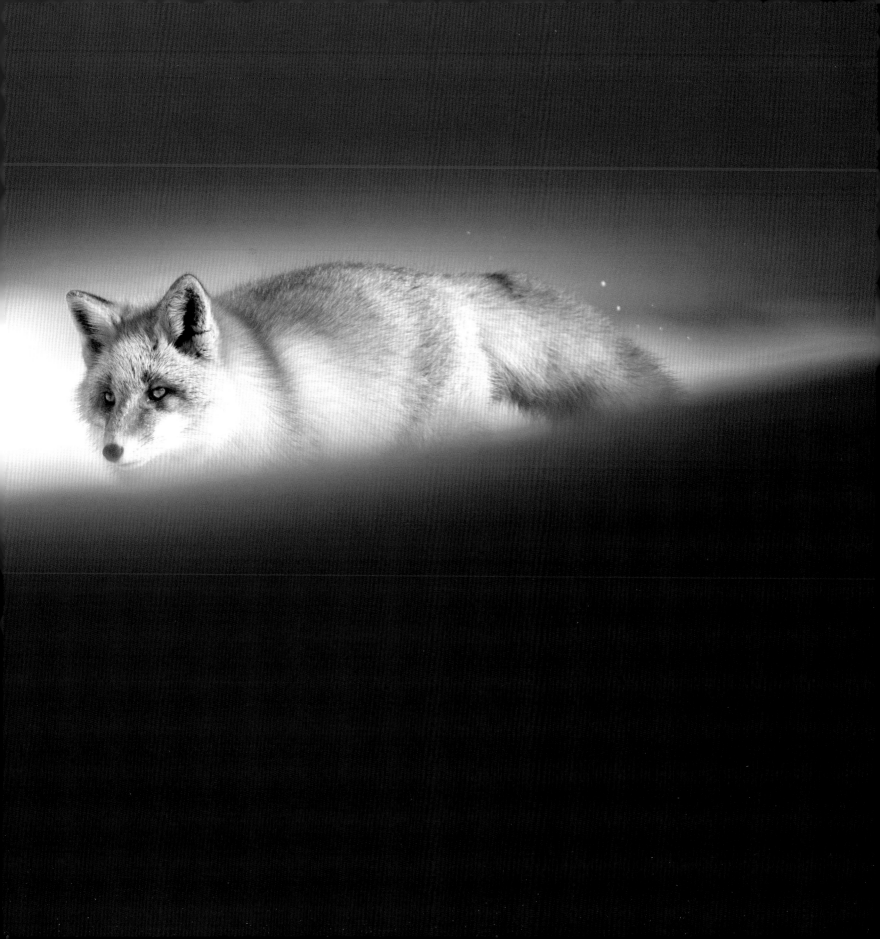

First published 2018 by Ammonite Press
An imprint of Guild of Master Craftsman Publications Ltd
Castle Place, 166 High Street, Lewes, East Sussex,
BN7 1XU, United Kingdom

Text © GMC Publications Ltd, 2018
Photography © individual photographers as detailed
in the relevant captions
Copyright © in the work GMC Publications Ltd, 2018

ISBN 978-1-78145-330-8

All rights reserved

No part of this publication may be reproduced, stored
in a retrieval system or transmitted in any form or by any
means without the prior permission of the publisher and
copyright owner.

While every effort has been made to obtain permission
from copyright holders for all material used in this book,
the publishers will be pleased to hear from anyone who
has not been appropriately acknowledged, and to make
the correction in future reprints.

The publishers can accept no legal responsibility
for any consequences arising from the application
of information, advice, or instructions given in
this publication.

The image caption information is supplied by
the photographers, and the publishers accept
no responsibility for any errors or omissions in
such information.

A catalogue record for this book is available from
the British Library.

Editor: Chris Gatcum
Consultant Editor: Steve Watkins
Publisher: Jason Hook
Designer: Robin Shields

Colour reproduction by GMC Reprographics
Printed in Turkey

Back cover photographs (clockwise from top left):
Dominic Byrne, Gigi Williams, Hamish Frost,
Pier A Mane

Euan Ross (United Kingdom)

Front cover: **Gásadalur, Faroe Islands.** Making my way towards the sea, I ventured down the steps that ran along the cliff's edge to get as close to the Atlantic as I dared to go. It was only then, as I turned back towards the tiny hamlet of Gásadalur, that this waterfall revealed itself, nestled at the point where the land meets the mythical Faroese coastline. As the river thundered over the edge, it created a near-perfect vertical drop of water, which on this occasion fought and won against the opposing sea gales.

Nikon D610 with 20mm f/1.8 lens, ISO 200, 114sec at f/9, 13-stop ND filter, polariser, tripod

circa35mm.com

Jay Kolsch (United States of America)

Page 2: **Yukon River.** Ian Finch and Caroline Cote push to make their miles on the 2016 Pull of the North Expedition, following the Yukon River from its source in British Columbia across Alaska to the Bering Sea.

Nikon D800 with 24-120mm f/4 lens at 105mm, ISO 320, 1/1000sec at f/4

jaykolsch.com

Johan Siggesson (Malta)

Page 4-5: **Notsuke Peninsula, Hokkaido, Japan.** Never have I seen so many foxes in any one location during such a short period of time as I did on Notsuke Peninsula, Japan. I saw fighting foxes, sleeping foxes, walking foxes and more. This particular one was trying to sneak away, hidden by a snowdrift. I found that the shaded snow in the foreground and the sky in the background framed the fox and the bright white snow it was crossing, almost as if a sliver of light was illuminating the fox through vegetation. I chose to convert the image to black & white to enhance this ambiguity.

Nikon D500 with 300mm f/2.8 lens and 1.4x teleconverter, ISO 200, 1/3200sec at f/4.5, handheld

johansiggesson.com

INTRODUCTION

Now in its seventh year, Outdoor Photographer of the Year is one of the most respected photography competitions around the globe. It offers a powerful insight into the landscapes, wildlife and nature of the planet, and the adventures to be found on it.

Thanks to a plethora of imagery and video content it can seem that we know our world inside out these days, but there always appears to be new places to discover and new ways of looking at things. Each month at the *Outdoor Photography* magazine office we are treated to a wonderful cross-section of the landscapes, wildlife and adventures to be found around the world, and in our annual Outdoor Photographer of the Year competition we look to reveal and celebrate the outstanding work of the most highly talented image makers out there.

This year, more than 18,000 photographs were entered into the competition by amateurs and professionals from over 60 countries, including the UK, USA, Canada, South Africa, China, Australia, Japan, Norway, Sweden, Germany and Italy, to name just a handful.

We are thrilled to continue our longstanding association with competition sponsor Fjällräven, the premium Swedish outdoor gear manufacturer, and this year we had exciting new Fjällräven Award prizes on offer, which allow the overall winner and runner-up to acquire an individually tailored selection of outdoor equipment to suit their own photography needs. You can see more details about all the prizes on the following page.

Once again we have been fortunate to have a superbly knowledgeable and diligent judging panel on the competition, including new judge Rachael Talibart – you can read more about each of them overleaf. The amount of care and consideration they put into assessing every image on the shortlist is extraordinary, and throughout they manage to maintain equality between their own particular genres and the others featured in the competition. I would like to take this opportunity to say a heartfelt thank you to them.

This has been the most hotly contested competition to date, with the high-quality imagery reaching new levels. As well as being a joy to look through, the entries are a dependable bellwether for where the outdoor photography genre is heading. Suffice to say, the genre is exploring new areas of the planet and new ways in which the scenes and subjects found on location can be creatively interpreted. One thing is for sure; there has clearly never been a better time to be an outdoor photographer. I hope you enjoy browsing the images and reading the stories behind them.

Steve Watkins – Editor, Outdoor Photography

SPONSOR AND PRIZES

In 1960, Åke Nordin founded Fjällräven in his basement in the Swedish town of Örnsköldsvik. From its very first innovative framed backpacks and lightweight outdoor jackets, Fjällräven has stayed true to its original mission of making it easier for more people to enjoy and stay comfortable in the great outdoors. Backed by its impressive heritage, the company has continued to grow and develop and its clothing and equipment is now popular with outdoor enthusiasts around the world.

All Fjällräven products are characterised by their functional, durable and timeless designs, and the company is best known for its adaptable G-1000 fabric. A hardwearing blend of polyester and cotton, the fabric is incredibly practical for life outdoors and can even be adapted with Fjällräven's natural Greenland Wax to suit the conditions. Passionate about protecting the environment that inspires it, Fjällräven is always looking for new ways to reduce its environmental impact; from its PFC-free Eco-Shell fabric to its highly ethical and fully traceable down-sourcing programme.

Overall winner prize: £3,000 Fjällräven Award

The prestigious title of Outdoor Photographer of the Year is given for the photograph, chosen from the adult category winners, that the judges feel is the best single image entered, and they receive a superb prize.

Where does photography take you? To frozen mountains, battling icy winds and flurries of snow? The desert, under fierce sun and far from supplies? Or to dense forests, with rainfall and high humidity? Whatever your preferred photography habitat, Swedish outdoor specialist Fjällräven has the equipment to match.

The overall winner of OPOTY will have the opportunity to assemble – with expert assistance – their dream collection of Fjällräven kit. They'll receive a £3,000 Fjällräven Award to get equipment, garments and accessories to enhance their outdoor photography experience. Every photographer is different, and a one-to-one consultation with a Fjällräven expert will help the winner pinpoint exactly what they need from their gear. They won't have to get everything in one go either, as they can use the award on several occasions to add to their outdoor gear collection, so can tailor selections to trips they are planning throughout the year.

The winner will have their photo included in a special exhibition, and will also receive the coveted Outdoor Photographer of the Year slate trophy.

Runner-up prize: £1,000 Fjällräven Award

This year we are pleased to offer a runner-up prize, the recipient of which will receive a Fjällräven Award of £1,000 to be used in the same way as the overall winner's award, plus a personal consultation on what gear best suits their needs. They will also feature in the OPOTY exhibition.

Category winner prize

Category winners will each receive a superb Fjällräven Kaipak 38 daypack, worth £170, and £200 in cash. The category winning images will also be included in the exhibition at The Photography Show at the NEC in Birmingham.

For more information go to fjallraven.co.uk

Steve Watkins
Judging Chair

Steve Watkins is the editor of *Outdoor Photography* magazine and has been a professional photographer and author for over 19 years. His work has taken him to over 60 countries and to every continent. He is the photographer and author of three bestselling BBC books in the *Unforgettable Things to do...* series. Among his other editorial clients are the *Telegraph, Times, USA Today, Wanderlust,* AA Publishing and *Geographical*.
stevewatkins.com

Julian Calverley

Julian Calverley is a landscape and advertising photographer. At home both in the studio and on location, shooting people, landscape, automotive and lifestyle images, his cinematic style, mixed with a resourceful and passionate nature, has gained him a trusted reputation with clients worldwide. Increased demand for his landscape work has spurred Julian to make it available as editioned large format prints. He has featured in *Lürzer's Archive 200 Best Ad Photographers Worldwide* for the last eight years.
juliancalverley.com

THE JUDGES

Brought together for their superb knowledge and critical insight into imagery from all the genres within outdoor photography, the judging panel, along with the Fjällräven UK CEO, ensures the selection process is rigorous.

Pete Bridgwood

Pete Bridgwood is a fine art landscape photographer and writer. He is fascinated by the creative foundations of landscape photography and passionate about exploring the emotional elements of the art. He is the creator and curator of the national biennial landscape photography exhibition Masters of Vision, held at Southwell Minster Cathedral in Nottinghamshire. He is a Fuji X-Photographer and a Manfrotto Ambassador.

petebridgwood.com

Fergus Kennedy

Fergus Kennedy is an experienced photographer and filmmaker. Originally a marine biologist, he loves exploring the underwater world, camera in hand. More recently he has been getting heavily into drone photography and video work and is the author of *Drone Photography & Video Masterclass*. His work has been highly commended in Wildlife Photographer of the Year and his clients include BBC, ITV, Canon, Toyota, Nissan, *National Geographic Arabia* and World Wild Fund for Nature.

ferguskennedy.com

Rachael Talibart

Rachael is a professional fine art photographer who exhibits frequently and has prints in private collections in the UK and USA. She owns f11 Workshops, through which she runs photography workshops in the south east of England, leads tours for Ocean Capture, writes for photography magazines and is in demand as a public speaker. She is also the winner of the Classic View category (2017) and the Sunday Times Magazine's Award (2016) in the Landscape Photographer of the Year competition.

rachaeltalibart.com

Pete Webb

With more than 25 years of working with the best athletes in extreme locations, Pete Webb is one of Europe's most sought after adventure sports photographers. Pete is also a part-owner in weareMerci, a creative marketing agency that uses its understanding of commercial photography and smart content to create business strategies for premium brand clients looking to make their visual identity stand out.

petewebb.com
wearemerci.com

Andrew Parkinson

Andrew Parkinson is a professional wildlife photographer who lives on the fringes of Derbyshire's Peak District, England. Although he has travelled widely, his greatest passion is for the wildlife and wild places of Britain. He has worked on assignment for *National Geographic* and regularly contributes to *BBC Wildlife* magazine and *Outdoor Photography*, and has also been published in the *New York Times*, the *Guardian* and the *Telegraph*.

andrewparkinson.com

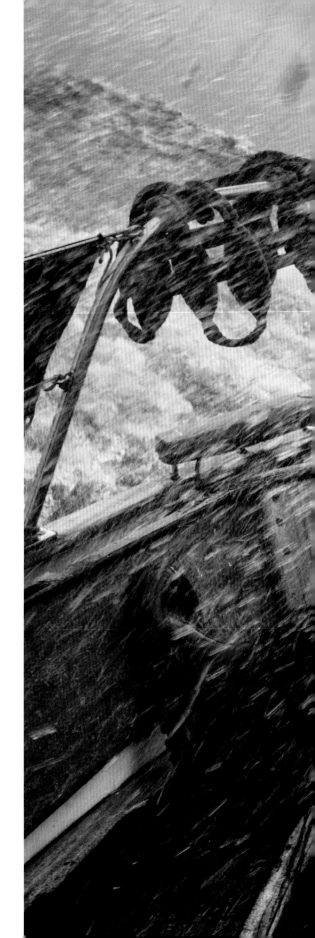

OUTDOOR PHOTOGRAPHER OF THE YEAR

OVERALL WINNER

Mikolaj Nowacki (Poland)

The Baltic Sea (somewhere on the way from the Swedish island of Utklippan to the Danish island of Christiansø). It was my first cruise on a yacht on the open sea and there were only two of us – myself and captain Jacek Pasikowski. I was helping Jacek take his small yacht Fri ('Free' in Danish) from the coast of Sweden to Poland, across the Baltic Sea. It was a stormy day, but the captain – who has more than 40 years of experience sailing in open seas – remained completely calm and relaxed, even though waves were breaking over him every few minutes. While taking this picture I was hiding partly below a folding canvas roof; scared, but pretending not to be.

Panasonic Lumix GH5 with 15mm f/1.7 lens, ISO 100, 1/125sec at f/4

mikolajnowacki.com

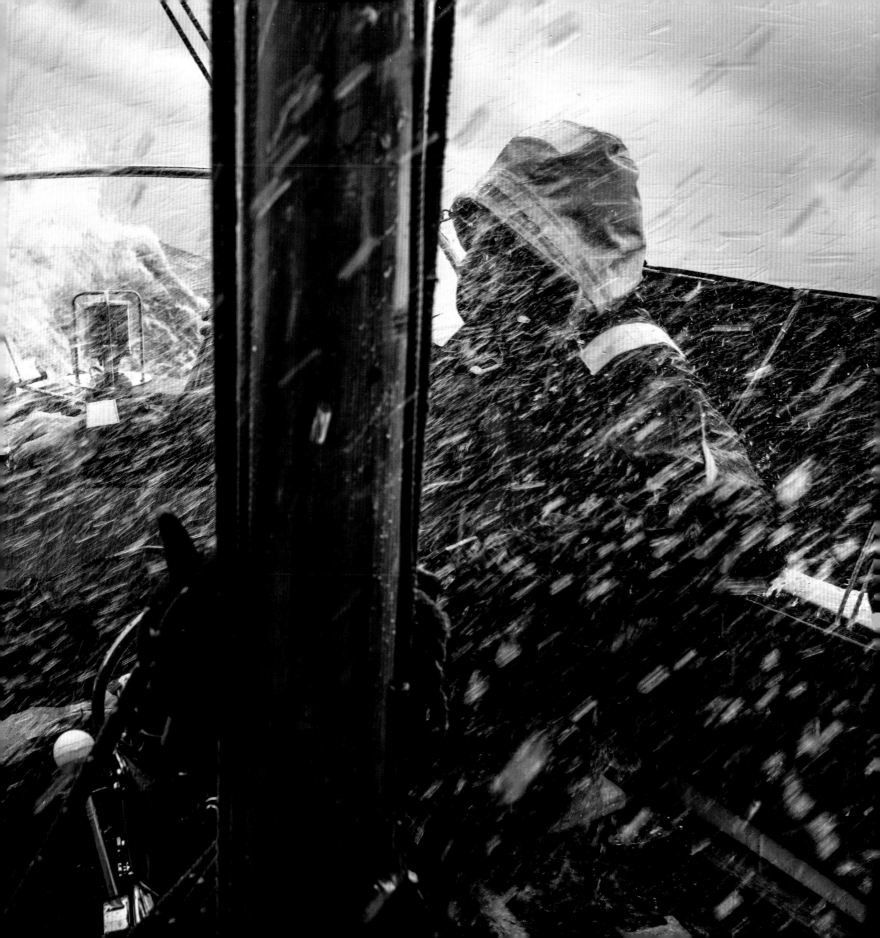

AT THE WATER'S EDGE

Lakes, rivers, waterfalls and the coast make for some of the most appealing outdoor photography subjects. At the Water's Edge showcases inspiring images of these watery subjects, either in the wider environment or more intimate views.

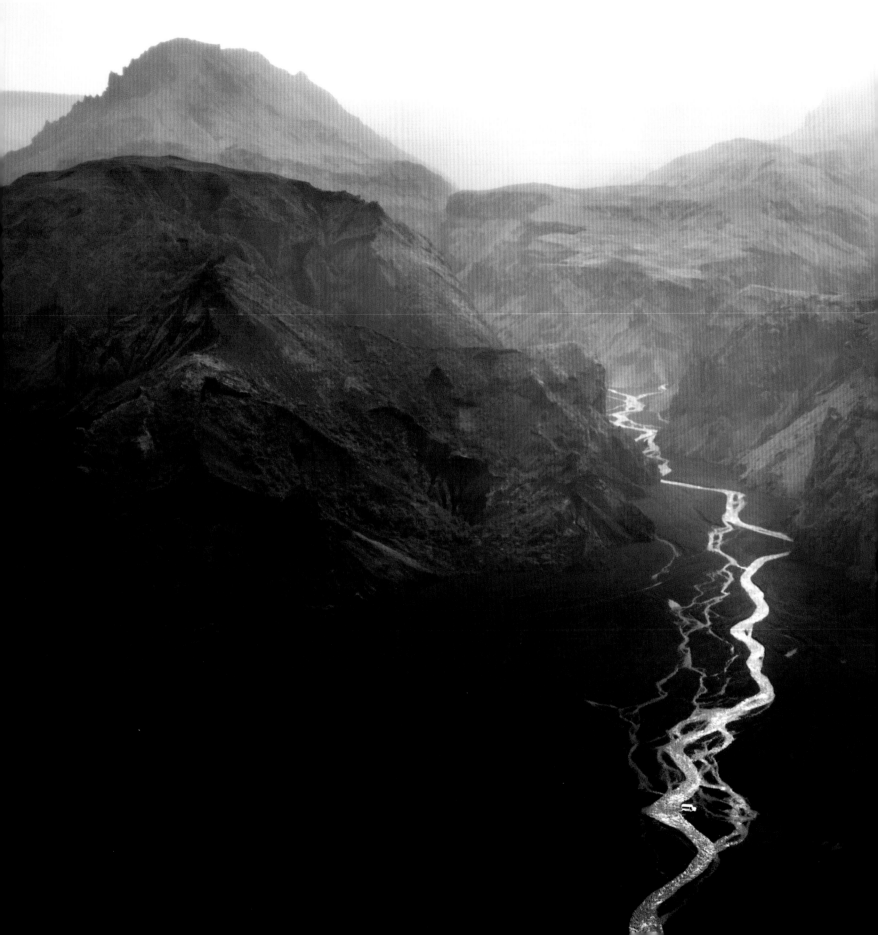

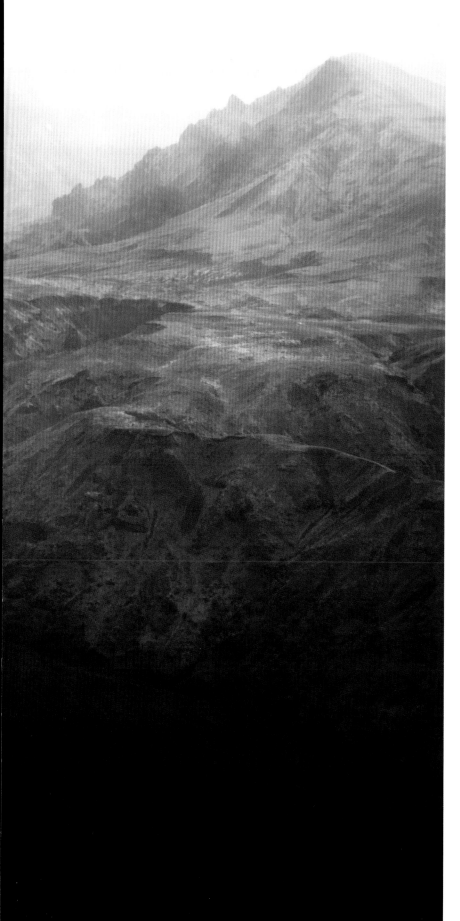

AT THE WATER'S EDGE – WINNER

Witold Ziomek (Poland)

Thórsmörk, Iceland. After a morning full of drama, during which we almost 'drowned' our car in a river – and then pulled out a young Frenchman who had – we reached Thórsmörk, in the south of Iceland. We walked up to a viewpoint where we could see...exactly nothing, due to the fog. We waited, and eventually the fog started to lift, but I still needed to wait a lot longer for a car to appear in the perfect position to add a sense of scale to the mountain landscape.

Nikon D610 with 24-105mm f/4 lens at 48mm, ISO 180, 1/200sec at f/7.1, polariser

instagram.com/witold_ziomek

Neil Burnell (United Kingdom)

Shoalstone Pool, Brixham, Devon, England. This outdoor swimming pool is one of my favourite places to photograph, as it is a unique location that offers multiple opportunities throughout the seasons and in various conditions. On this occasion there was a strong easterly wind blowing into the bay, which created dramatic, rough conditions. I stood 30–40m from the pool to take this shot, keeping a safe distance from the turbulent seas. I wanted to capture the movement and power of the water as it disfigured the surrounding barriers, so opted to shoot multiple exposures, which I then blended in Photoshop.

Nikon D800E with 50mm f/1.8 lens, ISO 100, 0.8sec at f/11, three-stop ND filter, tripod

neilburnell.com

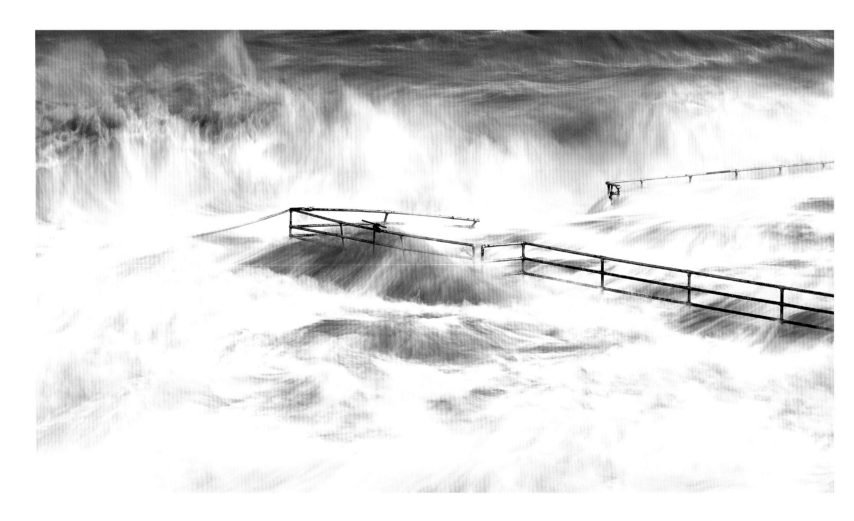

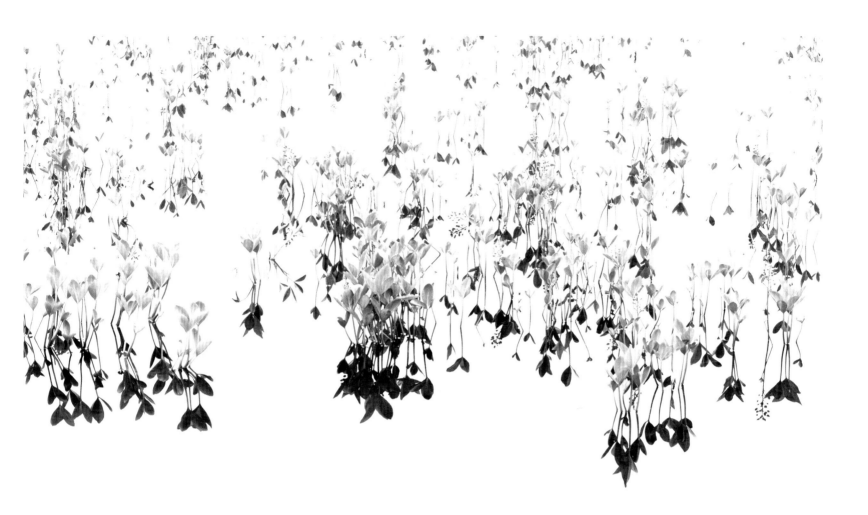

Annette Dahl (Switzerland)

Ånderdalen National Park, Senja, Norway. These buckbean plants caught my attention while I was hiking and photographing in Ånderdalen National Park, Norway. I was fascinated by the pattern and their reflection on the flat, mirror-like surface of the water. The completely overcast sky not only gave a fantastic diffused light, but also created the perfect white background. I wanted to achieve an airy feel, so left plenty of negative space at the bottom, which also gives the reflection space to breathe. The black & white conversion emphasises the abstract nature of the image.

Sony a6000 with 16-70mm f/4 lens at 59mm, ISO 100, 1/10sec at f/11, tripod

annettedahl.com

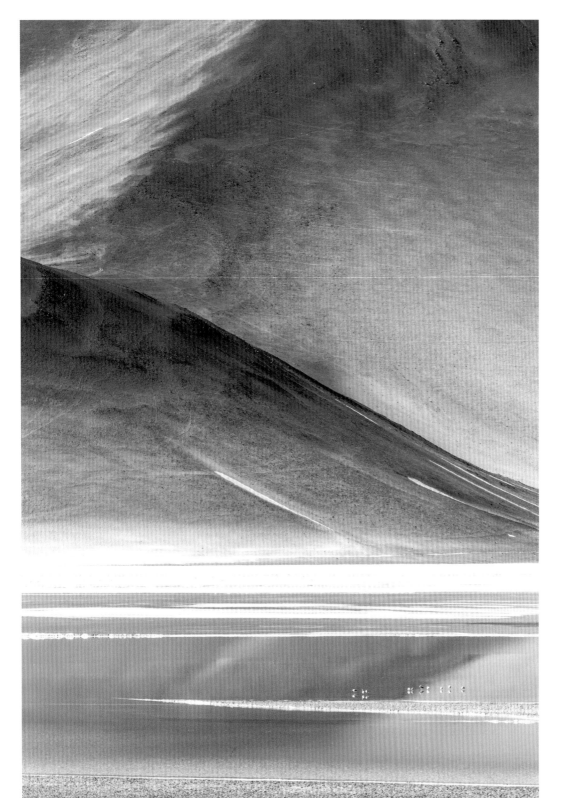

Agnès Proudhon-Smith (United Kingdom)

Left: **Salar de Aguas Calientes, Atacama Desert, Chile.** This shot was taken shortly after sunrise at the Aguas Calientes salt flats in the Chilean Altiplano, at an altitude of nearly 4,300m. I was attracted to the peace and tranquility of this lagoon and the amazing colours, which deliver a surreal effect. I decided to focus on a small part of the landscape to concentrate on the soft tones and textures of the water and the hills, conveying the extreme beauty of this unspoilt landscape. The Chilean flamingos add a sense of scale.

Canon EOS 7D with 70-200mm f/2.8 lens at 200mm, ISO 100, 1/320sec at f/8, handheld

500px.com/agnesps

Jon Gibbs (United Kingdom)

Right: **North Walsham and Dilham Canal, Honing, Norfolk, England.** I had spent a few days in this area photographing the now-disused canal when I spotted the potential for this image. I was drawn to the zigzag shape created by the grasses and the canal, but to get the composition involved walking across very marshy land that wouldn't support my weight. Returning a day or two later on a very cold and foggy morning – and more suitably dressed – I was able to precariously set up my camera and make the image.

Nikon D810 with 70-200mm f/4 lens, ISO 200, 1.6sec at f/8, tripod

jon-gibbs.co.uk

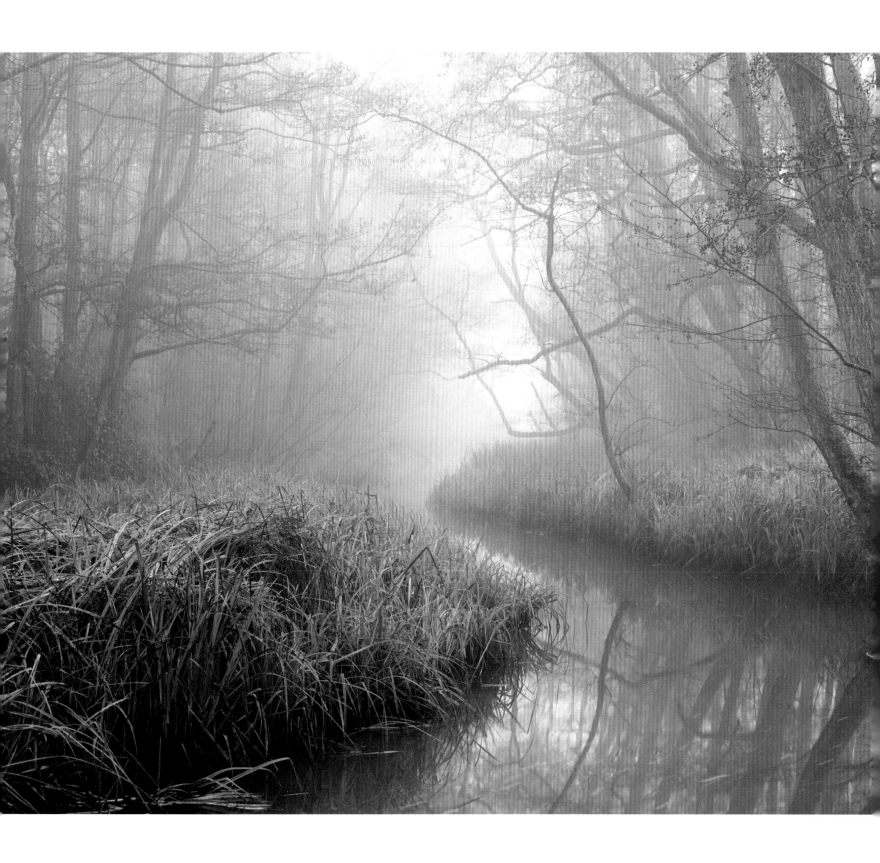

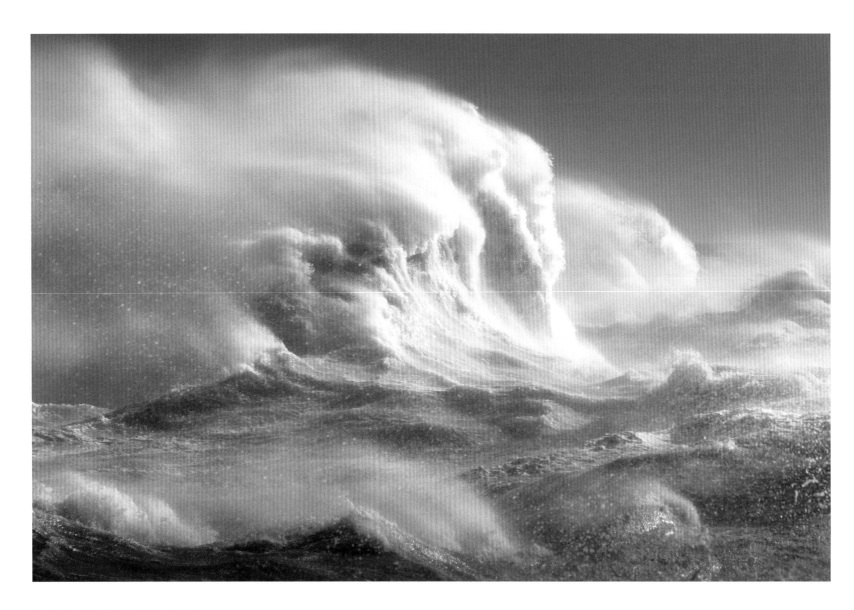

Craig Denford (United Kingdom)

Newhaven, East Sussex, England. This was taken as Storm Brian hit the shores of the United Kingdom. The conditions were better than I could have hoped for, with bright sunshine against a dark, brooding sky and a powerful surge at high tide. It was not without its challenges, though: staying on both feet while holding on to my tripod to prevent it flying off was difficult enough, but the sea spray also meant constantly having to clean the lens between shots. It was quite a relief to finally get back to the car to shelter from the constant battering from the wind.

Canon EOS 7D MkII with 75-300mm lens at 220mm, ISO 400, 1/2500sec at f/10, tripod

craigdenfordphotography.co.uk

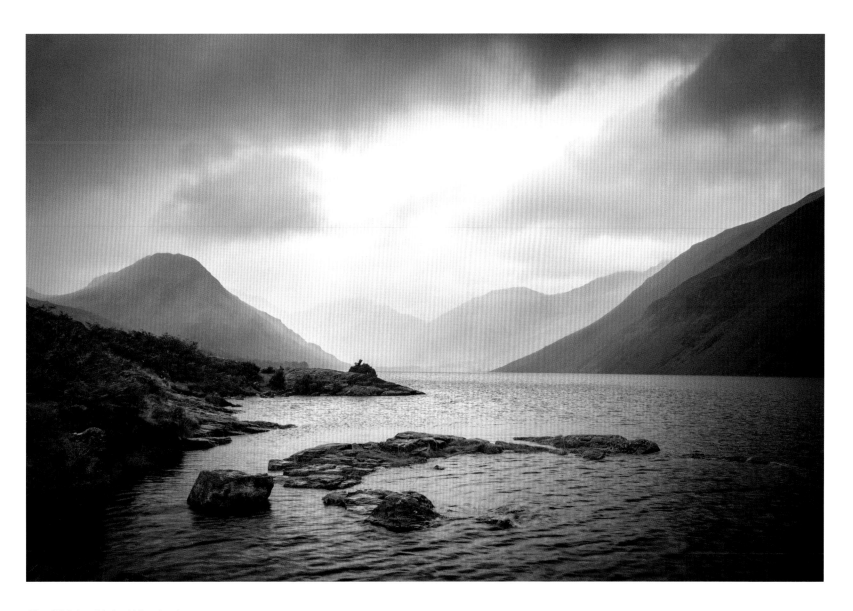

Alex Wrigley (United Kingdom)

Wastwater, Lake District, England. I headed to Wastwater because recent downpours promised a higher-than-average water level, which this composition required. I had been waiting to shoot it for a while, so I was happy to find that the water level was perfect. The morning progressed in dramatic fashion, with torrential squalls passing over and moving towards the distant peaks before the sun broke through. My gear got drenched numerous times and it was a challenge keeping water off my lens, but it shows that it's always worth heading out, even in poor weather.

Nikon D800 with 18-35mm lens at 32mm, ISO 100, 1/6sec at f/11, polariser, tripod

alexwrigleyphotography.com

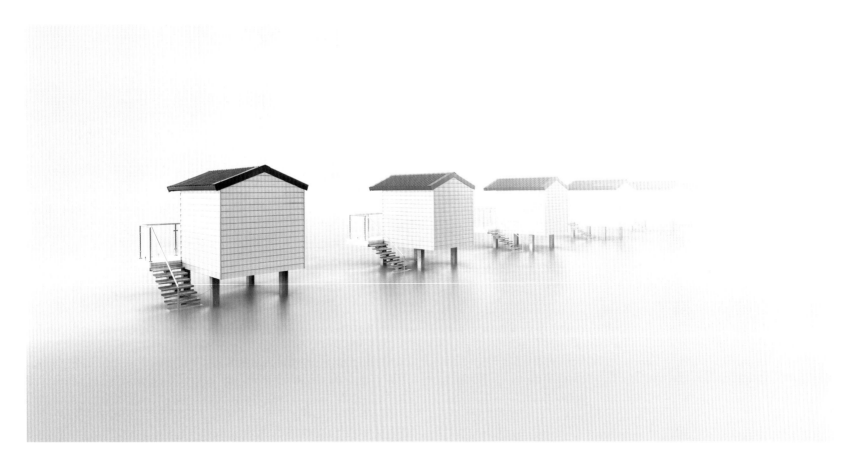

Neil Burnell (United Kingdom)

Osea Leisure Park, Blackwater, Essex, England. These unique beach huts
in Osea Leisure Park, on the Blackwater Estuary, are a minimalist landscape
photographer's dream. I photographed them on a cold January morning, when
there was a slight hint of mist that helped isolate them. A gentle breeze made
the water choppy, so I decided to smooth this out with a 10-stop ND filter. In
post-processing, all of the tonal work was done in Adobe Camera Raw, before
the image was taken into Photoshop and cleaned up using the clone stamp
and graduation tools. Finally, I converted the picture to monochrome, giving
it a classic, high-key style.

Nikon D810 with 21mm f/2 lens, ISO 64, 44sec at f/10, 10-stop ND filter, tripod

neilburnell.com

Tom Lowe (United Kingdom)

Right: **Whitley Bay beach, Tyne and Wear, England.** On a late-December morning I arrived at Whitley Bay beach to find the stormy winter seas had washed up large banks of tangled kelp. Overnight, sub-zero temperatures had dusted the kelp with a light frost, helping to accentuate their form. I visualised the central tangle of this image to be the frozen heart of some kind of mythical sea creature, and wanted to create a dark sci-fi feel reminiscent of work by the artist H.R. Giger. In post-production I desaturated the photograph and introduced cold blue tones, while boosting the contrast and clarity.

Canon EOS 6D with 24-105mm f/4 lens at 45mm, ISO 100, 6sec at f/11, tripod

instagram.com/f22digital

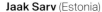

Jaak Sarv (Estonia)

Following page: **Prandi Springs, Järva County, Estonia.** This is the magic of an Estonian winter: although the temperature was -20°C, the water at this spring was flowing like it was summer. As the morning sun peeked out from behind the frost-covered trees it was like being in a fairy tale, with the warm orange light starting to penetrate the desolate blue landscape. To make the most of the scene I created a stitched panorama, reflecting the cinematic drama of the location.

Canon EOS 5D MkIII with 70-200mm f/4 lens at 70mm, ISO 100, 2.5sec at f/11, two-stop soft ND grad filter, three-stop ND filter, polariser, tripod

jaakphoto.com

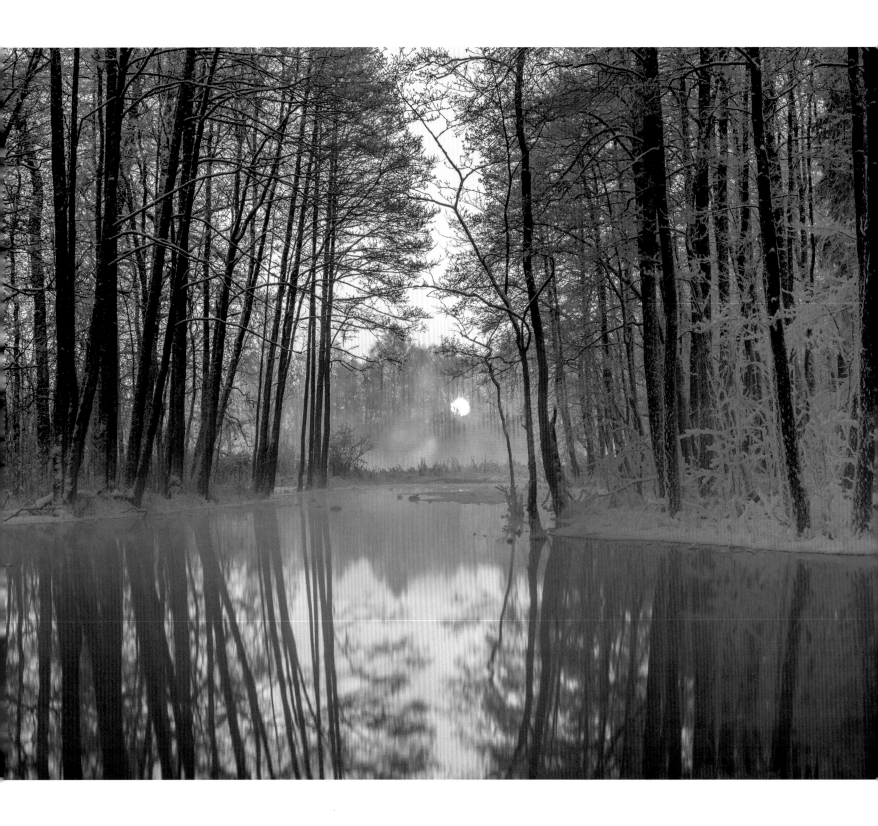

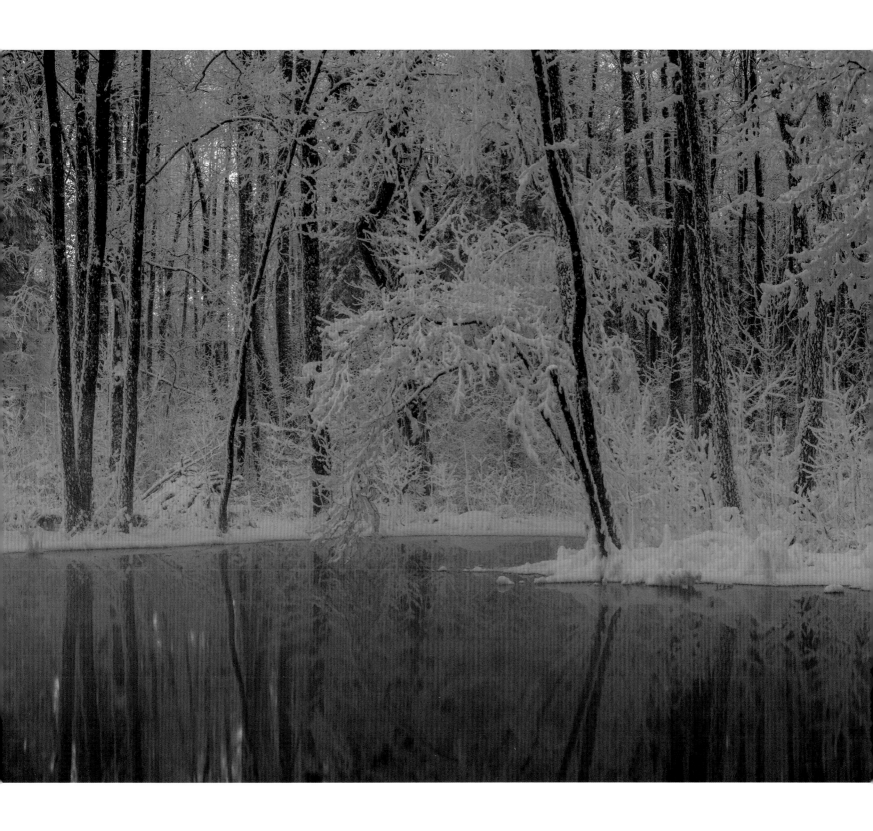

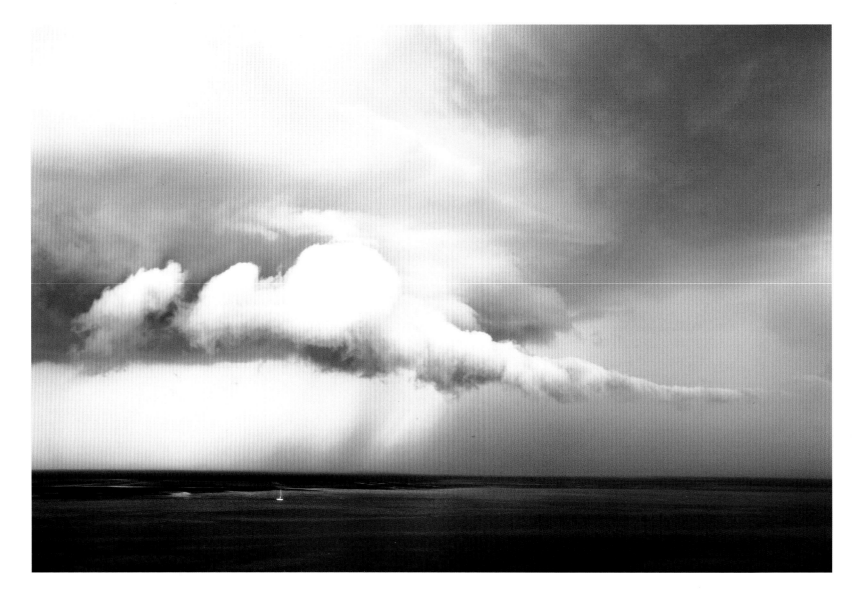

Felicity Millward (United Kingdom)

Öresund, Sweden. I was travelling round Sweden in summer and had gone to have a look round a lighthouse. I got to the top and as I was taking in the stunning view the weather took a dramatic turn, with a storm rolling in. My companions started heading back to the car to stay dry, but I stayed at the top of the lighthouse to capture the change in the weather, battling against the wind and the torrential rain that followed.

Canon EOS 5D MkIII with 24-70mm f/2.8 lens at 33mm, ISO 160, 1/40sec at f/16

felicitymillward.com

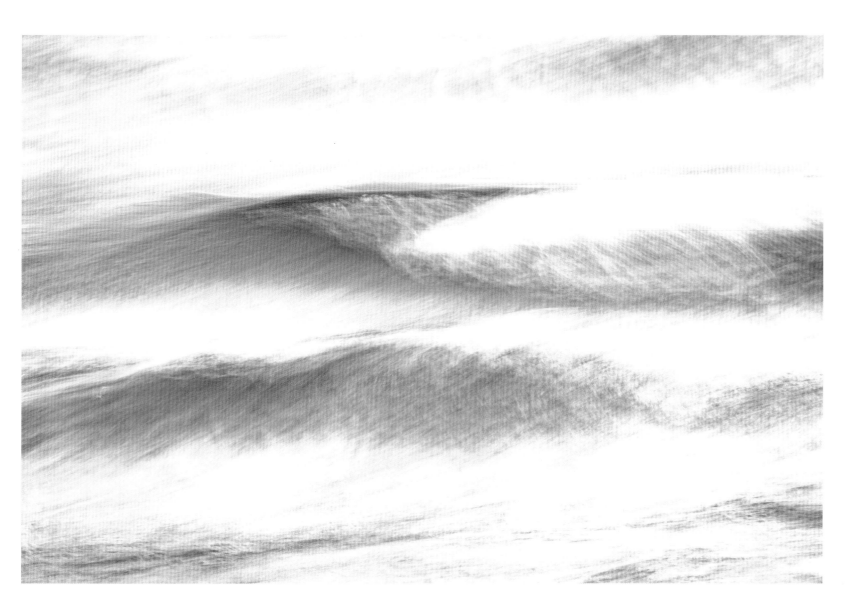

Andy Holliman (United Kingdom)

Lake Wakatipu, South Island, New Zealand. Lake Wakatipu is the shape of a huge lightning flash, and the surrounding hills funnel the winds down from the Southern Alps to create waves on the surface. I experimented with different combinations of shutter speed to try to capture the movement of the water and keep some structure in the waves. Grey overhead light brought out the colours of the water, which were then enhanced in Lightroom. There's a high failure rate with this kind of photography, but it is very satisfying when an image such as this one works.

Nikon D500 with 70-200mm f/2.8 lens at 150mm, ISO 100, 1/4sec at f/22

allthisuselessbeauty.co.uk

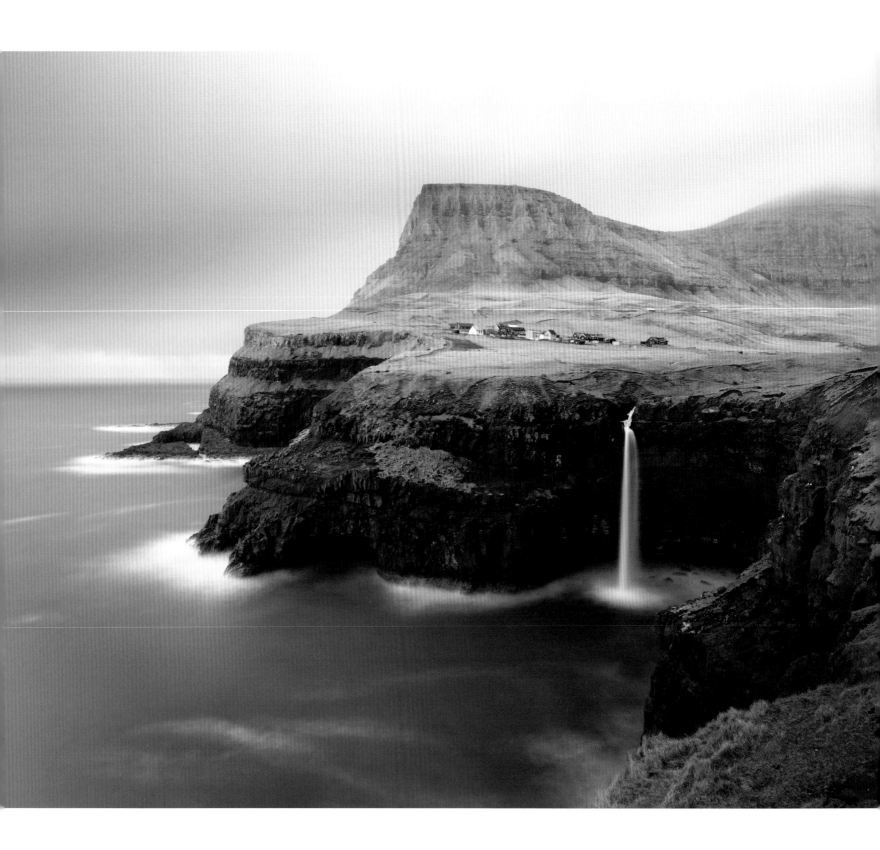

Euan Ross (United Kingdom)

Left: **Gásadalur, Faroe Islands.** Making my way towards the sea, I ventured down the steps that ran along the cliff's edge to get as close to the Atlantic as I dared to go. It was only then, as I turned back towards the tiny hamlet of Gásadalur, that this waterfall revealed itself, nestled at the point where the land meets the mythical Faroese coastline. As the river thundered over the edge, it created a near-perfect vertical drop of water, which on this occasion fought and won against the opposing sea gales.

Nikon D610 with 20mm f/1.8 lens, ISO 200, 114sec at f/9, 13-stop ND filter, polariser, tripod

circa35mm.com

Damian Shields (United Kingdom)

Gjógv from Kallur, Kalsoy, Faroe Islands. I made the journey via ferry from Klaksvík to the wonderfully remote Kalsoy island, then drove to the most northern village, Trøllanes. A hike up to the lighthouse at Kallur gave me an incredible view of the northern reaches of the finger-like isles stretching out before me into the Atlantic. This shot was taken shortly before I decided to call it a day, as a heavy bank of storm clouds was rapidly approaching and the light was fading fast. The local fishermen must have had thoughts of home on their minds too, and I loved watching the multitude of boats making a bid for land, safe harbour and home.

Nikon D800 with 70-200mm f/2.8 lens at 70mm, ISO 50, 1.6sec at f/11, tripod

damianshields.com

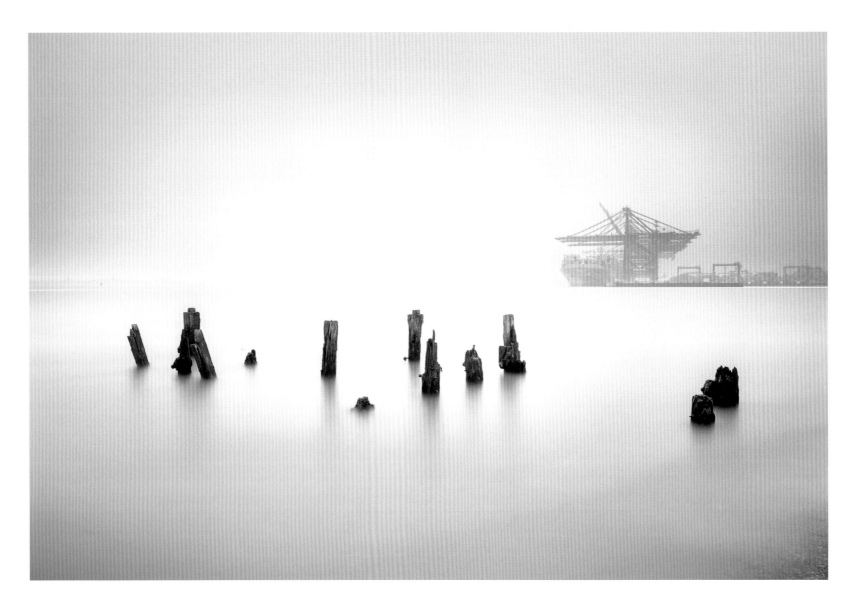

Dave Watts (United Kingdom)

Felixstowe docks, Suffolk Bay beach, England.
I had this shot in mind for a while but for it to
work it needed some low white cloud, high tide
and sunrise to come together on the same day. The
low cloud would help mask the distant distractions
and simplify the port, leaving only the modern
cranes and the remains of the old timber pier in
the foreground. Finally, the perfect conditions
arrived and I was there to record the moment.

*Canon EOS 6D with 16-35mm f/4 lens at 24mm, ISO 100,
261sec at f/10, 10-stop ND filter, polariser, tripod*

davewattsphotography.com

Tom Lowe (United Kingdom)

Whitley Bay beach, Tyne and Wear, England. I was really drawn to the contrasting textures in this particular scene, as the untouched sand of Whitley Bay beach is juxtaposed against the mackerel-like patterns appearing in the fast-flowing stream running out to sea. I framed the shot diagonally to give equal balance to both elements, and in post-production boosted the contrast and clarity.

Canon EOS 6D with 24-105mm f/4 lens at 45mm, ISO 50, 5sec at f/16, tripod

instagram.com/f22digital

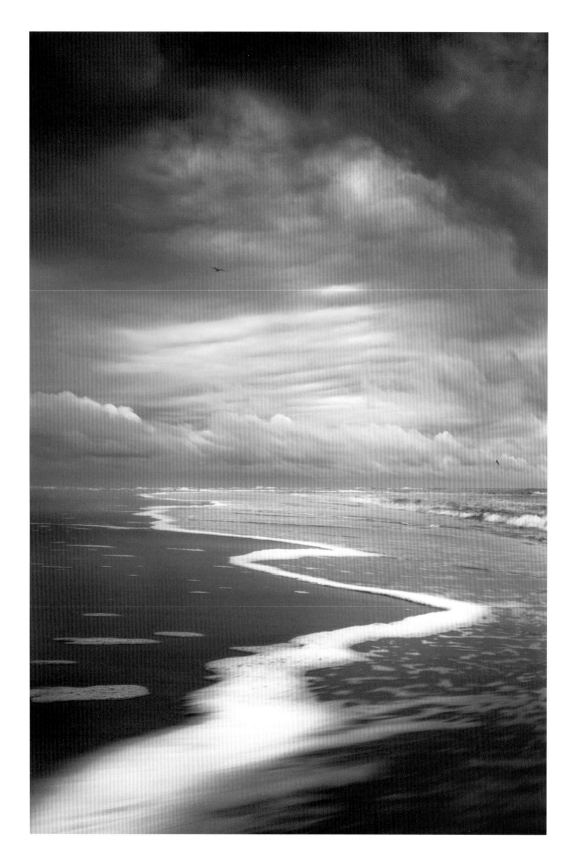

Daniel Laan (Netherlands)

Huisduiner Strand, Den Helder, Netherlands. The beach at Huisduinen is a desolate place in a storm. I took this photograph during the 'blue hour' and wanted to capture a gull and a lapping wave creating an interesting lead-in line. There was already plenty of drama in the sky, but when the low clouds suddenly broke slightly, they revealed the mid-level clouds above, bringing an increased sense of depth to the composition. This coincided with the perfect positioning of both the water and a gull.

Nikon D750 with 15-30mm f/2.8 lens at 30mm, ISO 100, 1/4sec at f/6.3, tripod

laanscapes.photography

Benjamin Graham (United Kingdom)

Bognor Regis, West Sussex, England. The evening of 18 June was one of the calmest and warmest days of the summer of 2017, and it presented me with this minimalist opportunity. The muggy seas off the south coast at Bognor were so uncannily unruffled it could almost have been a view across a lake. Shot at 180 degrees to the sunset, I eliminated what slight amount of tidal movement there was by using a 10-stop ND filter and an exposure time of 93sec. Astonishingly, the little yellow buoy that provides visual punctuation to the impressionistic peachy rose and chalky blue haze of sea, cloud and sky, moved imperceptibly throughout the duration of the exposure.

Nikon D810 with 50mm f/1.4 lens, ISO 64, 93sec at f/9, 10-stop ND filter

benjamingraham.co.uk

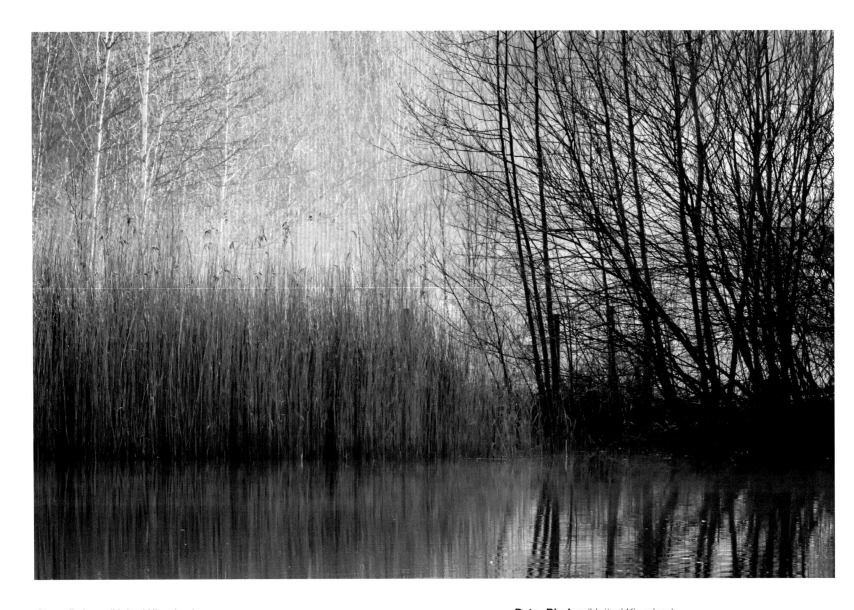

Steve Palmer (United Kingdom)

Lindow Common, Wilmslow, Cheshire, England. As I arrived at this lake on a cold morning in February, the low winter sun had only just begun to reach the birch trees, casting a warm light on their bare branches. Walking further along the lake, I was drawn to the contrast of the light and dark elements across the water from me. I waited until the sun fully illuminated the left side of the small birch wood before I took my shot.

Pentax K-5 IIs with 70-200mm f/2.8 lens at 200mm, ISO 400, 1/125sec at f/8, handheld

stevepalmer.photography

Peter Bindon (United Kingdom)

Right: **Holme Fell, Cumbria, England.** Sometimes you just have to look at the world differently, so I flipped this image so it was upside down to give a surreal perspective to a beautiful Lakeland scene. I also edited the image to a square crop, as I felt this complemented the scene and the feeling I was aiming to reproduce.

Nikon D800 with 45mm f/2.8 lens, ISO 100, 1/4sec at f/11, polariser, tripod

peterbindon.co.uk

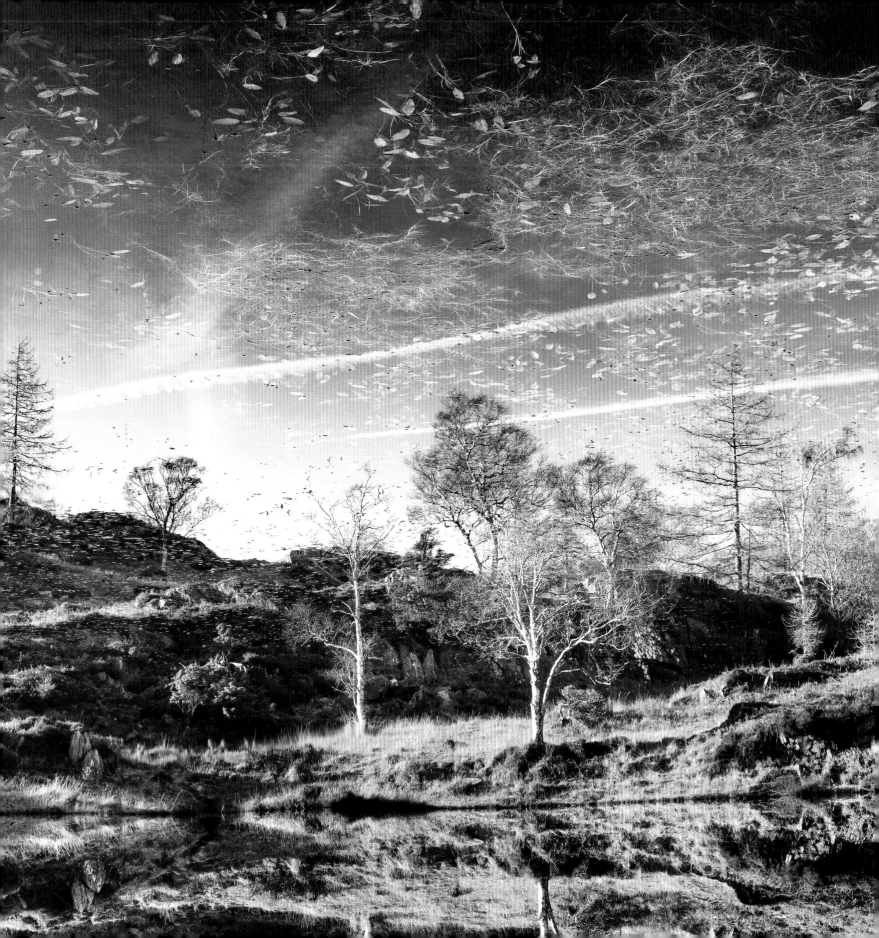

Mark Cornick (United Kingdom)

Sennen Cove, Cornwall, England. This photograph forms part of a larger project entitled 'Fathom'. The image was captured at Sennen Cove beach in Cornwall, during a wonderfully moody summer evening. Cornish beaches are one of my favourite locations for creating images and I love visiting the ocean at times when you have the beach almost to yourself. I wanted to take a fresh approach to photographing this location, so decided to focus on creating ICM (intentional camera movement) images using a six-stop ND filter to give me a 4sec exposure time. I knew that the shallow pool of water going out to sea would create a very interesting lead-in line, so it was just a matter of patience and spending time creating movements that would result in pleasing patterns. In post-production, it was a simple case of correcting the colour cast created by the filter and adding some contrast to create impact and drama.

Canon EOS 6D with 17-40mm f/4 lens at 17mm, ISO 100, 4sec at f/5.6, Lee Filters Little Stopper (six-stop ND filter), handheld

markcornickphotography.co.uk

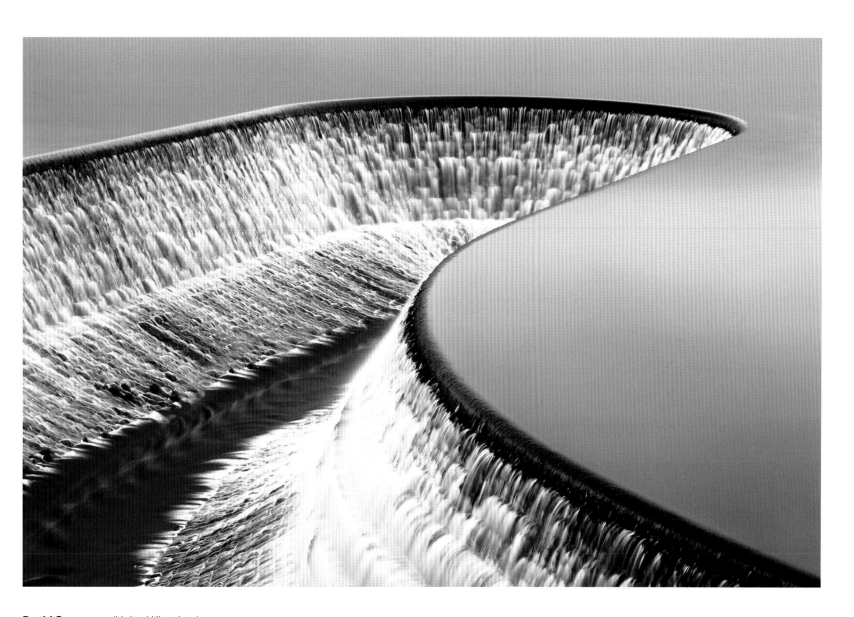

David Semmens (United Kingdom)

Torside reservoir, Derbyshire, England. The biggest challenge with this photograph was standing in a swarm of midges to get the best composition. I had to have the cable release in the camera and then stand at arm's length with the cable at full stretch. This allowed me to get as far away from the camera as possible and keep the swarming midges near me, away from the front of the lens. The weather was very poor, but the fog worked a treat in softening the light. I only got around five minutes between rain showers to get the shot.

Nikon D810 with 70-200mm f/2.8 lens at 110mm, ISO 64, 4sec at f/14, tripod

facebook.com/DPSNature

WILDLIFE INSIGHT

There has never been a better time to be a wildlife photographer.
Wildlife Insight celebrates compelling compositions that show
the spirit and behaviour of wildlife around the planet.

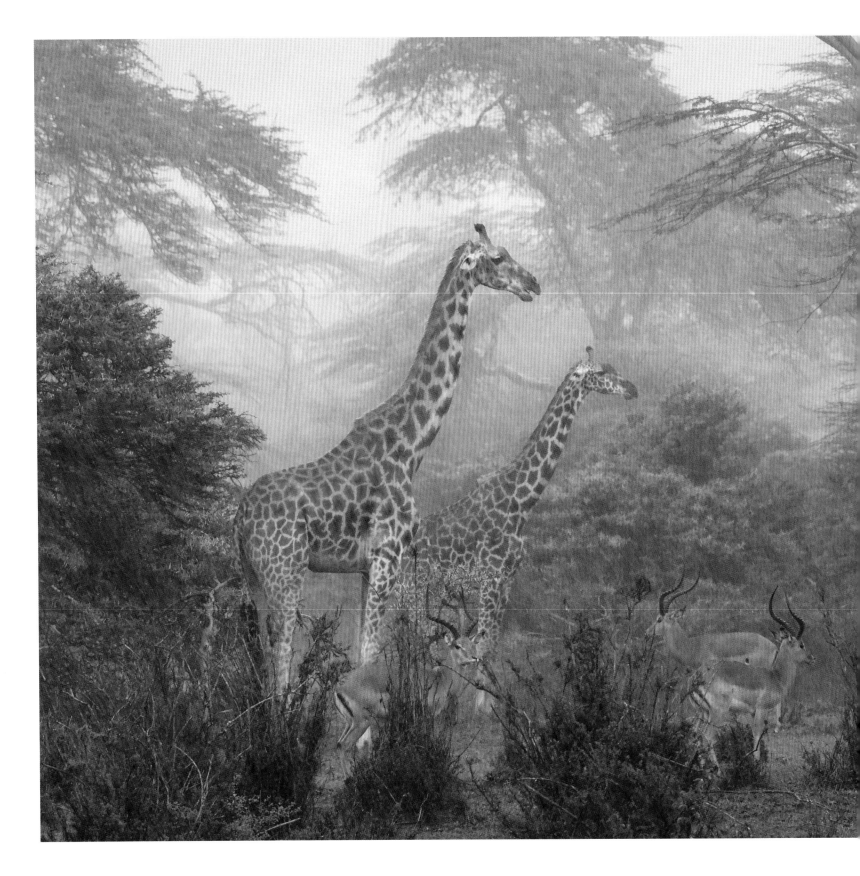

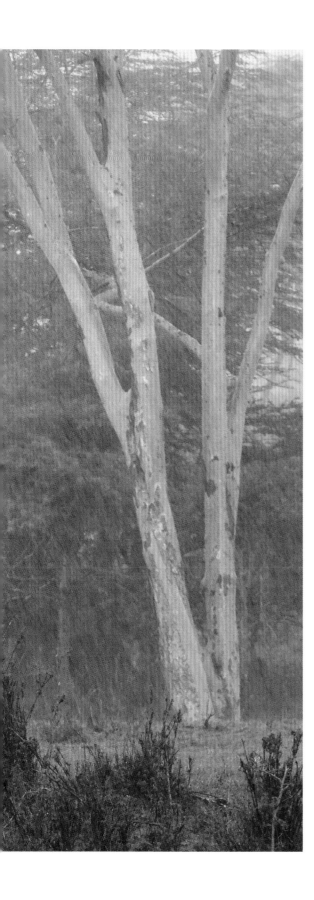

Jose Fragozo (Portugal)

Nairobi National Park, Kenya. This image shows two giraffes and three impalas in the rain in the forest region of Nairobi National Park, Kenya, which is also home to the Athi lion pride. I have observed these lions hunting many times in the rain, which possibly explains why different species of preyed animals stay together; it's a defence mechanism, so they can collectively sense predators better. In this case, however, the lions were far away. The photo was taken from inside a 4x4 vehicle, and the major challenge was keeping the camera and lens dry.

Canon EOS 1D X MkII with 200-400mm f/4 lens at 278mm, ISO 100, 1/80sec at f/9, car door mount

fragozowildlife.com

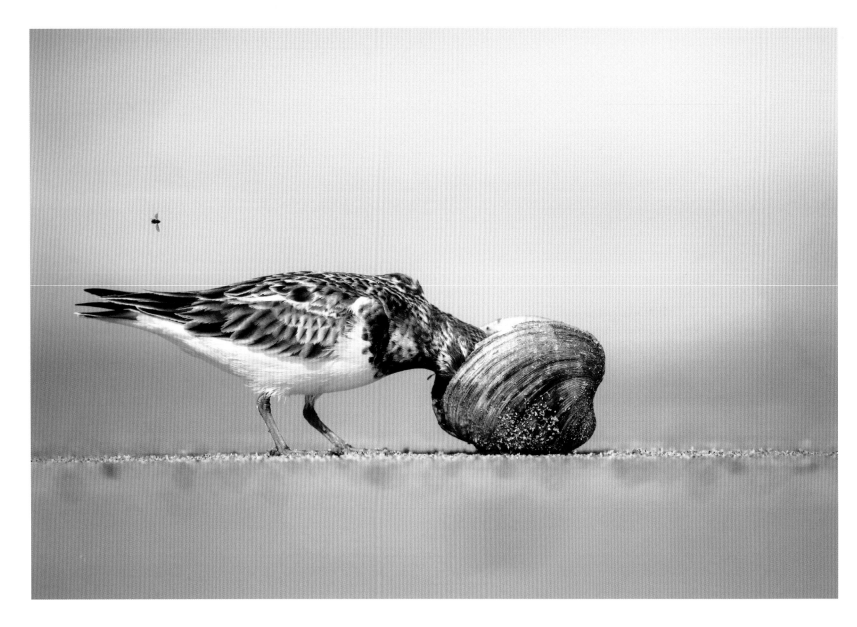

Barb D'Arpino (Canada)

Ruddy turnstone, Merritt Island seashore, Titusville, Florida, United States of America. I love spending time at the beach photographing shorebirds, as they are always entertaining. It was an extremely windy morning when I took this, and the waves were washing up several types of shells that the birds were fighting over. I lay on the ground so I would be at eye level to photograph the action. It was hard to isolate a single bird, but luckily for me, this ruddy turnstone had the shell all to itself for a brief time (except for the photobombing fly!). It was starting to cloud over, so I had to shoot wide open to keep the shutter speed high and the ISO low.

Canon EOS 5D MkII with 500mm f/4 lens, ISO 100, 1/2000sec at f/4, handheld

flickr.com/photos/barbaralynne

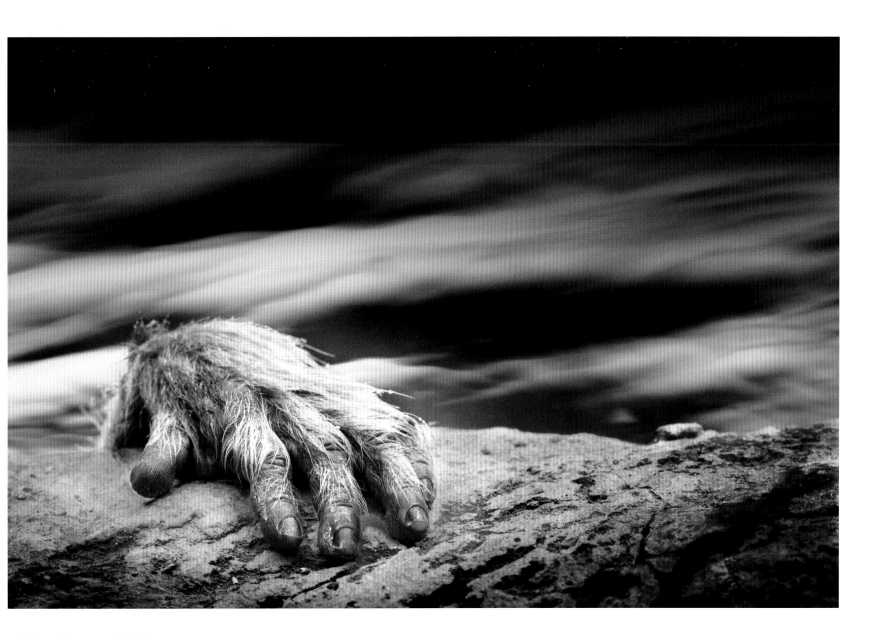

Johan Siggesson (Malta)

Jigokudani, Japan. Photographing the snow monkeys in Japan's Hell Valley is easy: they are everywhere, they are close and they are not afraid of people. At the same time, this also makes it incredibly difficult to achieve something that is different and unique. While photographing the monkeys resting in the hot pool, trying to get some kind of facial expression from them, I noticed that if I composed the image in a certain way it would look as though a human-like creature is climbing up from below and is just about to reach the top.

Nikon D500 with 300mm f/2.8 lens and 1.4x teleconverter, ISO 400, 1/250sec at f/13, handheld

johansiggesson.com

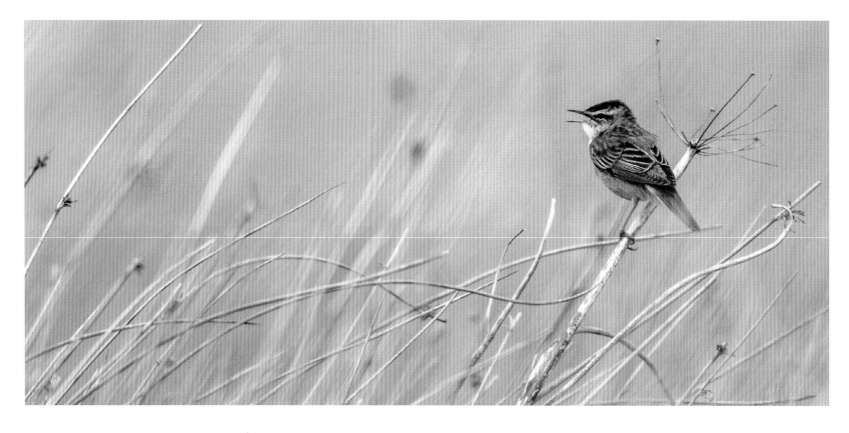

Richard Whitson (United Kingdom)

Sedge warbler, Cathkin Marsh Wildlife Reserve, Glasgow, Scotland.
Mid-May is a great time to see recently arrived warblers out singing after
their return to the United Kingdom from Africa, as the grasses, rushes
and foliage have not yet started to grow. When I took this, the sedge
warblers at Cathkin Marsh Wildlife Reserve were being kinder to me
than previous years, allowing me some good – albeit distant – views.
I favour wider crops that include the habitat and like using negative
space to draw the eye to the subject.

*Canon EOS 7D MkII with 400mm f/2.8 lens and 1.4x teleconverter, ISO 125,
1/1600sec at f/4, tripod*

2far2see.co.uk

Tesni Ward (United Kingdom)

Right: **Mountain hare, Cairngorm National Park, Scotland.** I had sat observing
this particular hare for a few hours in the pouring rain, gradually creeping closer,
in the knowledge that this individual was relatively relaxed around humans. As
the storm finally passed, light flooded the mountains behind him and a rainbow
broke through. I was in a prime position to use my wideangle lens, attempting
to show the stark contrast between the hare and his surroundings. While their
white coats have evolved to camouflage them, an ever-warming climate means
this can also work to their detriment, putting them at a higher risk of predation
and human persecution.

Olympus OM-D E-M1 MkII with 12-40mm f/2.8 lens at 15mm, ISO 320, 1/160sec at f/5, handheld

tesniward.co.uk

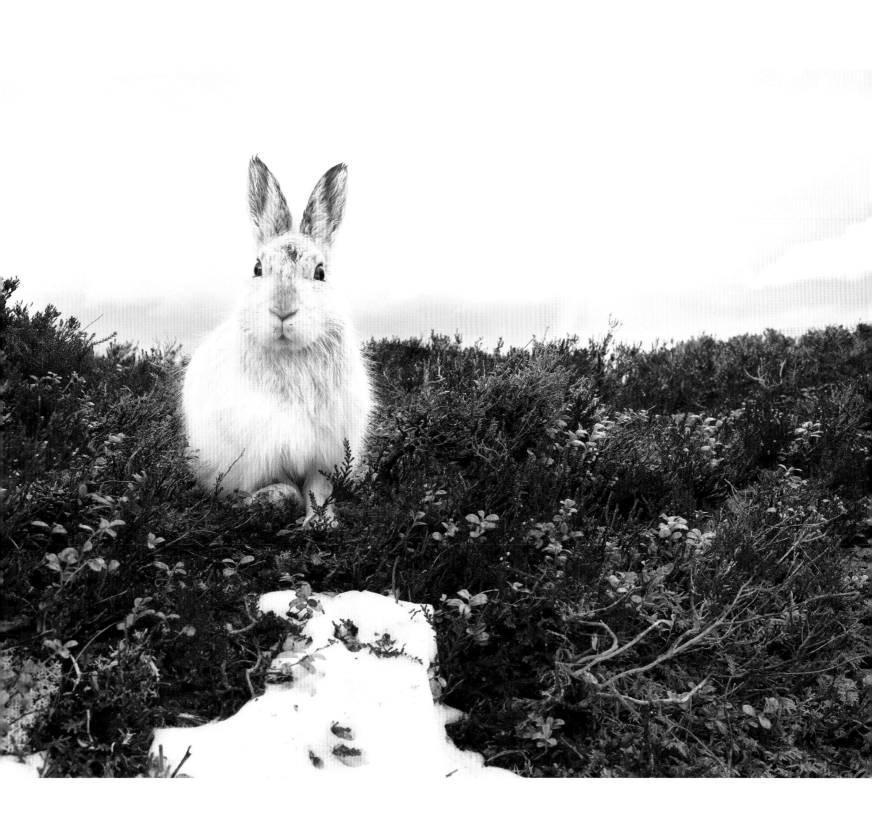

Prelena Soma Owen (South Africa)

Lion cub, Sabi Sand Game Reserve, South Africa. We came across a lion pride feeding on a wildebeest carcass. I noticed a hole in the carcass and focused my camera in anticipation of one of the cubs peering through it. The hole was not very large and it took several attempts to get the eye in focus at the right moment.

Canon EOS 5D MkIII with 600mm f/4 lens, ISO 1000, 1/350sec at f/6.3, handheld

echoesofthewild.com

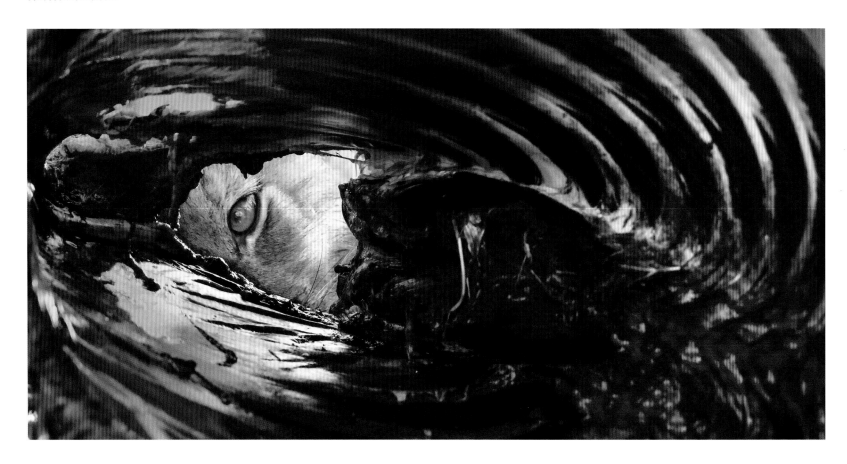

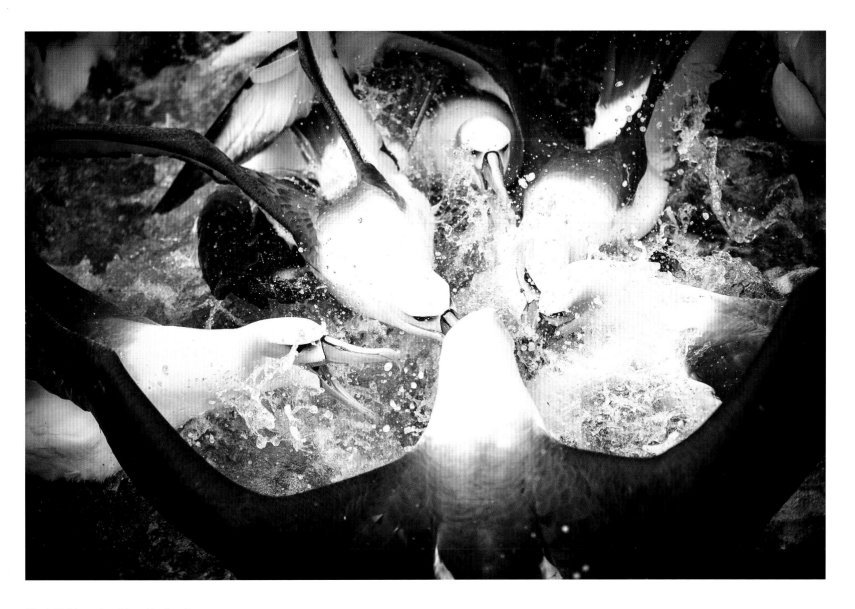

Mark Bridgwater (New Zealand)

White-capped mollymawks, Stewart Island, New Zealand. These are not gulls, but white-capped mollymawks fighting over a fish just off the coast of Stewart Island, New Zealand. They are also known as white-capped albatross, and although they are a medium-sized albatross they can still boast a wingspan of up to 2.5m.

Nikon D3s with 80-200mm f/2.8 lens at 100mm, ISO 200, 1/3200sec at f/2.8, handheld

markbridgwater.co.nz

Bence Máté (Hungary)

Red fox and white-tailed eagle, Kiskunság National Park, Hungary.
Over the last four winters I have spent more than 200 full days photographing from a hide, and in this time there have been only three occasions when I've seen a fox and an eagle together. In this instance the fox didn't approach the hide, but deliberately teased the birds resting on the ice. They occasionally flapped towards him, which emboldened the fox more and more – he continued to provoke the birds for about 10 minutes before vanishing into the reeds. The scene was strengthened by the snow sitting on the ice and the foggy conditions, which enabled me to show my subjects in a completely white environment: this happens just a few times every winter.

Canon EOS 1D X MkIII with 400mm lens, ISO 1600, 1/2500sec at f/4.5

matebence.hu

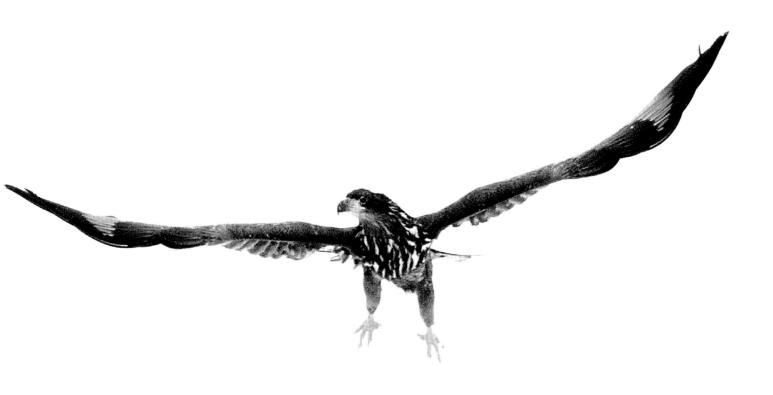

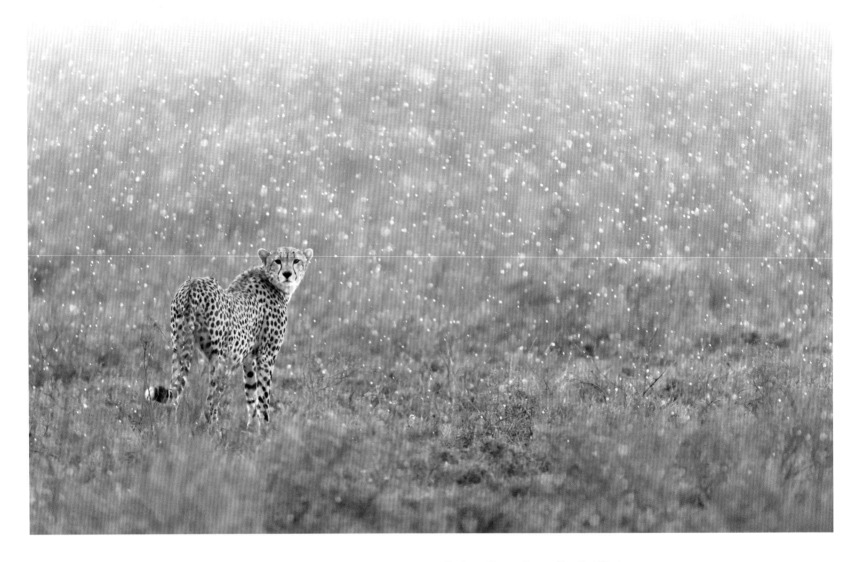

George Turner (United Kingdom)

Cheetah, Ndutu, Tanzania. I wanted to capture the vulnerability of the cheetah in a single image, but without being too morbid. My destination was Ndutu in the Serengeti in February, when huge storms mix with big, bright skies. I drew up my dream composition and waited patiently to get it. It took nearly a week to get this shot, as so many literal elements needed to line up. When it eventually happened, the cheetah looked at me for all of three seconds. That – as well as the difficult shooting conditions – made this image extra special for me.

Nikon D5 with 500mm f/4 lens, ISO 1000, 1/1600sec at f/4, handheld

georgetheexplorer.com

Prelena Soma Owen (South Africa)

Right: **African elephant, Chobe River, Botswana.** I am always looking for unique ways to showcase the beauty of elephants, in the hope that it will make a difference in the way they are viewed and appreciated. This image was taken when a herd of elephants came down to the banks of the Chobe River in Botswana for an afternoon drink. The opportunity presented itself as the trunk of the elephant in the foreground framed the eye of the elephant in the background. I focused on the eye, and with some creative cropping was very pleased with the final result.

Canon EOS 1D X with 600mm f/4 lens, ISO 1250, 500sec at f/7.1, gimbal head mounted on boat

echoesofthewild.com

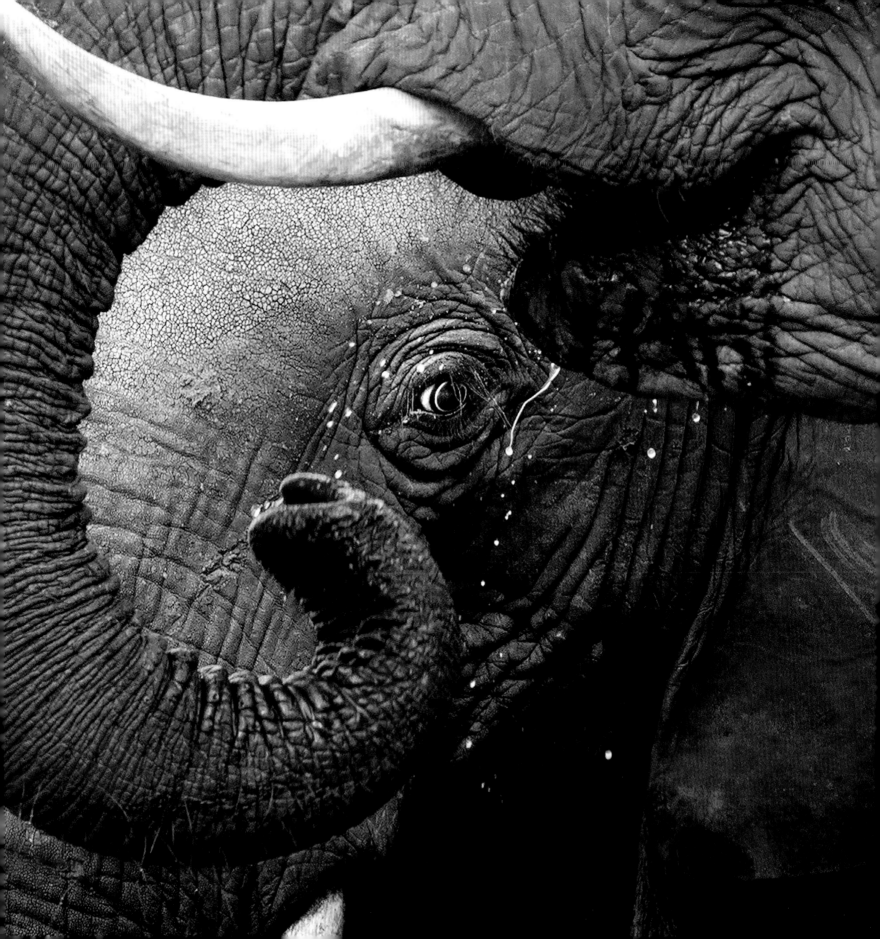

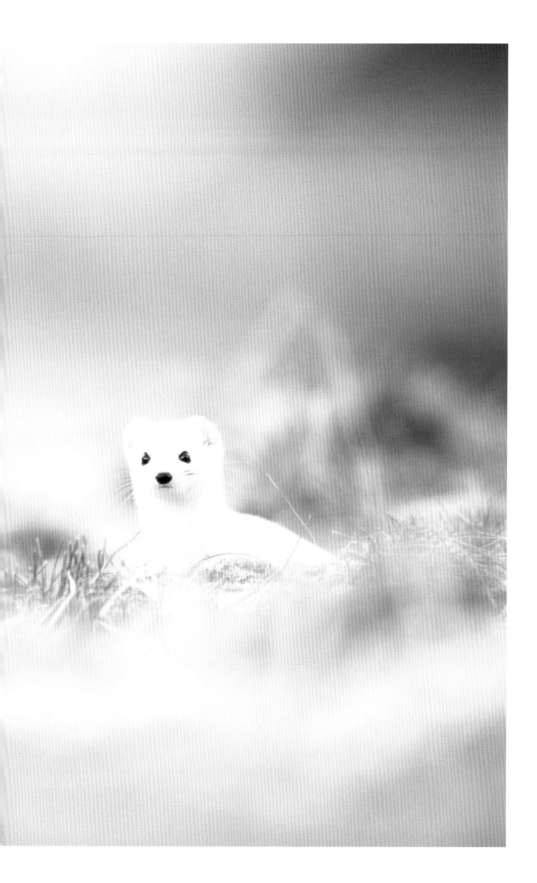

Thomas Delahaye (France)

Pralognan-la-Vanoise, France. I took this photograph of a stoat in my village in the French Alps, which is at an altitude of 1,450m. There is a big field with a lot of chalets all around, which means it is possible to create an atmosphere that isn't entirely natural: here, a large light from the swimming pool is creating the moon-like circle in the background.

Canon EOS 5D MkIII with 500mm f/4 lens, ISO 1000, 1/500sec at f/4, handheld

thomasdelahaye.fr

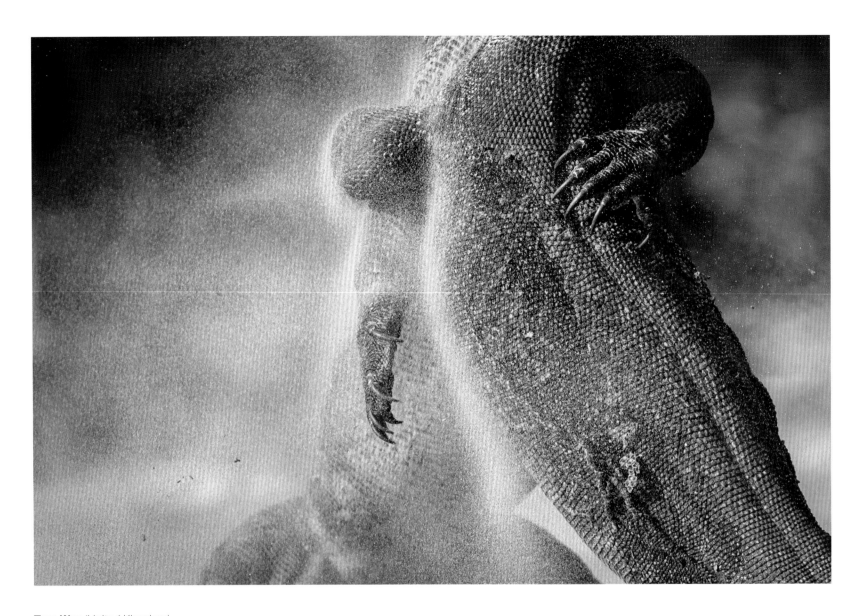

Tom Way (United Kingdom)

Komodo dragons, Rinca Island, Indonesia. To photograph the largest lizard on the planet is a challenge in itself. Not only is Komodo National Park difficult to access, but getting close enough for a shot can be extremely dangerous: Komodo dragons weigh up to 150kg and have both venom and fatal bacteria in their bite. My aim was to try to take close-up portraits of the dragons, so we drifted silently in a small inflatable dinghy towards two dragons resting on the shoreline. The only sound was that of the lapping waves against the beach and the buzz of cicada in the trees. Suddenly, the dragons reared up on their back legs and clashed together. I wanted to have the action as large as I could in the frame to show the detail in the skin and to highlight the sand blast against the dark background. There was something extremely prehistoric about this titanic battle as the claws grated against the scales – I felt like it was almost a snapshot of a bygone age.

Canon EOS 1D X with 500mm lens, ISO 320, 1/3200sec at f/4, handheld

tomwayphotography.co.uk

Bence Máté (Hungary)

Red fox, Kiskunság National Park, Hungary. I was shooting bird behaviour at a forest drinking station when I saw an increasing number of bees appear on the water. A few days later there were so many of them that the birds would disappear from that spot; whenever a bird arrived, I could see that it was afraid to approach the water because of the bees. I found out that a beekeeper had moved his bees a short distance away and I almost gave up shooting, when a young fox appeared in the background. It clearly did not feel comfortable either, but from time to time it lapped a bit of water.

RED camera with 200mm lens, ISO 1000, 1/24sec at f/7.1

matebence.hu

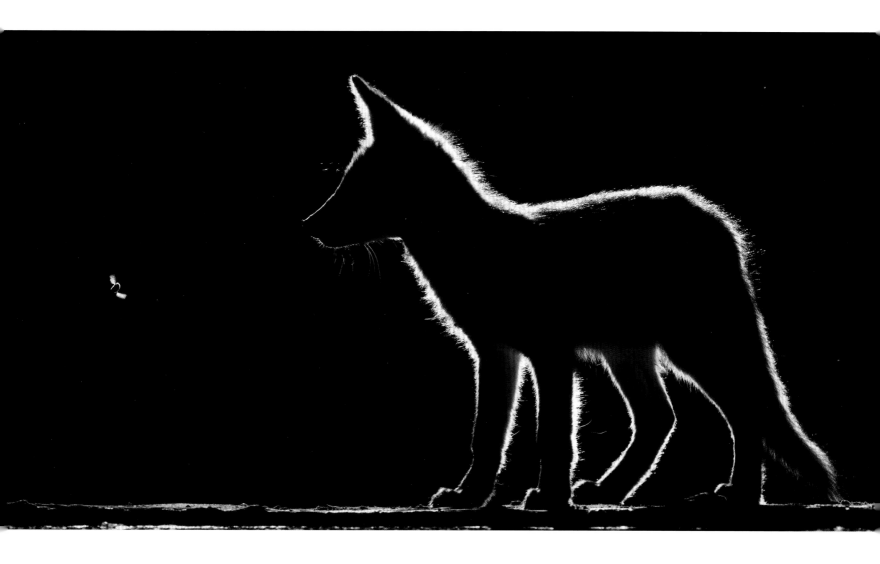

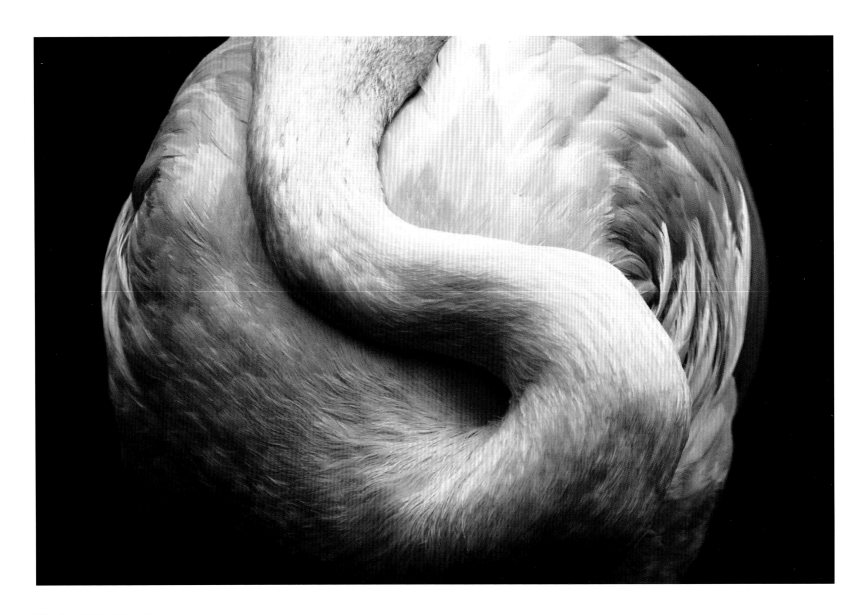

Yingting Shih (Taiwan)

Red crane, Kaohsiung, Taiwan. This red crane cleaning its feathers looks like a
'taijitu' – a round symbol representing Taiji (Supreme Ultimate), which contains an
inner pattern of symmetry representing yin and yang. The concept of Taiji can be
traced back to the Daoism in the Dao De Jing; the oneness of the Dao implies the ideal
way of existing in our world. This photo captures the dynamic and harmonious Taiji,
suggesting there is a perfect balance of nature in itself that we must respect and value.

Canon EOS 7D MkII with 16-300mm f/3.5-6.3 lens at 300mm, ISO 100, 1/80sec at f/10

yingtingshih.com

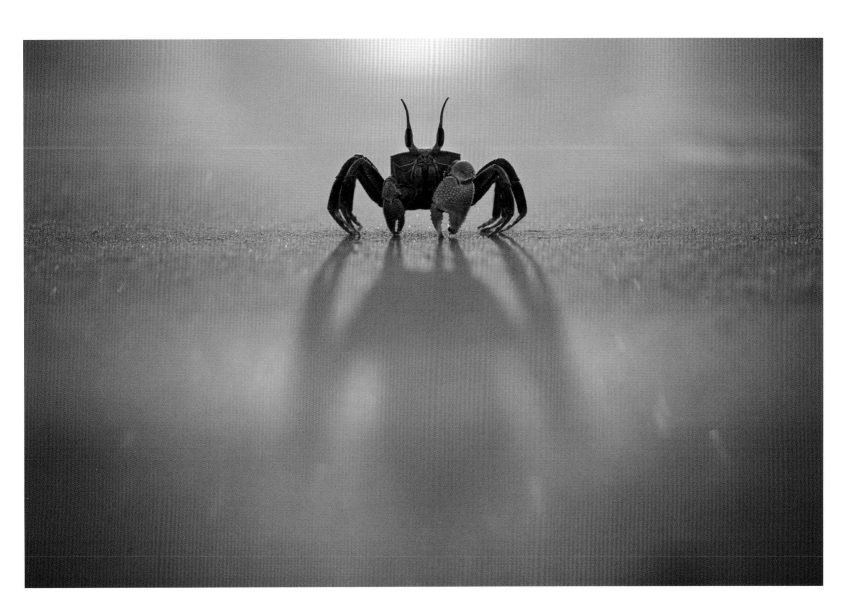

Daniel Trim (United Kingdom)

Ghost crab, Morondava, Madagascar. It took some time to find a relaxed crab that didn't scuttle off across the beach as I got near to it, but there was also another challenge: how to get it to face the right direction, so it would be silhouetted perfectly against the setting sun, giving the profile and shadow seen here. Luckily my fiancée was on hand to stand over me, attracting the crab's attention and causing it to face us directly. That allowed me to line the shadow up and achieve the central composition.

Canon EOS 5DS with 100mm f/2.8 lens, ISO 160, 1/640sec at f/2.8

danieltrimphotography.co.uk

Gigi Williams (Australia)

Great white pelican, Walvis Bay, Namibia. I shot these gorgeous pelicans when really I was looking for flamingos. That's what I love about photography, though – you never know what you will come back with. I saw a huge flock of pelicans flying from one end of the beach to the other, occasionally landing. These two just skirted the sand and had fabulous shadows below them. I shot hundreds of images (all handheld) to get this one with the shadows just right. I knew that to stop their wingbeats I would need a very fast shutter speed so sacrificed image quality by using a high ISO.

Nikon D7200 with 80-400mm f/4.5-5.6 lens at 400mm, ISO 800, 1/5000sec at f/6.3, handheld

robinwilliamsphotography.com

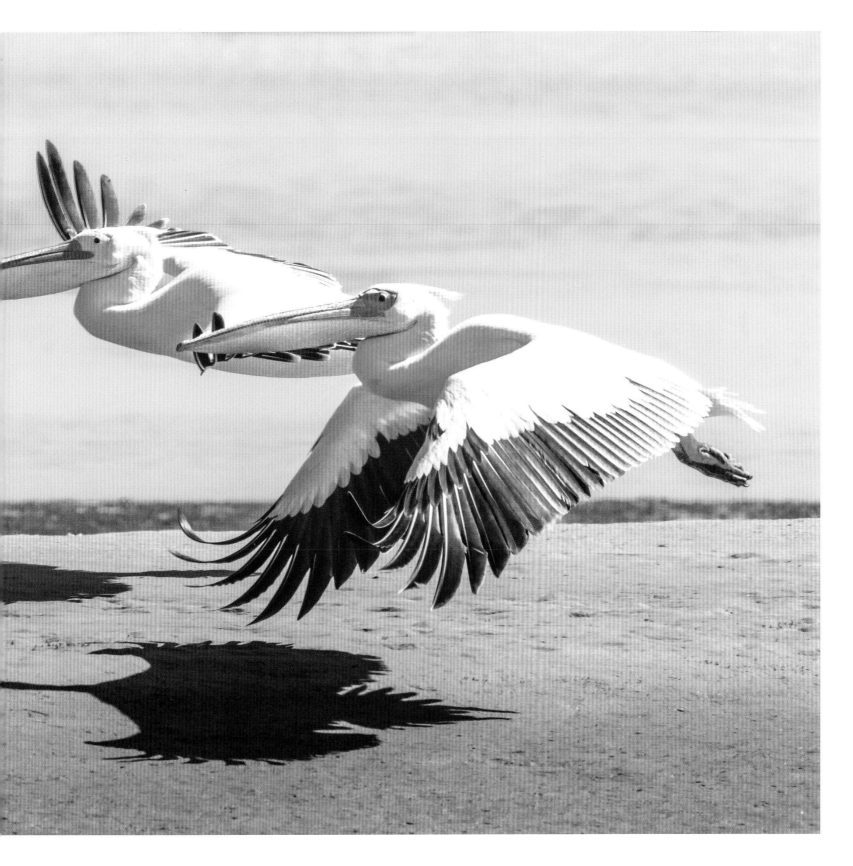

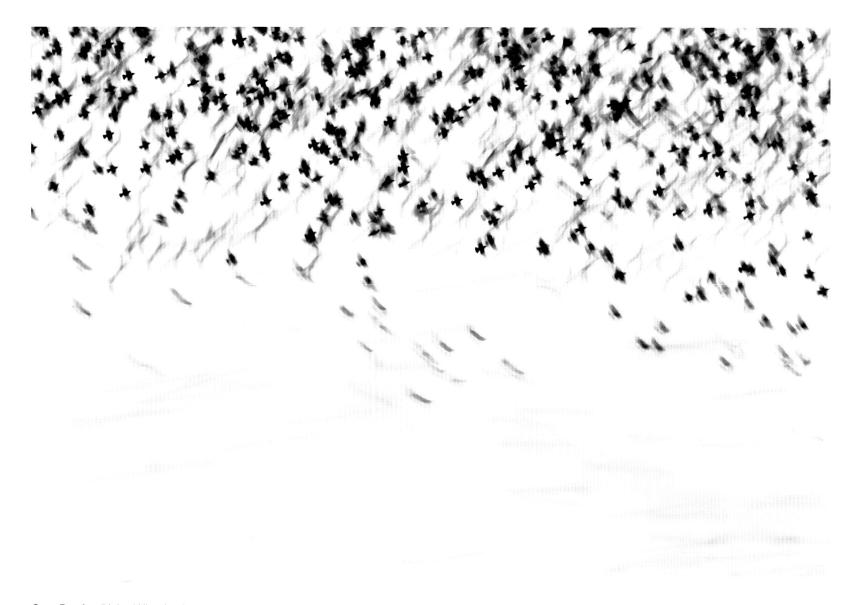

Sam Rowley (United Kingdom)

Somerset Levels, Somerset, England. Starling murmurations are one of the United Kingdom's most incredible wildlife spectacles, and are something I have always wanted to photograph. I thought I'd challenge myself by setting my shutter speed to 1/13sec for the entire event, forcing me to be more creative. I used a slow shutter speed to highlight the different layers of birds moving in different directions and at different speeds. While lots of images from the evening are more or less just a blurry mess, the odd one came out just as I had hoped.

Nikon D500 with 200-400mm f/4 lens at 200mm, ISO 100, 1/13sec at f/13, tripod

sam-rowley.com

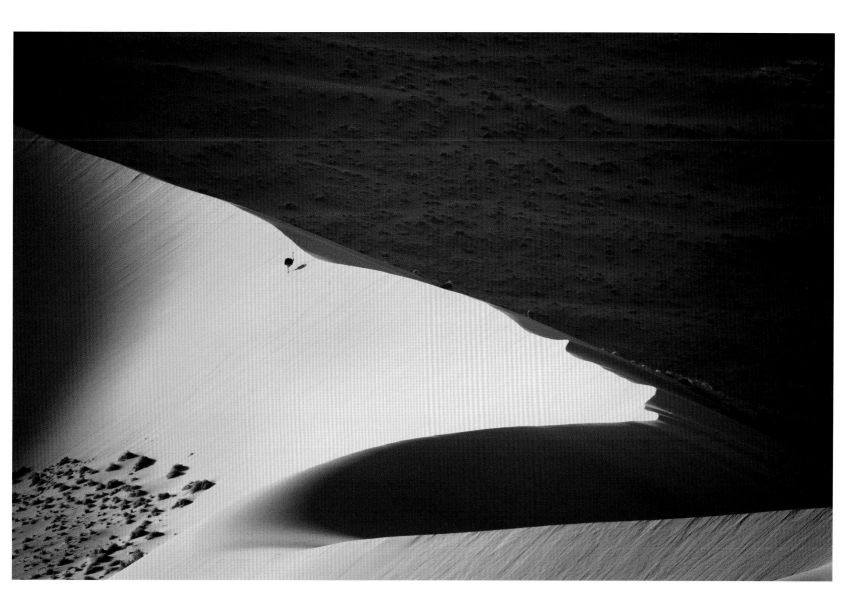

Salvador Colvée Nebot (Spain)

Ostrich, Namib-Naukluft National Park, Namibia. I was walking with a friend through the dunes of the Namib-Naukluft National Park in Namibia, looking for oryx to photograph, when I saw these ostriches. I wanted to show the harsh desert environment in which these birds live, so used a long lens to get the shot.

Canon EOS 5D MkIV with 150-600mm lens at 600mm, ISO 100, 1/250sec at f/8, handheld

reptilogia.com

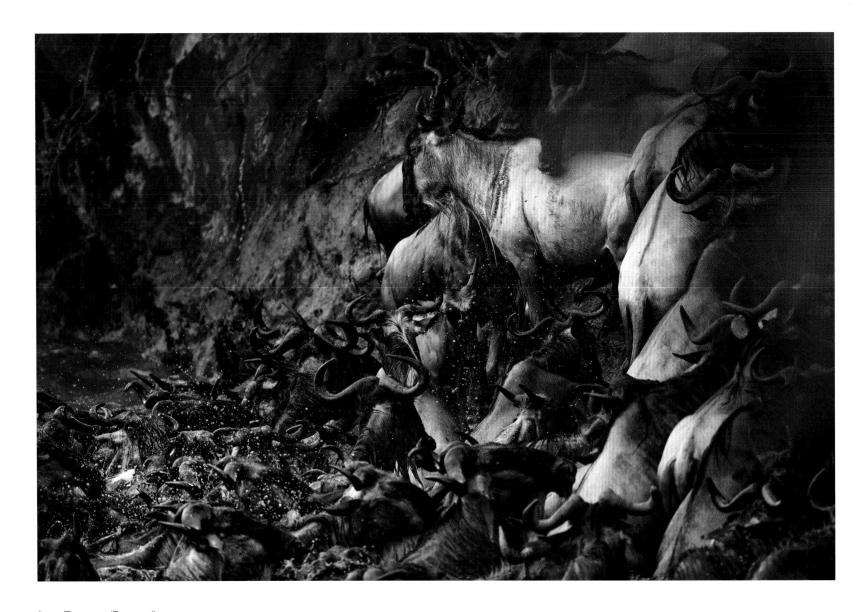

Jose Fragozo (Portugal)

Wildebeest, Masai Mara, Kenya. A herd of wildebeest crosses the Mara River. A mother reaches the opposite riverbank, but her little one is missing. While most of the creatures are struggling for their lives, she first stops and watches for her baby, and then, seconds later, goes back to the other side to look for her calf, despite the dangers of predators and drowning during the crossing. I was inside a 4x4 vehicle and chose a position where I could use the bush leaves to add a partial green blurring frame to the photo.

Canon EOS 1D X with 600mm f/4 lens, ISO 1000, 1/2000sec at f/4, car door mount

fragozowildlife.com

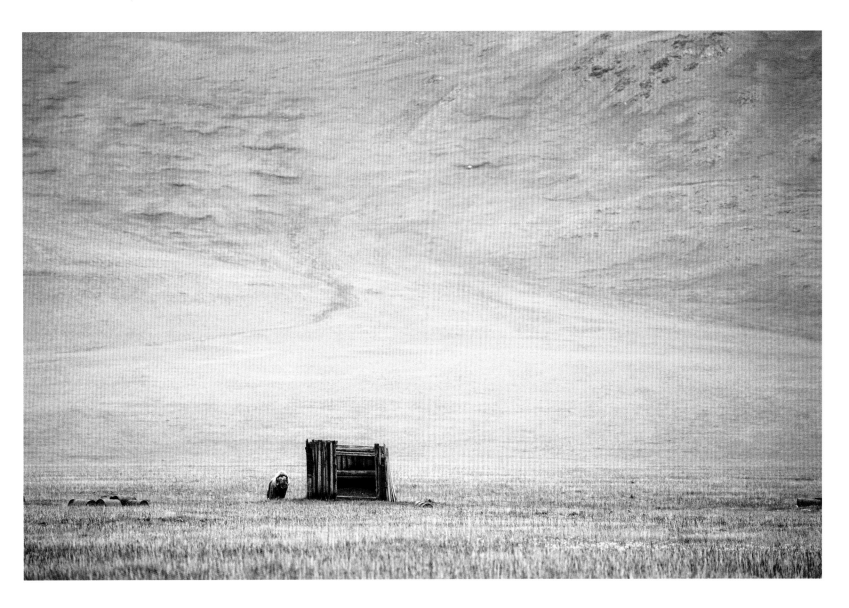

Claire Waring (United Kingdom)

Musk ox, Wrangel Island, Russia. This lone musk ox was on Wrangel Island, a nature sanctuary in the Russian Far East, off the north-east coast of Siberia. We stalked it across the tundra as unobtrusively as we could given there was absolutely no cover, but ran out of time to get closer. I find it very poignant to see this animal in its wild environment, standing alongside the deserted hut and rusting oil drums abandoned by humans. The muted colours of the hillside beyond were just part of the stunning scenery of this amazing island.

Canon EOS 1D X with 100-400mm f/4.4-5.6 lens at 400mm, ISO 1600, 1/1000sec at f/6.3, handheld

LIVE THE ADVENTURE

From hiking and mountain biking to backcountry skiing and paragliding – and everything in between – see the thrill of life lived to its maximum through images of adventure sports and extreme activities from around the globe.

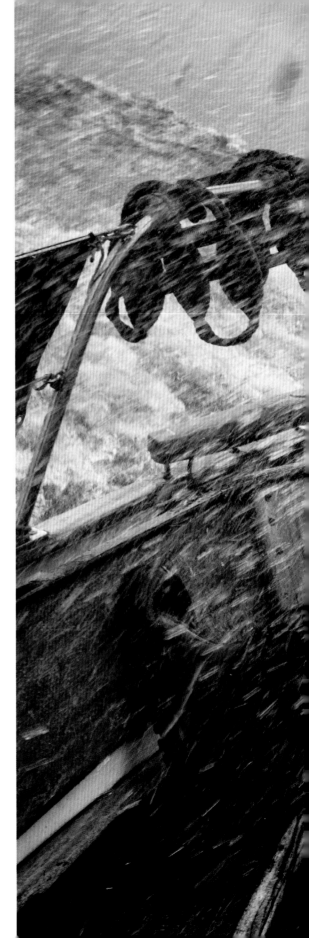

LIVE THE ADVENTURE – WINNER
OVERALL WINNER

Mikolaj Nowacki (Poland)

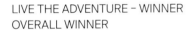

The Baltic Sea (somewhere on the way from the Swedish island of Utklippan to the Danish island of Christiansø). It was my first cruise on a yacht on the open sea and there were only two of us – myself and captain Jacek Pasikowski. I was helping Jacek take his small yacht Fri ('Free' in Danish) from the coast of Sweden to Poland, across the Baltic Sea. It was a stormy day, but the captain – who has more than 40 years of experience sailing in open seas – remained completely calm and relaxed, even though waves were breaking over him every few minutes. While taking this picture I was hiding partly below a folding canvas roof; scared, but pretending not to be.

Panasonic Lumix GH5 with 15mm f/1.7 lens, ISO 100, 1/125sec at f/4

mikolajnowacki.com

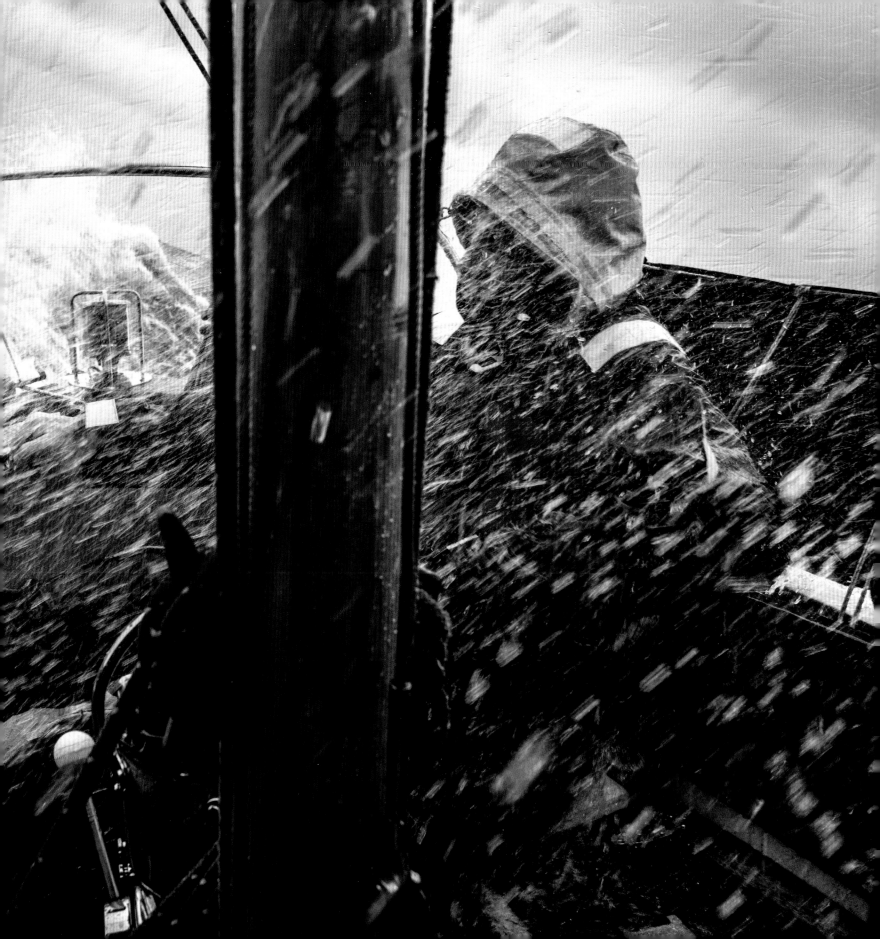

Spencer Clubb (United Kingdom)

Routeburn River, Mount Aspiring National Park, New Zealand. This image
depicts the moment of truth for a member of a canyoning group as she took the
plunge into the raging torrent of a tributary of the Routeburn River. I like the way
that the characters depict the transition from complete safety to full commitment
and the point of no return – you can almost sense their respective emotions.
The image required a fast shutter speed to capture the action, coupled with
sufficient depth of field to keep both people in focus. As the canyon was in
the shade, a high ISO was needed to successfully complete the shot.

Sony a7R with 16-35mm f/4 lens at 35mm, ISO 3200, 1/250sec at f/7.1, handheld

spencerclubb.net

Jay Kolsch (United States of America)

Cold-water surfer, Rockaway Beach, New York, United States of America. Kat Herine wipes the snow from her face as we run back to the car. The impending blizzard had brought solid surf to New York, but with the weather window closing and the wind picking up, we decide to call it a day. While post-holing through the thigh-high snowdrifts on our way to the car's relative shelter, some onlookers informed us that the mayor had just shut down the city.

Nikon AW-1 with 11-27.5mm f/3.5-5.6 lens at 11mm, ISO 400, 1/640sec at f/5.6, handheld

jaykolsch.com

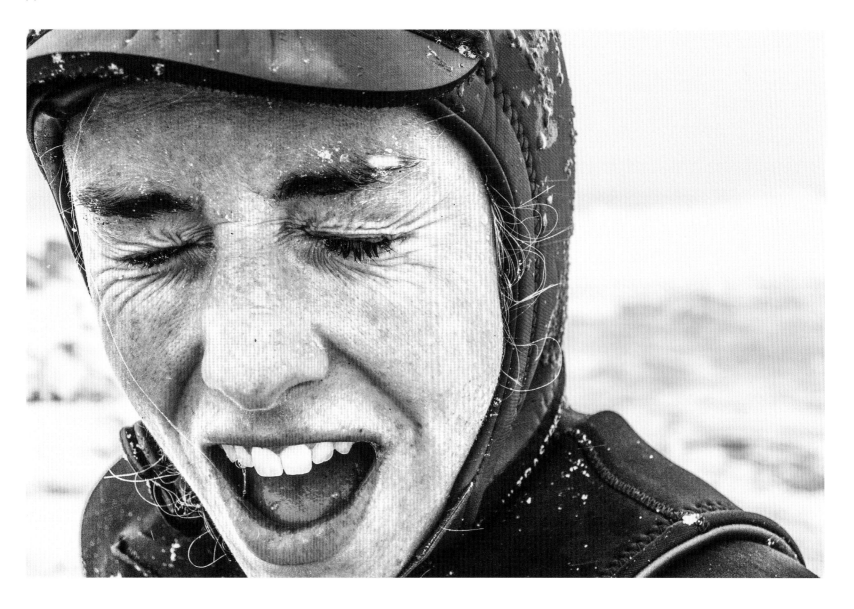

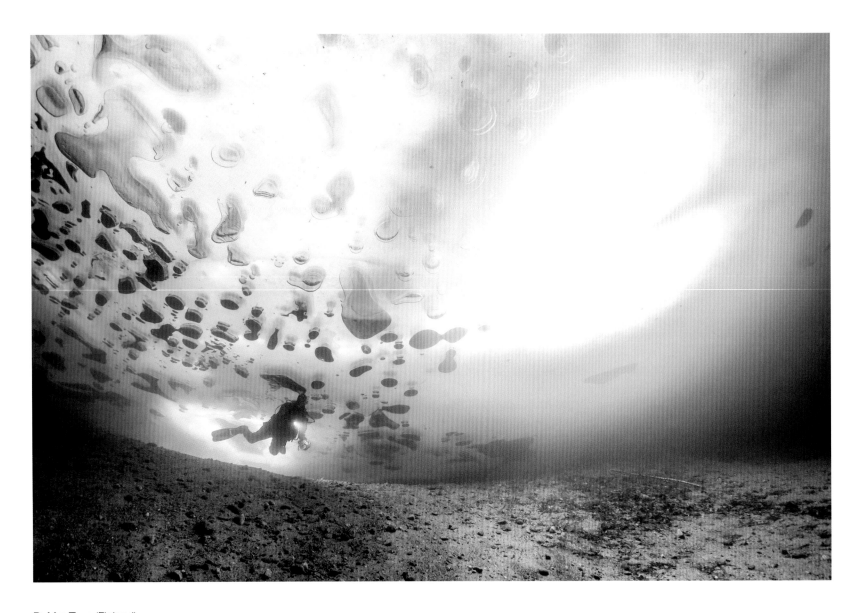

Pekka Tuur (Finland)

Lake Melkutin, Finland. My wife and I decided to go ice diving in a clear water lake. As we are still in love (after 35 years), we shovelled off the snow that was on top of the ice to make a heart shape. Under the ice I noticed that divers' bubbles had penetrated half way through the layered ice above, creating a very photogenic pattern. My wife followed with a reel and I took advantage of the special bubble formations to take this shot.

Canon EOS 5D MkIII with 15mm f/2.8 lens, ISO 800, 1/50sec at f/5, Subal housing

facebook.com/Vedenalainen-Suomi-240978516022608

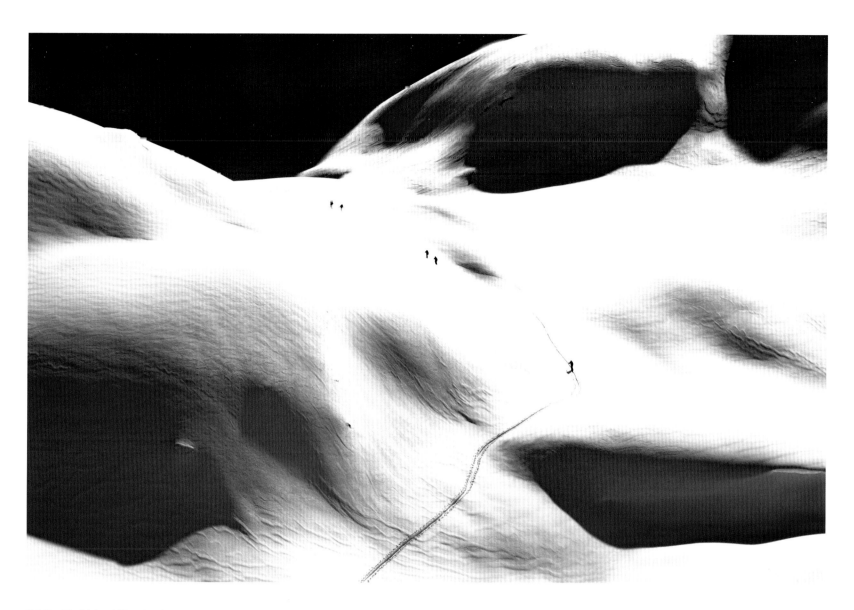

Ed Smith (United Kingdom)

Vorarlberg backcountry, Klösterle, Austria. Heading into the Vorarlberg backcountry for three days of freeride skiing, our planned route was thwarted by strong winds causing an avalanche risk. The wind had sculpted extraordinary shapes rolling down from the Östliche Eisentaler Spitze and the sight of our diverted route evoked visions of facing heavy ocean swells. To convey a sense of scale and perspective it was important for me to hold back in an elevated position, so I could see the trail of the team among the shadows. I carved a strong position into the snow and used my loaded pack to support a long focal length lens.

Nikon D810 with 80-200mm f/2.8 lens at 200mm, ISO 200, 1/800sec at f/16, handheld

edsmithphotography.com

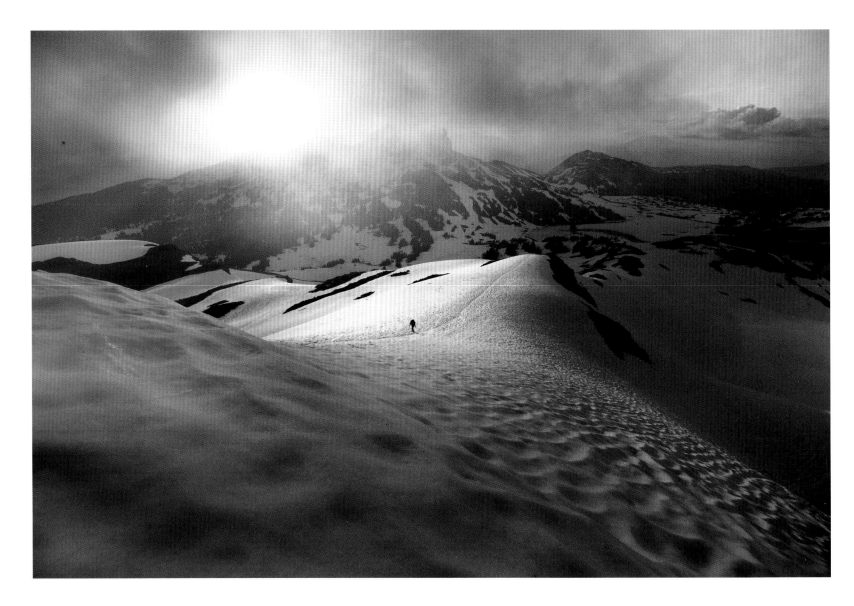

Martina Gebarovska (Czech Republic)

Panorama Ridge, British Columbia, Canada. This photograph was taken in June 2017. I was surprised by the amount of snow on the trail, but continued to the top, where I waited five hours for sunset. I'm glad I did, because it turned out to be magical: the golden light was really intense as I started to take pictures. Realising that there was no sense of scale, I pushed my tripod deep into the snow so the strong wind wouldn't have a chance to move it, and quickly ran down the hill so I could include myself in the shot, hoping for the light to last. After taking a few shots I sat on a big rock, soaking up the beauty with no one else around.

Canon EOS 6D with 16-35mm f/2.8 lens at 16mm, ISO 100, 1/640sec at f/6.3, tripod, remote release

instagram.com/dreamingandwandering

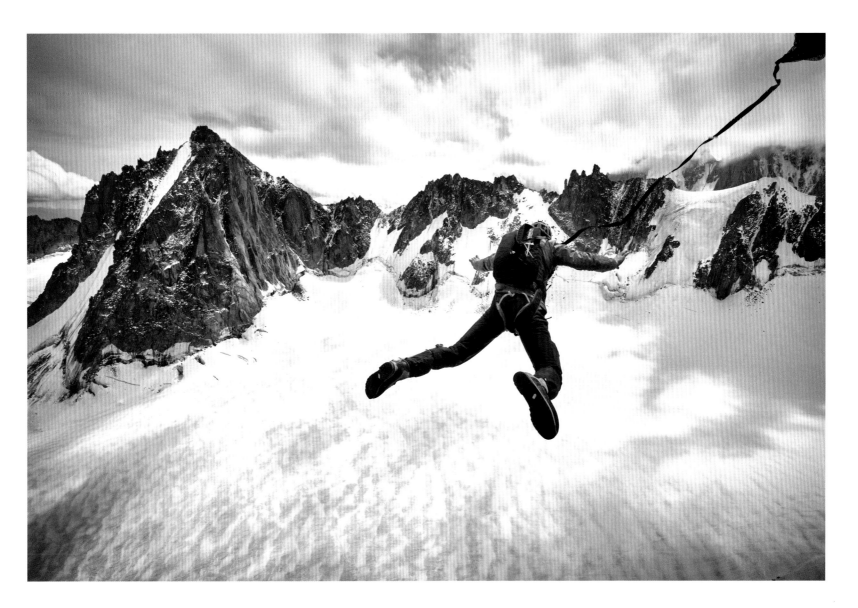

Hamish Frost (United Kingdom)

Trident du Tacul, Mont Blanc massif, France. To celebrate his 28th birthday, Tim Howell pulled together an ambitious plan to base jump off the Trident du Tacul, a granite spire high on the Mont Blanc massif. Reaching the top of the spire involved a glacier crossing and a 250m rock climb. With nothing to pre-focus on, I stopped down my aperture and increased the ISO to give myself a large depth of field and a fast shutter speed, then just hoped I caught a good frame as Tim flew past. There wasn't much chance of asking Tim to jump again, so it was a high-pressure shot.

Sony a7R II with 16-35mm f/4 lens at 16mm, ISO 1000, 1/2000sec at f/16

hamishfrost.com

Richard Whitson (United Kingdom)

Following page: **Crossapol, Tiree, Inner Hebrides, Scotland.** Some morning air for local windsurfer Stewart Cowling, showing his skill and endurance in an early autumn blow. There are plenty of challenges with this type of photography, including knowing where and when the action will happen, picking the shooting angle and elevation, timing the shot to catch the perfect moment, as well as the physical challenge of shooting long sessions in powerful winds and cold squally conditions. With this photograph I was seeking to not only show the skill of the rider, but also the strength and beauty of the waves.

Canon EOS 1D X with 400mm f/2.8 lens and 1.4x teleconverter, ISO 100, 1/1600sec at f/4, tripod, waterproof cover

2far2see.co.uk

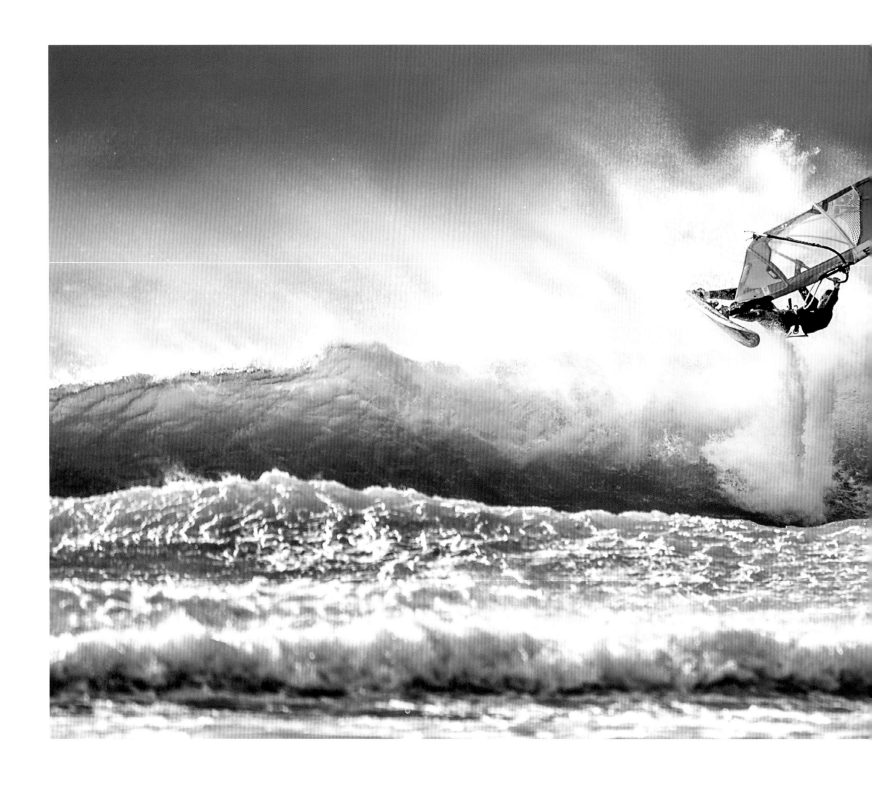

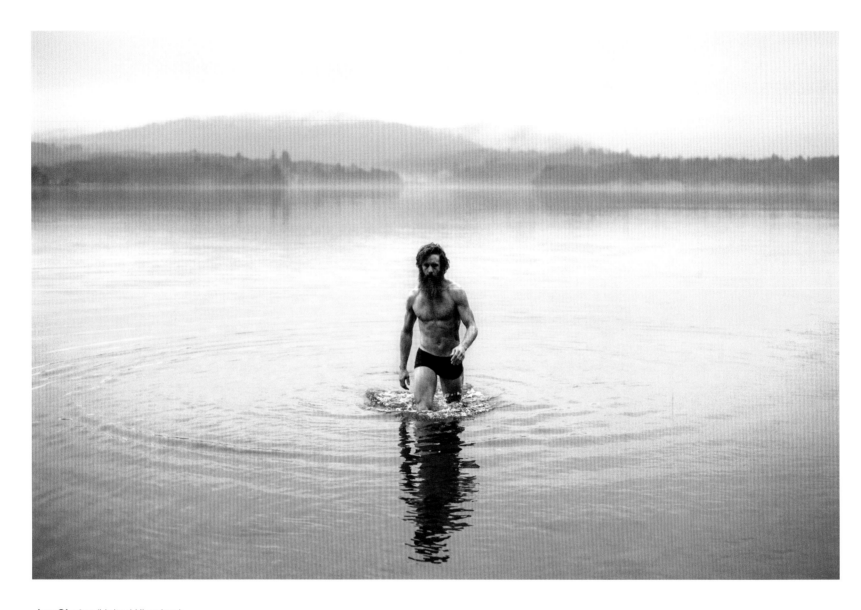

Jon Chater (United Kingdom)

Lake Windermere, Cumbria, England. Extreme adventurer Sean Conway strides out of Lake Windermere after a freezing cold-water swim. Sean swears by cold-water swimming, both for physical and mental wellbeing. It was a December evening, mist was rolling in over the lake and the light was fading fast, so we had to work quickly. I set a high ISO and positioned myself on the shore, crouching down to frame the shot with Sean right in the centre. As he strode out of the water I fired off around 10 frames. After the shoot I jumped in the lake myself: it was excruciatingly cold, but really exhilarating and I felt amazing afterwards.

Nikon D800 with 50mm f/1.8 lens, ISO 4500, 1/200sec at f/3.2, handheld

jonchater.com

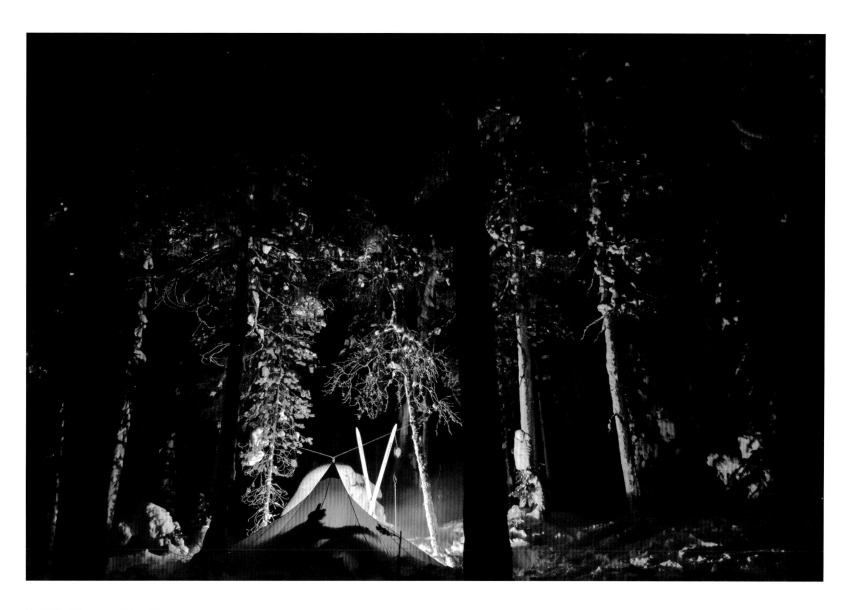

M-P Markkanen (Finland)

Kylmäluoma, Taivalkoski, Finland. This self-portrait was taken in the northern Finnish wilderness on a cold winter's night. I was on a training course for nature and wilderness guides, in preparation for an impending one week solo ski in Lapland. I wanted to capture my silhouette cast on the wall of the open tarp as I was sitting by the fire surrounded by the dark, frozen forest. After finding the right spot for my camera I set up the timer: the -20°C temperature and one-metre deep layer of snow posed some small challenges when it came to shooting, but eventually I got what I wanted.

Nikon D600 with 24-120mm f/4 lens at 24mm, ISO 1600, 1.3sec at f/4, tripod

Instagram.com/mpxmark

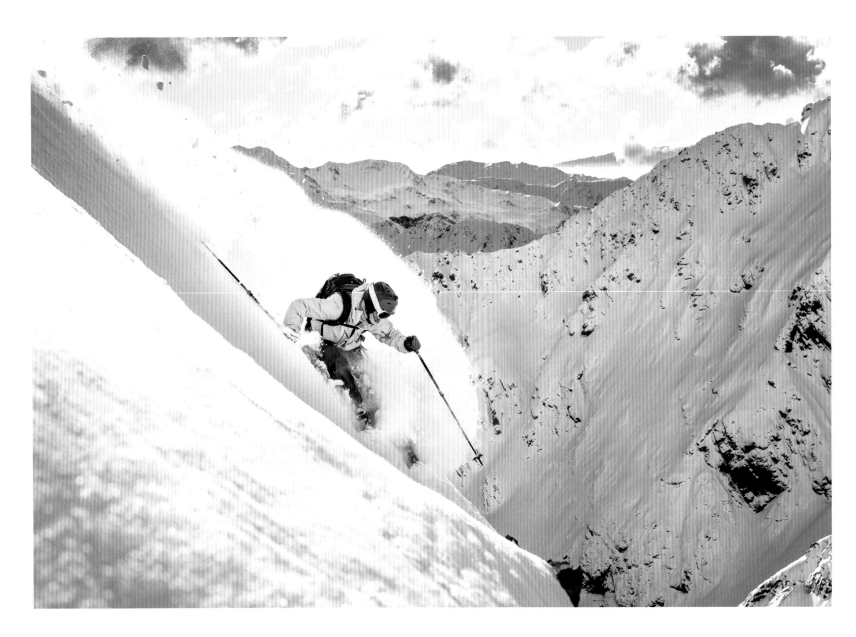

Mark Bridgwater (New Zealand)

Temple Basin, Arthur's Pass, Canterbury, New Zealand. There are some moments in time when the photography stars align; clouds break in the perfect spot and the sun shines exactly where you are standing. This was one of those moments for Charlie Lyons and myself. While most people were oblivious to the perfection we had found on our mid-week excursion, we were having the time of our lives.

Nikon D4s with 70-200mm f/2.8 lens at 70mm, ISO 800, 1/2000sec at f/11, handheld

markbridgwater.co.nz

Mark Bridgwater (New Zealand)

Macaulay Hut, Canterbury, New Zealand. After a long, 1,800m vertical day, climbing and skiing Mount Sibbald from Macaulay Hut, Jared takes in the beauty of the Southern Alps from the comfort of his fire bath, with a well-earned beer close by.

Nikon D3s with 17–35mm f/2.8 lens at 17mm, ISO 800, 15sec at f/5, tripod

markbridgwater.co.nz

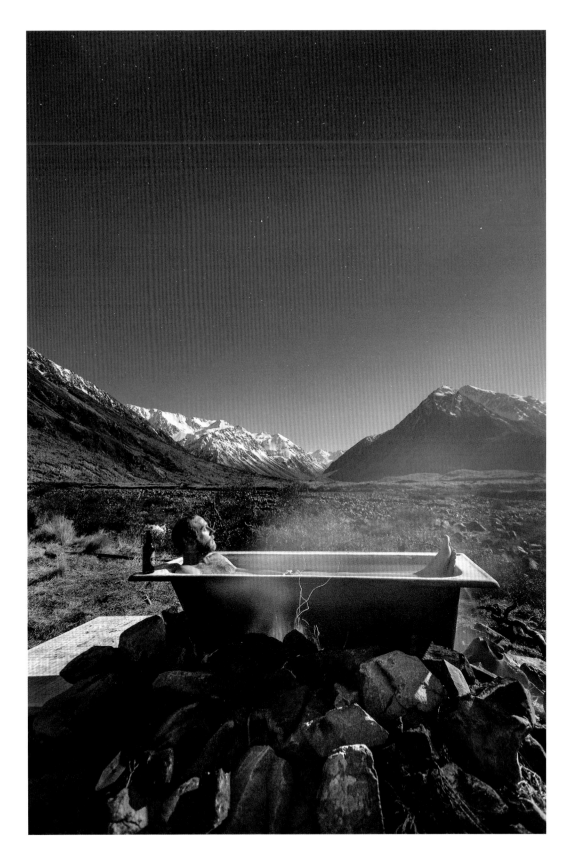

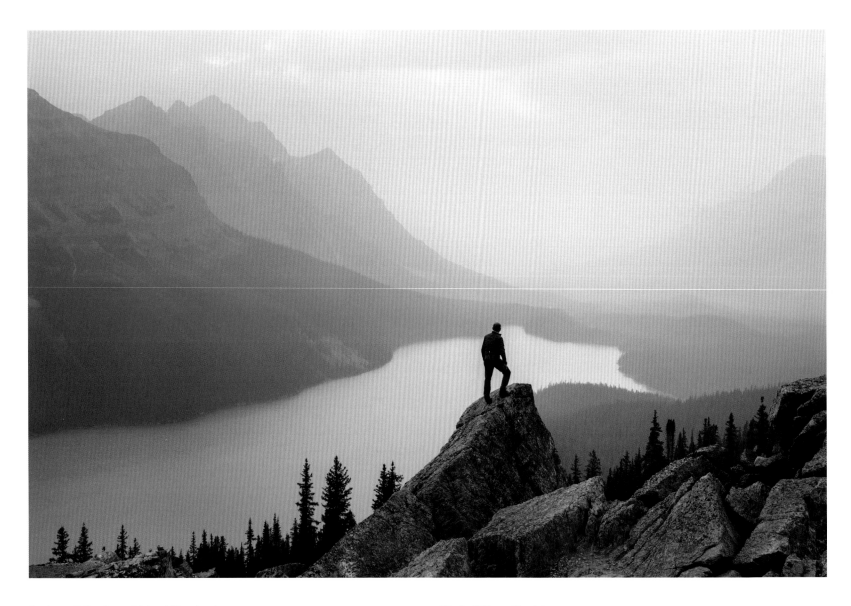

Andrew Robertson (United Kingdom)

Peyto Lake, Banff National Park, Alberta, Canada. I had been in Canada for a week and finally the wildfire haze that had plagued my trip began to lift – there was even a touch of colour in the sky as I headed to Peyto Lake, hoping for a sunset. My aim was to find a high viewpoint to help flatten the bright blue lake and I found this jagged rock to use as foreground. It was still hazy and I thought the image would benefit from a more defined focal point so I scrambled on to the rock and tried to look heroic without falling off.

Canon EOS 5D MkIV with 16-35mm f/2.8 lens at 35mm, ISO 100, 1/10sec at f/11, polariser, tripod

andrewrobertsonphoto.com

Yhabril Moro (Spain)

Right: **Astún, Spain.** We climbed the mountain early in the morning, looking for another shot that we had planned days before. However, when we saw the wind lip (at the right of the frame) we decided to go for this shot instead. I studied the light and the composition while the rider climbed to get some speed, and decided I wanted the 'angry face' at the right of the mountain in my frame; that meant I had to climb the mountain in front to get into position. I call this shot *Oreo's Wrath*, after the god of the mountains in Scandinavian mythology. In this image the mountain is looking with wrath at the human that violates its sanctuary.

Nikon D7100 with 70-300mm f/4.5-5.6 lens at 105mm, ISO 100, 1/800sec at f/16, handheld

yhabril.wixsite.com/yhabril

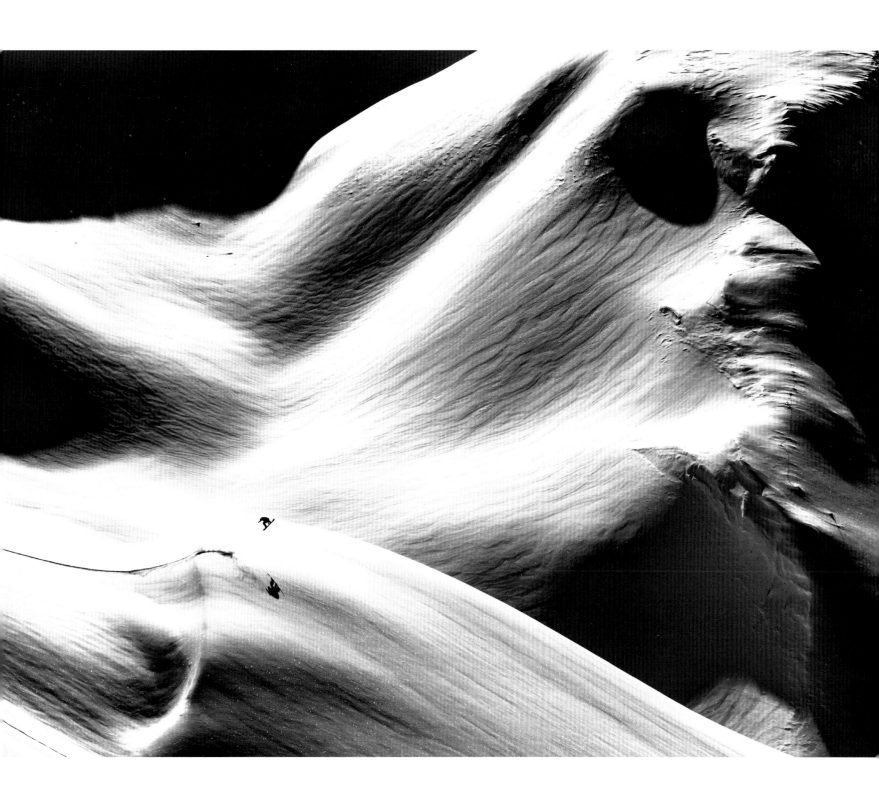

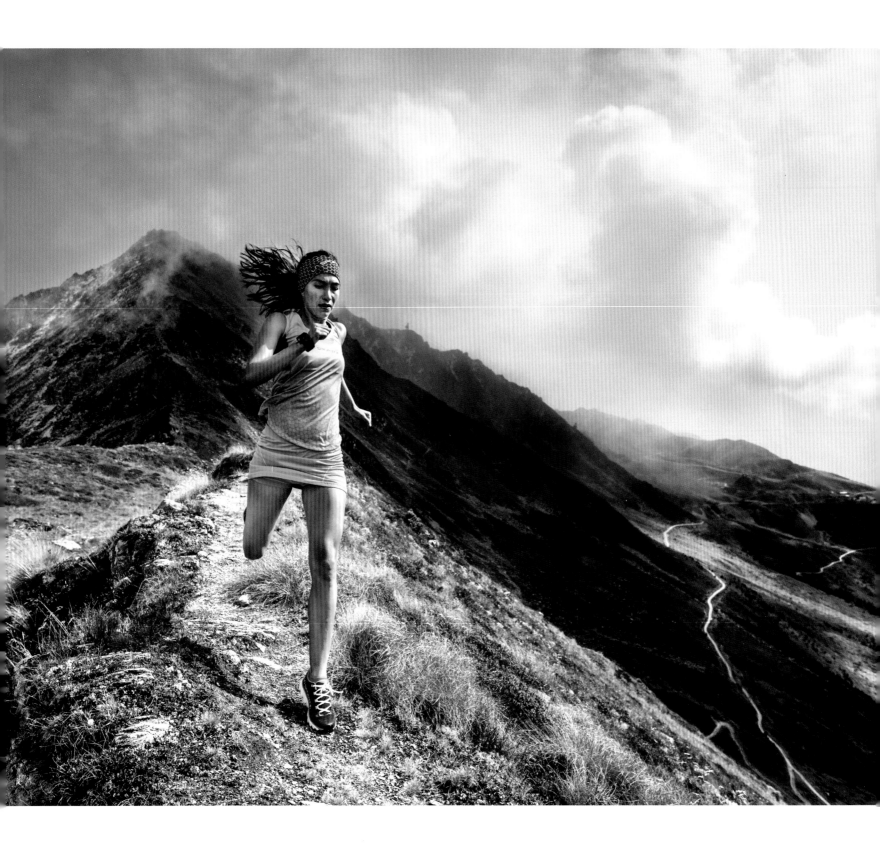

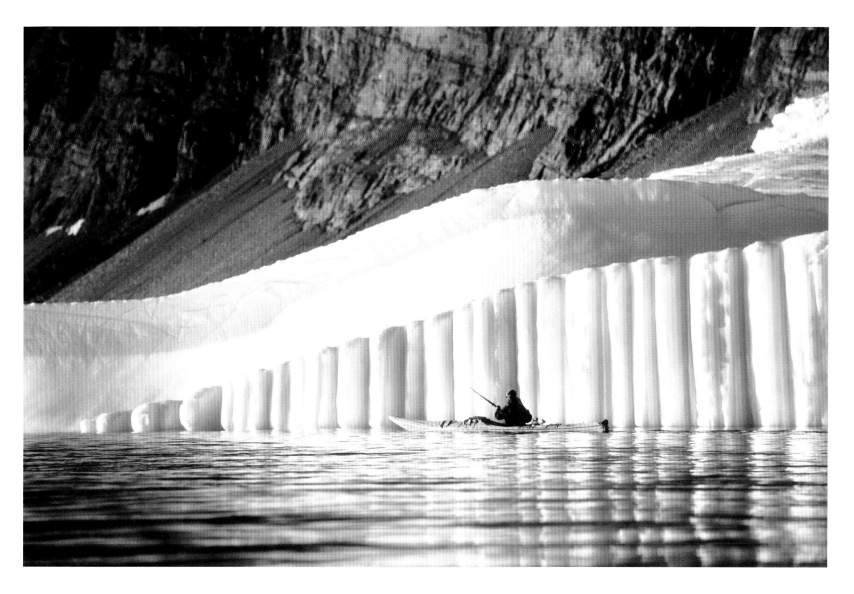

Jonas Paurell (Sweden)

Left: **Tête des Etablons, Verbier, Valais, Switzerland.** A storm was about to hit the Swiss Alps, and I thought it would bring great conditions for powerful images. Veronica and I hiked up to an exposed ridge at 2,500m with trepidation in our hearts. The visual conditions were indeed great, but we had increasingly strong winds trying to throw us off the mountain, so had to work fast. This image shows the storm coming in behind Veronica, with snow already starting to accumulate on the left slopes. Afterwards we had to run down in snow, making it back just as the full force of the storm hit.

Nikon D750 with 18-35mm f/3.5-4.5 lens at 18mm, ISO 100, 1/1000sec at f/4.5, polariser, handheld

jonaspaurell.com

Jean-Luc Grossmann (Switzerland)

Uummannaq, Greenland. Greenland is a great place to see ice carved into the most fantastic shapes. Under the midnight sun the colour of the sea changes to crimson blue, mountainsides lighten into powerful reds, shadows lengthen and the icebergs seem to be under a giant spotlight. I enjoyed the creative challenge of capturing nature's essence on film, although I had to take in to account the risk of shooting from a kayak. With 24 hours of daylight and surrounded by these sumptuous scenes it was easy to forget the time, but taking photographs in Greenland was a gratifying and inspiring experience.

Nikon F6 with 80-200mm f/2.8 lens at 200mm, ISO 400, 1/160sec at f/5.6, shot from a sea kayak

instagram.com/planetvisible

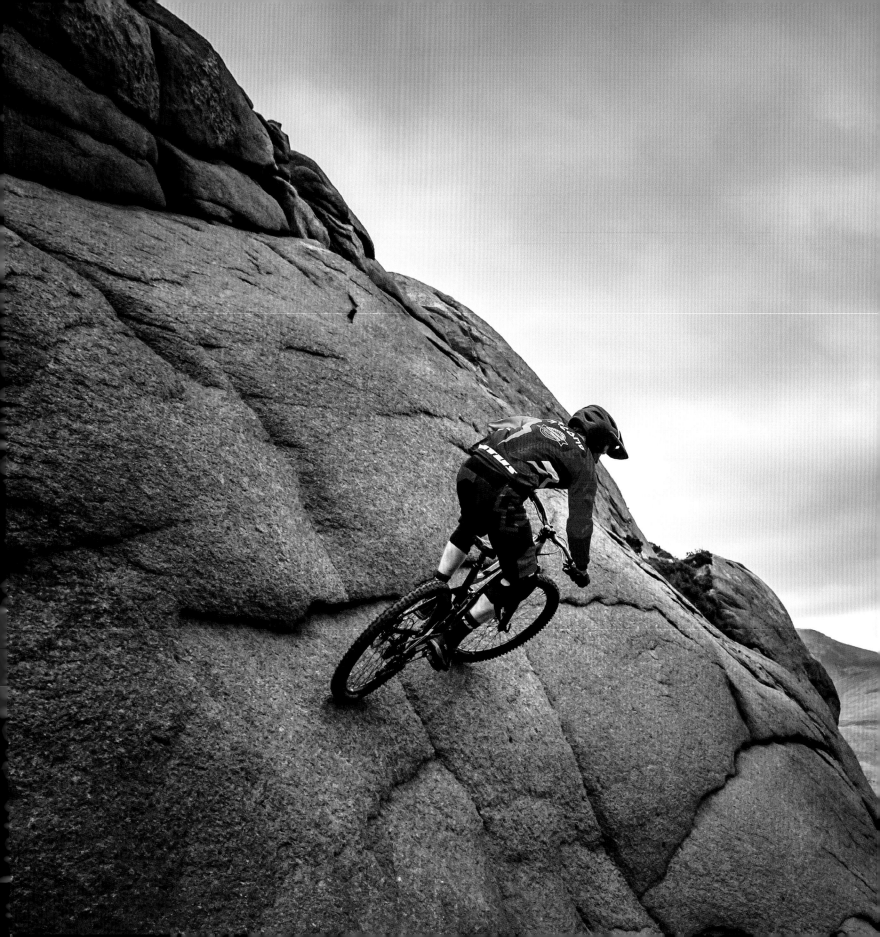

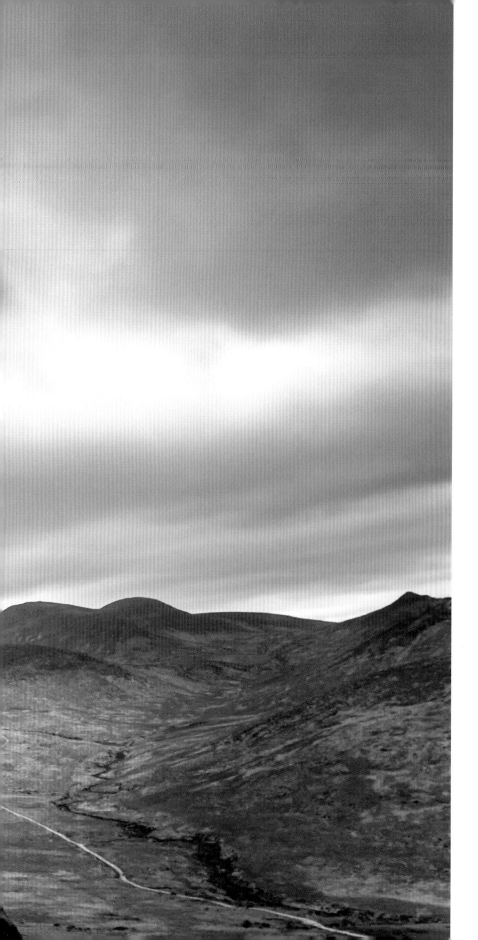

Warren McConnaughie (United Kingdom)

Hen Mountain, Mourne Mountains, Northern Ireland. This image was taken on the south face of Hen Mountain, in the Mourne Mountains. After a long hike up from the path below, my aim was to capture the extreme sport of mountain biking. I was also keen to portray the look of the rider going off the side of the cliff and down to the road beneath.

Canon EOS 1D MkIV with 24-70mm f/2.8 lens at 24mm, ISO 1600, 1/1250sec at f/6.3

warrenmcconnaughie.com

LIGHT ON THE LAND

Under a fiery sunset sky, in fleeting twilight, with the gentler light of the moon or with the first rays of a new day: this category is for stunning landscape images from anywhere in the world.

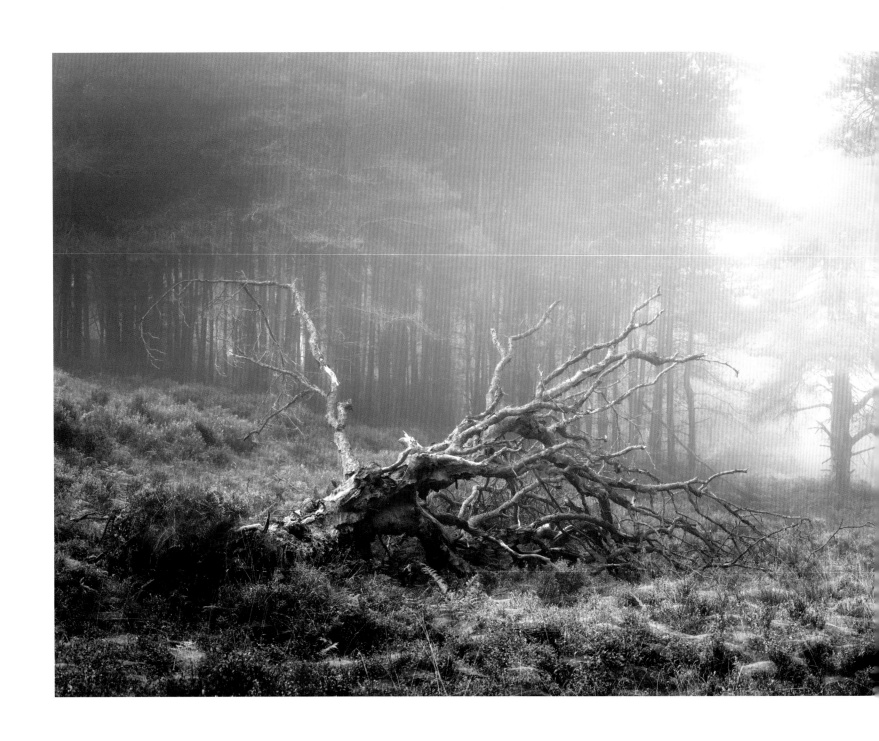

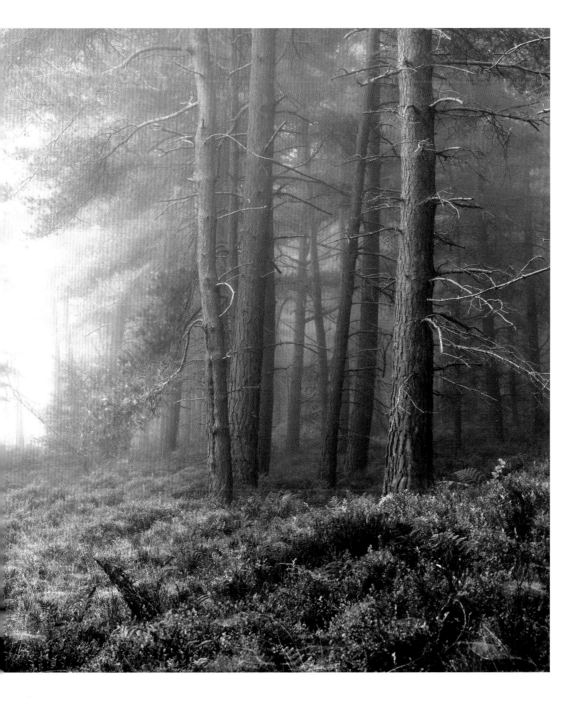

Simon Baxter (United Kingdom)

North Yorkshire, England. I originally captured a similar scene to this during a flurry of unexpected snow in April 2016. It's typically the first spot I come to when exploring this private woodland, and I couldn't help but capture it again when I was treated to these wonderful – but rare – conditions of mist with a hint of warm light as the morning sun tried to break through. The combination of the damp cobwebs, fallen birch, dominant old pine and the soft light filling this atmospheric and shallow valley makes it a favourite spot of mine for solitude.

Sony a7 II with 24-70mm f/2.8 lens at 65mm, ISO 100, 1/20sec at f/8, tripod, six-frame stitched panorama

baxter.photos

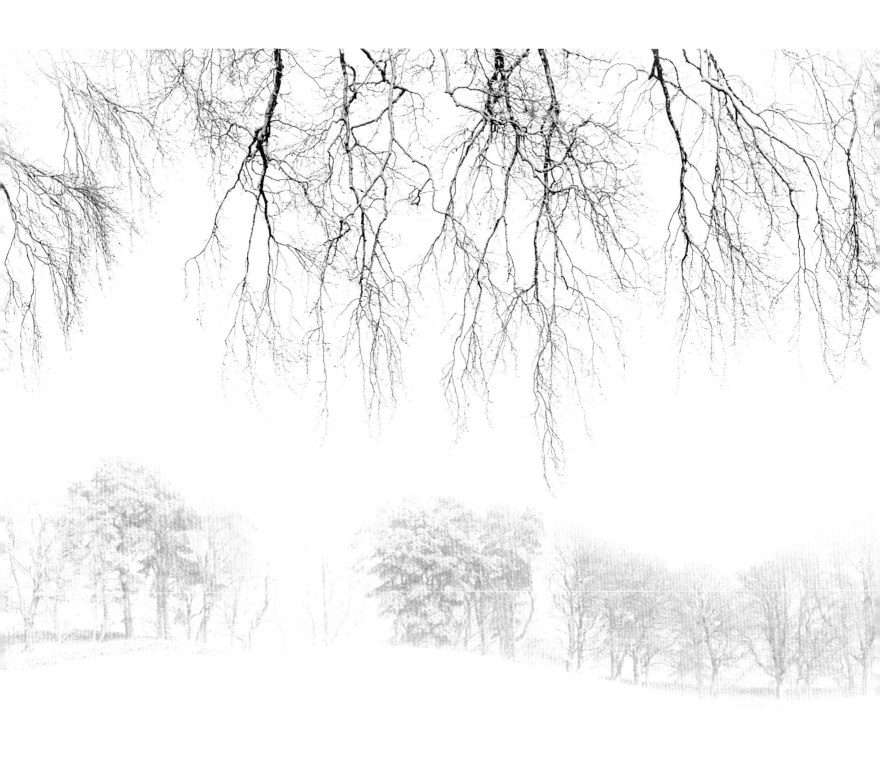

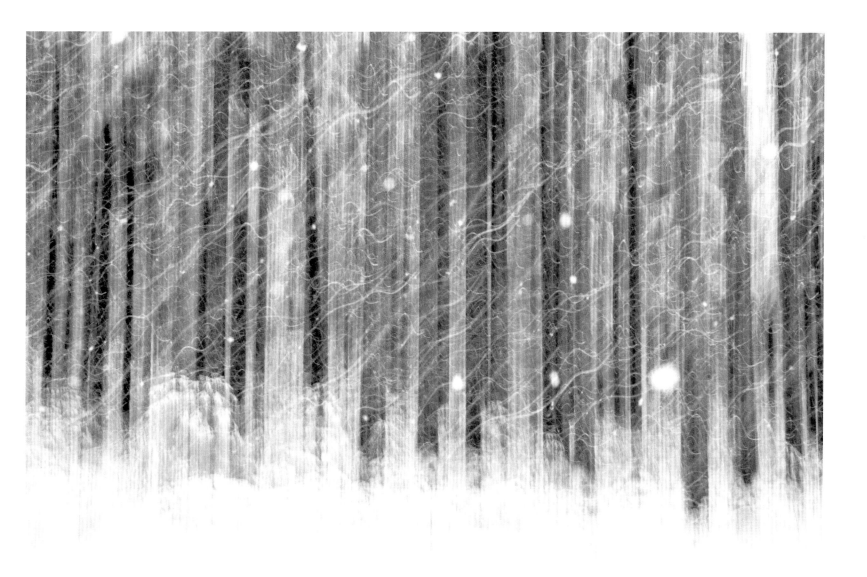

Lizzie Shepherd (United Kingdom)

Left: **A70, Lanarkshire/West Lothian border, Scotland.** Overhanging beech boughs and a hilly row of distant trees, rendered as a minimalist sketch on a snowy winter's morning, with echoes of line drawings and notes of music. This avenue of beech trees on the A70 always catches my eye and on this occasion I was lucky enough to pass by in snow.

Fuji X-T10 with 18-55mm f/2.8-4 lens at 50mm, ISO 200, 1/160sec at f/7.1, handheld

lizzieshepherd.com

Henrik Spranz (Austria)

Forest near Münichreith, Austria. I had a shot like this in mind for a while and was just waiting for the right conditions: heavy snowfall. My plan was to create a tree-panning shot with the added dimension of falling snow captured in motion and 'frozen' using flash and second curtain sync. Despite all the planning, the curly lines of the snow due to the long exposure still surprised me.

Canon EOS 5D MkIII with 70-200mm f/4 lens at 70mm, ISO 250, 1/3sec at f/20, flash

spranz.org

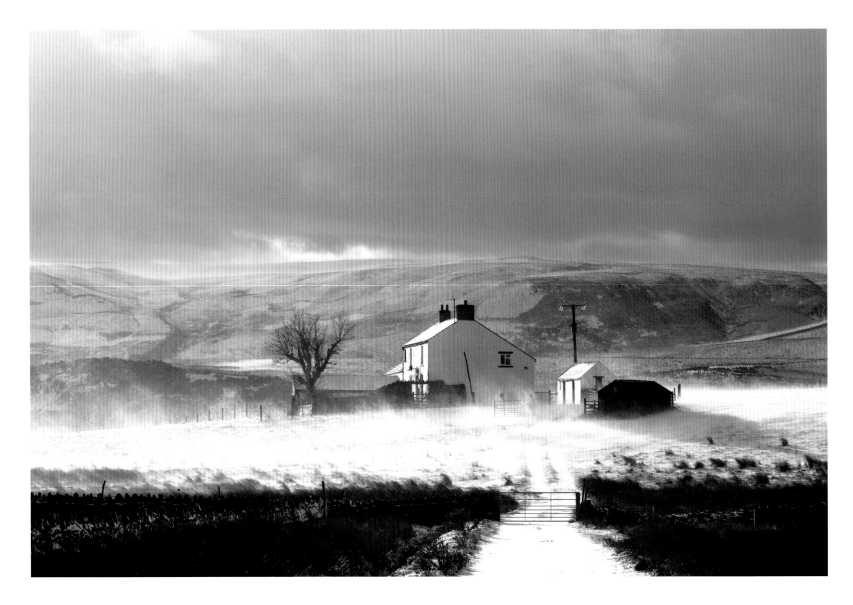

David Forster (United Kingdom)

Forest-in-Teesdale, North Pennines, County Durham, England. I really enjoy shooting weather-related imagery, especially in marginal conditions. On this particular day I noticed that the sun was illuminating spindrift streaming past an isolated farmhouse in the North Pennine valley of Teesdale. The problem was that the moment when the sun and windblown snow came together was fleeting, as dark clouds kept blotting out the sun. It was also bitterly cold, with a high wind chill, and this made for a rather uncomfortable wait. Fortunately, I got a brief window when the sun appeared at the same time as a gust of wind blew spindrift past the farmhouse.

Canon EOS 5D MkII with 24-105mm f/4 lens at 105mm, ISO 100, 1/250sec at f/8, handheld

bluestoneimages.com

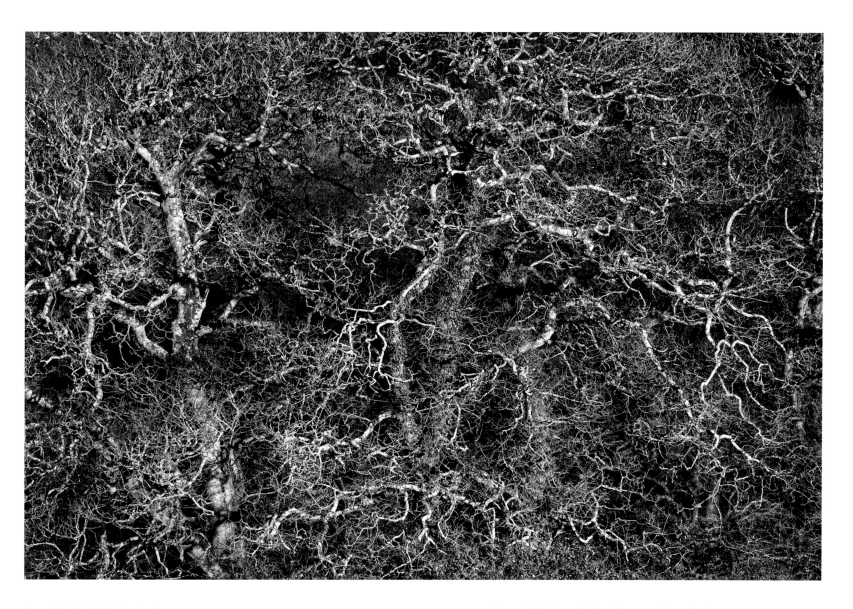

Annette Dahl (Switzerland)

Ludon Valley, near Crackington Haven, Cornwall, England. While exploring the valley I found these lovely crooked trees. It was late afternoon in February and low sunlight hit the scene very nicely, picking out the intricate network of branches and trunks from the darker background. There were plenty of compositional opportunities, but it was a challenge to find order among the chaos. Most important for me was to naturally frame the dominant stems with the smaller branches. The black & white treatment helps to focus attention on the details and texture.

Sony a6000 with 70-200mm f/4 lens at 122mm, ISO 100, 1/125sec at f/10, tripod

annettedahl.com

Aaron Feinberg (United States of America)

Following page: **Central Californian coast, United States of America.** While spending some time capturing the central Californian coast in March 2017 we ended up at this dune location on multiple occasions. After an initial scouting trip, I knew I needed to come back at sunset, and as there was a full moon on the way that seemed like the ideal time. We returned to the location and as the twilight waned there was a brief moment where the light from the setting sun and from the rising moon balanced each other: this is that moment.

Nikon D800 with 24-70mm f/2.8 lens at 24mm, ISO 800, 30sec at f/10, tripod

expandingvisualreality.com

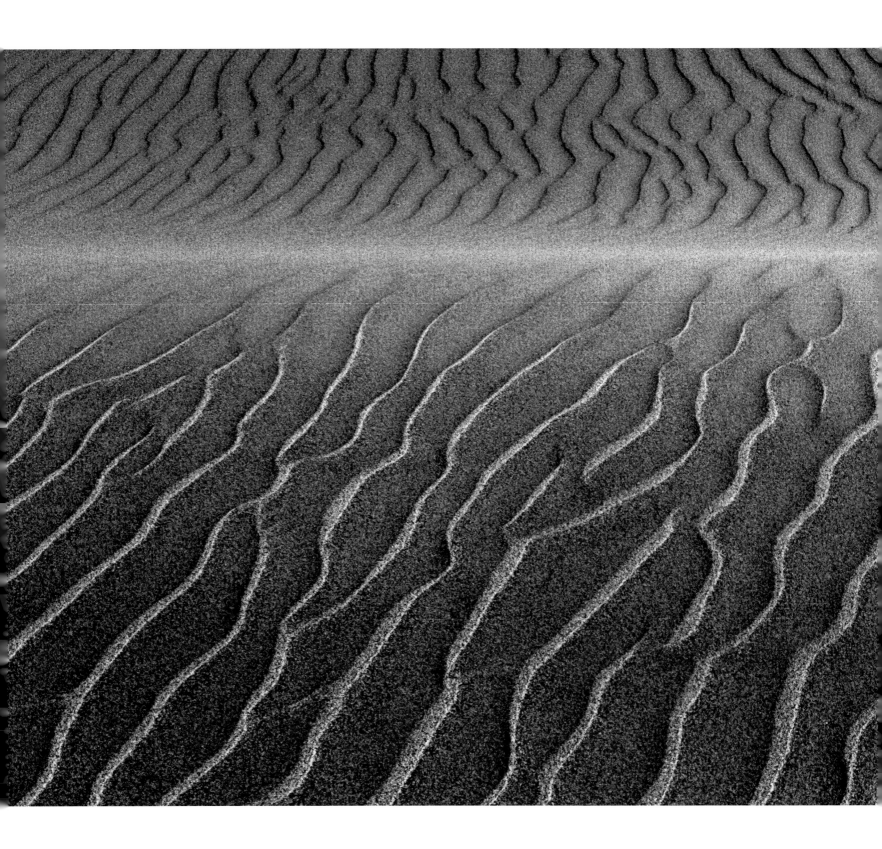

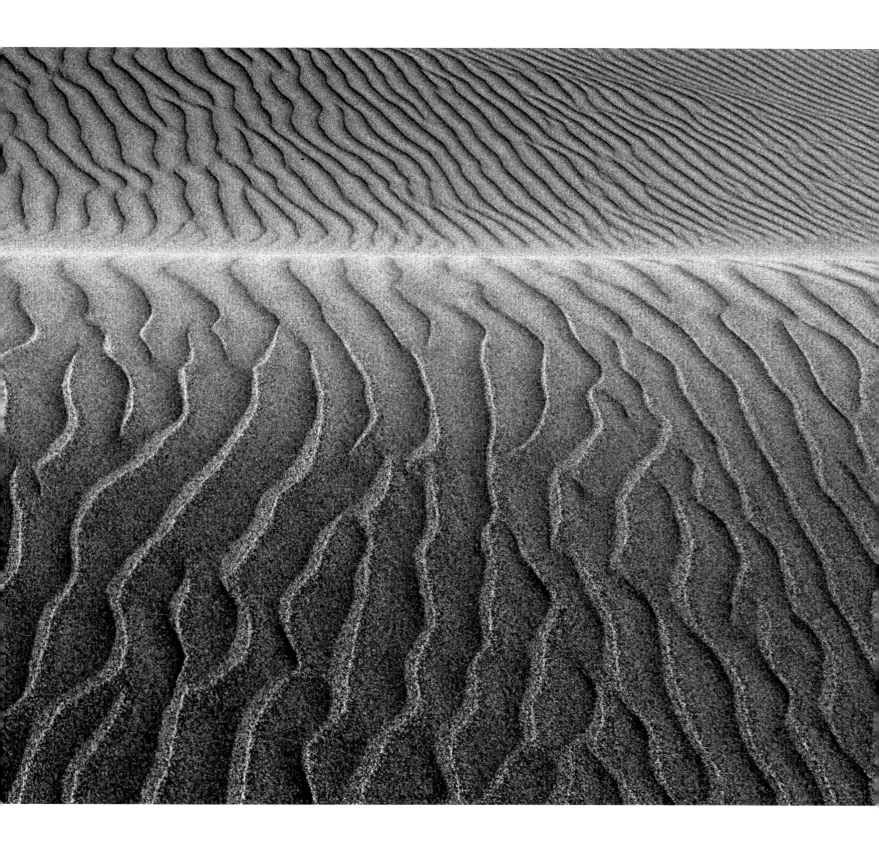

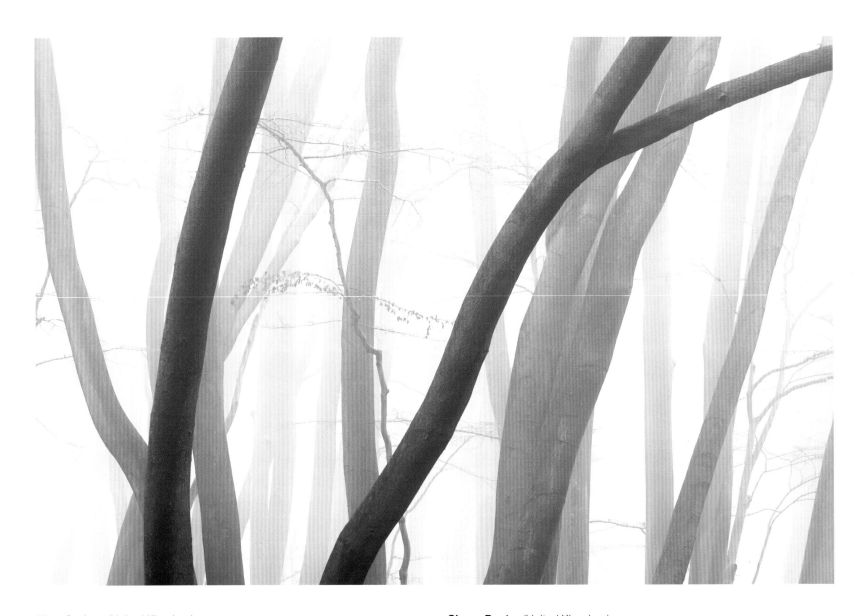

Matt Garbutt (United Kingdom)

Hornbeams and beeches, Epping Forest, England. In the dark of winter – in thick fog and stripped of almost all their foliage – the hornbeams in Epping Forest reveal their twisting, interwoven patterns. This little area of the forest is my favourite and this picture is part of an ongoing mini-project that I work on when the fog descends. It was very cold that morning, and finding the compositions I had in mind was proving quite tough. Eventually I found this simple and graphic arrangement, applying a high-key edit to reveal the layers.

Nikon D750 with 70-200mm f/2.8 lens at 195mm, ISO 100, 1/2sec at f/11, polariser, tripod

ghostedout.photo

Simon Baxter (United Kingdom)

Right: **North Yorkshire, England.** Early one summer's morning I ventured out in some beautifully foggy and eerily calm conditions to explore a local woodland. Looking through gaps in a dark and dense plantation I spotted the moss-laden branches of a spooky oak tree glowing under the delicate light that funnelled down from an opening in the canopy. Chilled drops of water hit my neck as they fell from the sodden branches and only the occasional flap of wings through the treetops broke the silence. My dog sat motionless, staring into the foggy woodland behind me. The combination of exploration, atmosphere and the strangely unnerving experience makes this my favourite discovery to date.

Sony a7 II with 16-35mm f/4 lens at 20mm, ISO 100, 1sec at f/5.6, tripod

baxter.photos

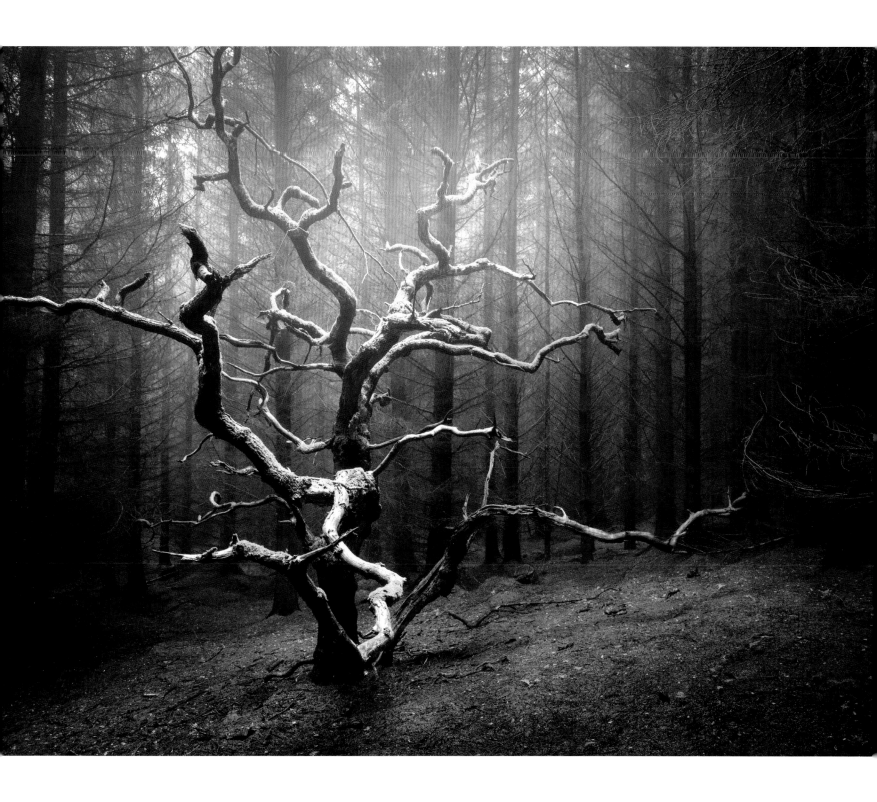

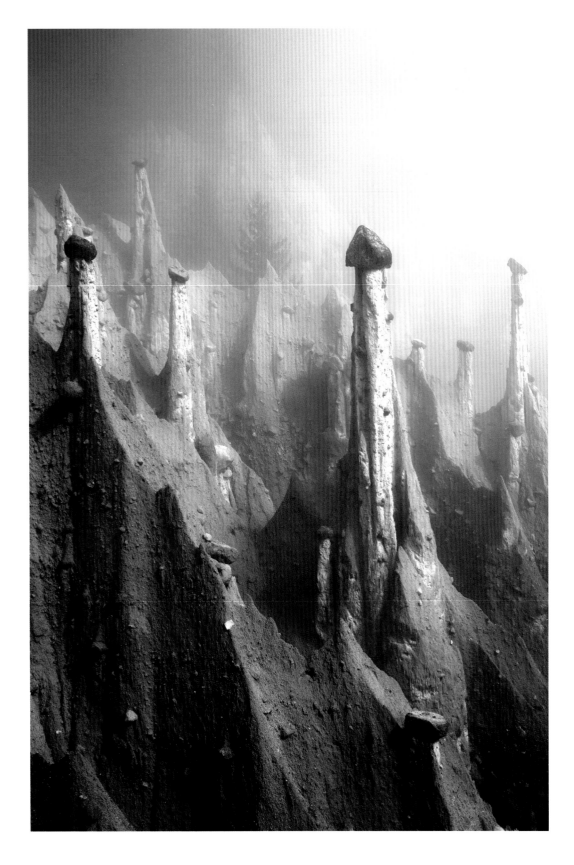

Marco Grassi (Italy)

Earth pyramids, Trentino Alto Adige, Italy. This incredible formation of earth pyramids in the north of Italy is the result of a continuous transition between periods of torrential rain and drought. I've never seen anything quite like this before: the pillars have a truly alien look. I've been going back to this place for quite a while, but I really wanted to capture it with foggy conditions to get this mysterious mood. Finally, I was able to get the shot I'd had in mind for so long.

Canon EOS 5D MkIII with 24-70mm lens at 42mm, ISO 100, 1/160 at f/13, two-stop ND grad filter, handheld

marcograssiphotography.com

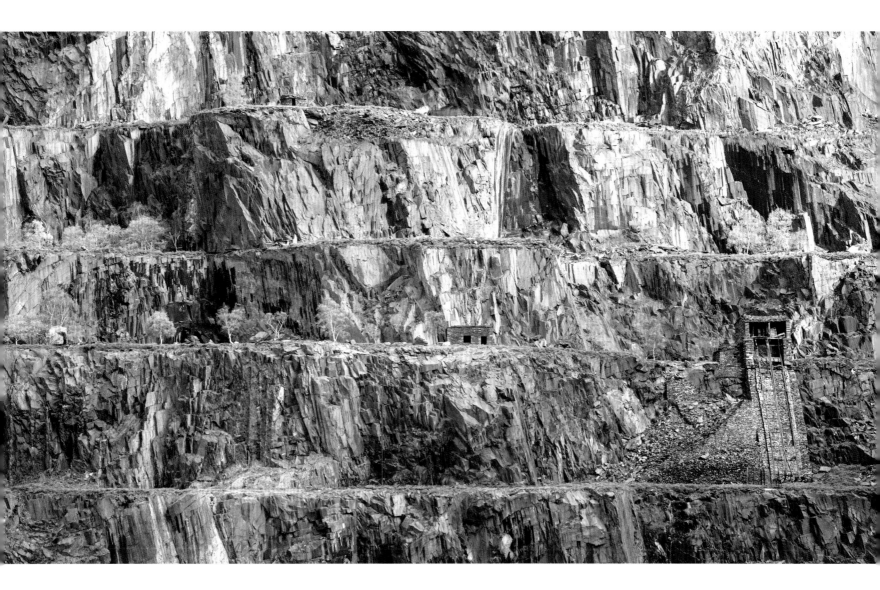

Neil Burnell (United Kingdom)

Dinorwic quarry, Snowdonia, Wales. This was my first visit to Dinorwic quarry and I was amazed at the scale of this stunning location. This was a quick handheld shot from the roadside looking towards the sculpted landscape. I stood watching the fleeting light as it shimmered across the slate quarry, lighting up the beautiful textures and autumnal leaves. It was a brief, but very enjoyable moment from a memorable trip with photography friends.

Nikon D810 with 80-200mm f/4.5 lens at 200mm, ISO 125, 1/125sec at f/8, handheld

neilburnell.com

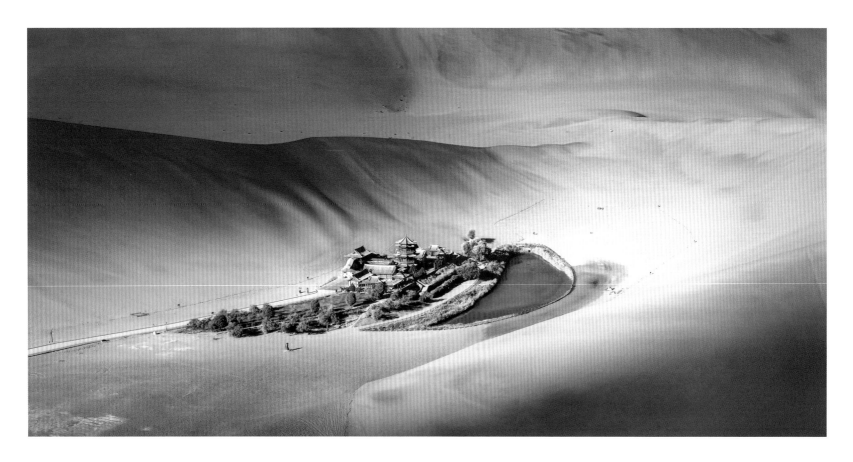

Youcang Wu (China)

Crescent Lake, Dunhuang, Gansu Province, China.
Named after its unique shape, Crescent Lake is
surrounded by Echoing-sand Mountain and enjoys
fame as one of the 'eight wonders in Dunhuang'.
With crystal-clear water and green plants on the
side, the turquoise lake sits in stark contrast to
the sand that surrounds it.

*Nikon D610 with 24-70mm f/2.8 lens at 70mm, ISO 100,
1/250sec at f/11, tripod*

Lee Acaster (United Kingdom)

Right: **British Sugar plant, Bury St Edmunds, England.** The sugar-processing
plant in Bury St Edmunds is a local landmark that always signals I am nearly
home when I've been away. I was given permission to photograph it from up close
one evening and while the conditions were not great, it didn't matter too much, as
I had a very stylised finished image in mind. I shot it as a long exposure, utilising
the dwindling available light, and then processed the image in Photoshop using
levels and masks to enhance the light on the factory and create a slightly surreal,
futuristic result.

Canon EOS 5D MkIII with 18mm f/3.5 lens, ISO 100, 59sec at f/13, polariser, tripod

leeacaster.com

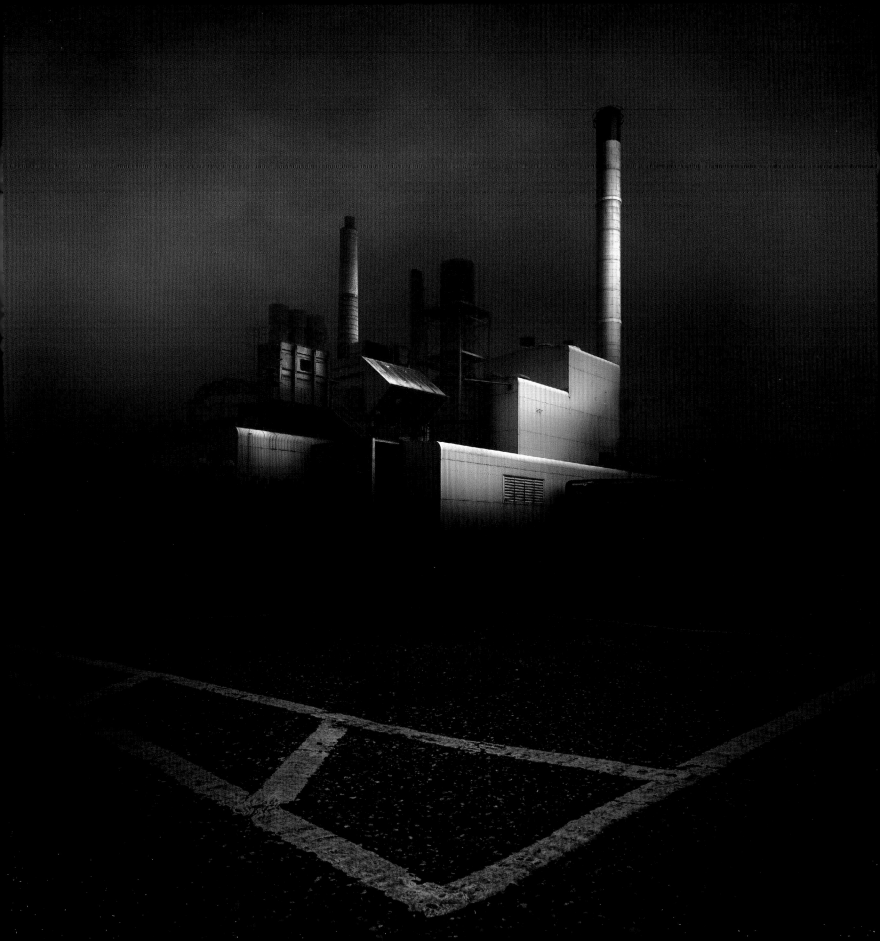

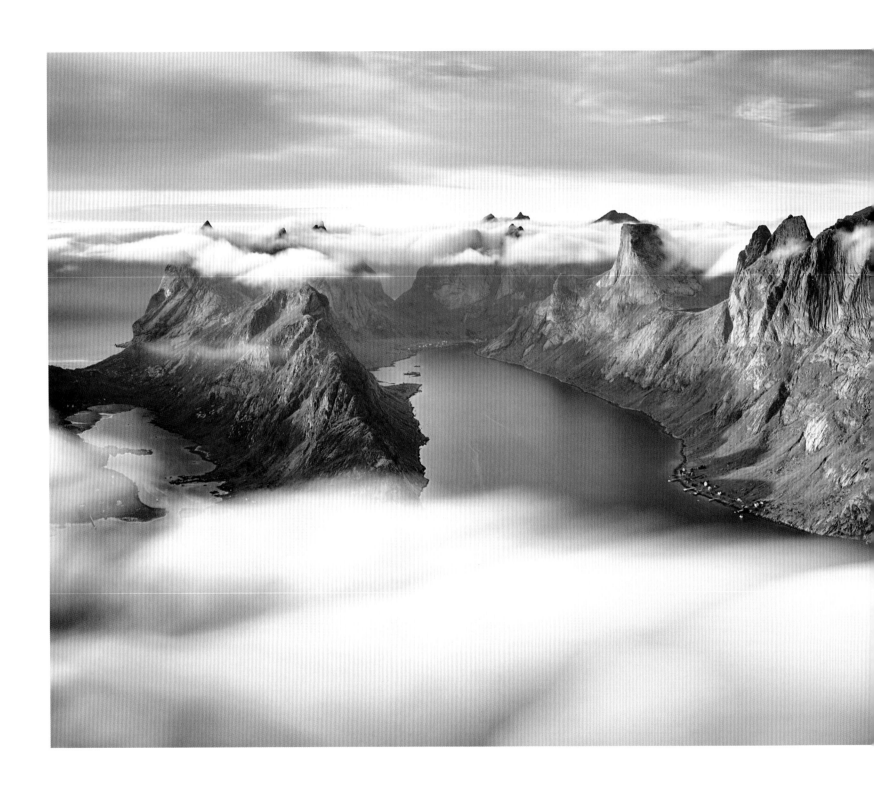

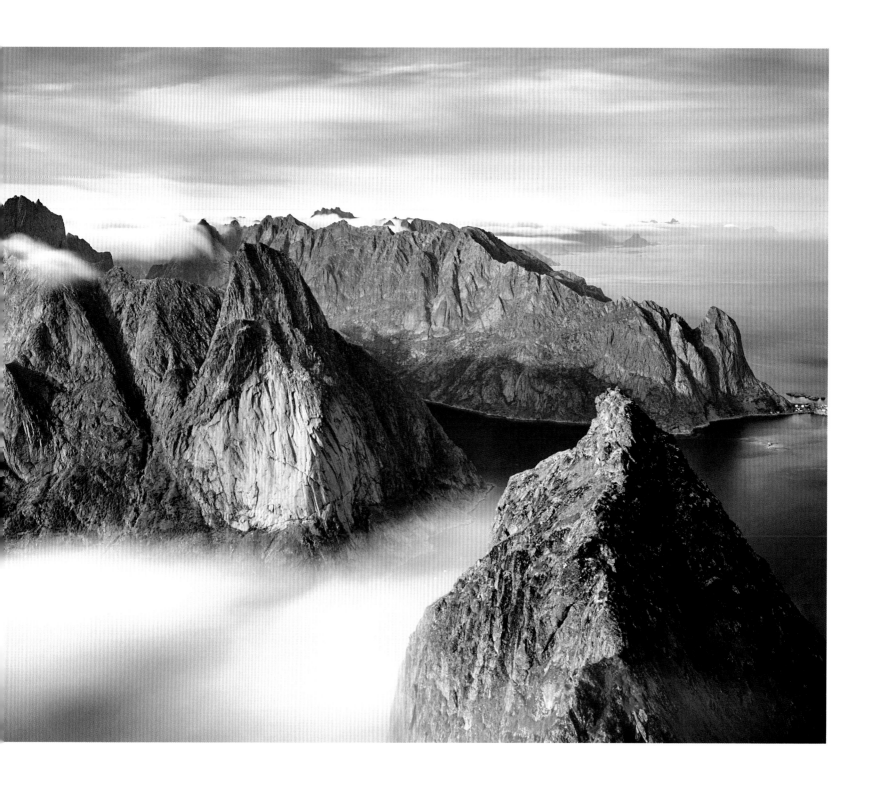

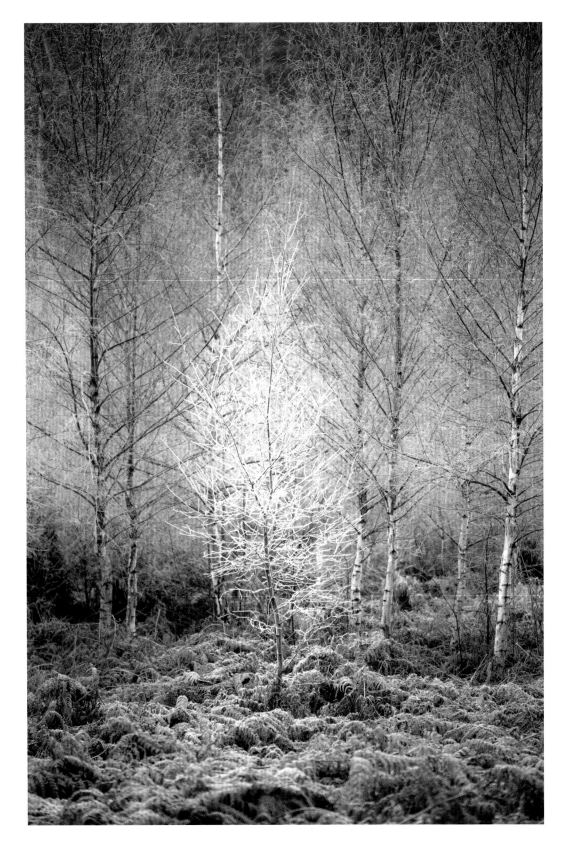

Wojciech Kruczynski (Poland)

Previous page: **Lofoten Islands, Norway.** The hardest part of this shot was getting to the location, which is a rarely frequented peak that has not even got a name. The hike takes you through the Helvete – or 'Hell' – valley, which is apt, as the trip is long and difficult. To take a picture at sunset you have to camp afterwards, which means taking a lot of equipment and food to the top; camping isn't easy due to the frequent strong winds. You can't be afraid of heights either, as this view is from the top of a very high cliff, so this is one of those locations where a landscape photographer has to be in good condition, both physically and mentally.

This image is a stitched panorama made up of five frames, each of which had an exposure of almost one minute. The problem here was the weather and light conditions were often different at the end of the sequence to the beginning. However, if you can overcome all these difficulties, the result can easily exceed your expectations. That was the case here, and when I look at this picture I feel as if I was on this difficult and beautiful journey again.

Nikon D7000 with 10-24mm lens at 24mm, ISO 100, 54sec at f/13, 10-stop ND filter, tripod, five-frame stitched panorama

stroop.pl

Chris Dale (United Kingdom)

Sherwood Forest, Nottingham, England. I found this small, frost-covered sapling a couple of days after Christmas while I was exploring some of the outer edges of Sherwood Forest. It really stood out from the bigger silver birch trees behind in the small bracken-carpeted clearing, but I emphasised it further by using a wide aperture and some local dodging and burning. This image became one of the first of a year-long project at Sherwood, capturing the hidden corners of the forest as it changes through the seasons.

Canon EOS 6D with 70-300mm lens at 183mm, ISO 200, 1/50sec at f/5, handheld

chrismdale.co.uk

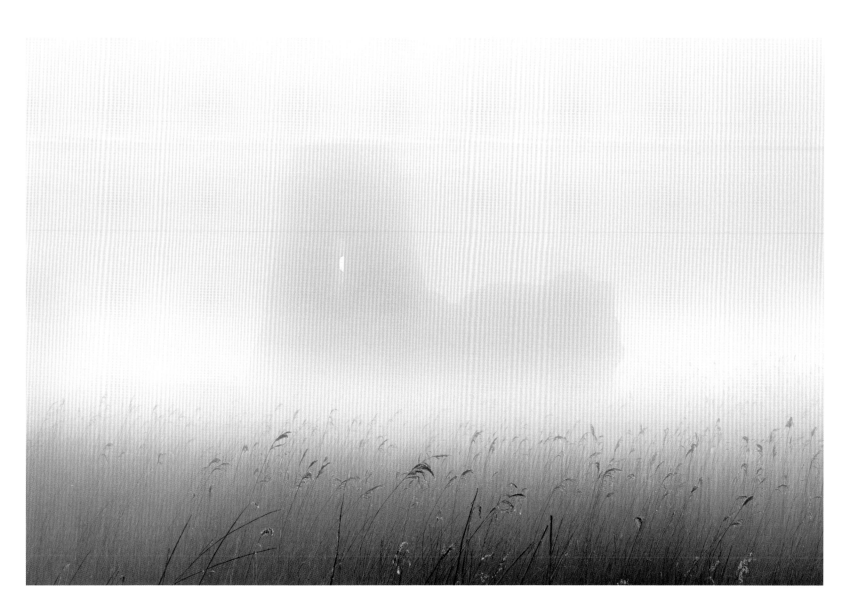

Justin Minns (United Kingdom)

St Benet's Abbey, Norfolk, England. When the forecast predicts mist, the low-lying marshes of the Norfolk Broads are always a good place to find it. On this occasion I found a little more than expected – even when the sun was up, the visibility was poor, although it was still a beautiful morning. Taking advantage of the diffusing effect of the fog, I composed this image so the sun appeared as a golden disc through a gap in the ruins, their ambiguous shape lending a sense of mystery to the shot.

Canon EOS 5D MkIV with 24-105mm f/4 lens at 88mm, ISO 100, 0.3sec at f/16, one-stop medium ND grad filter, tripod

justinminns.co.uk

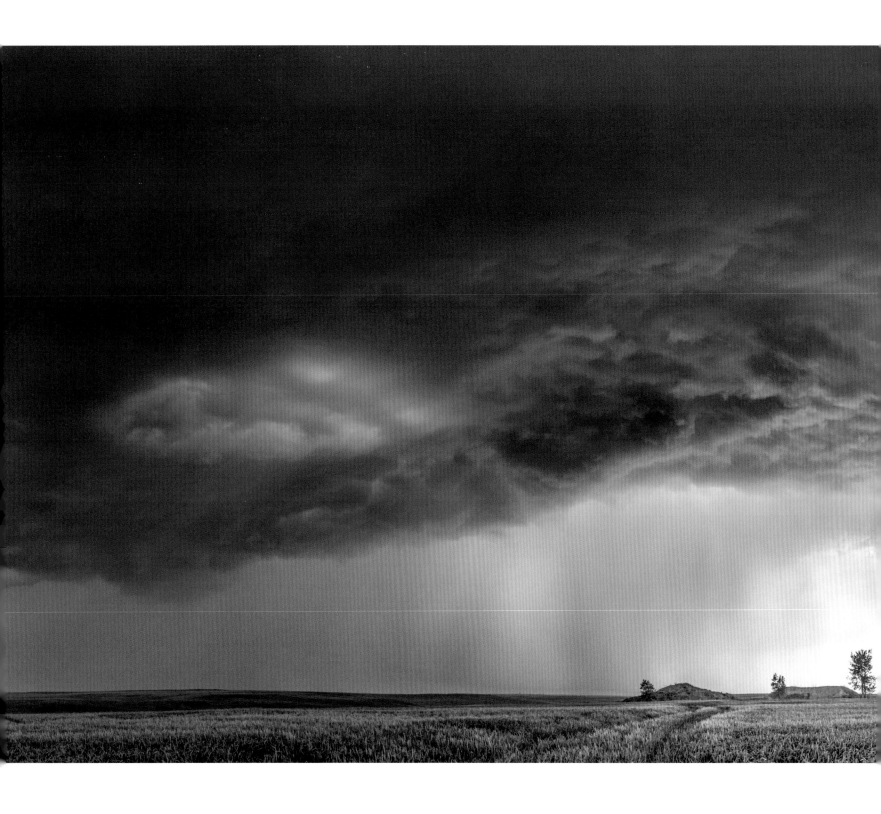

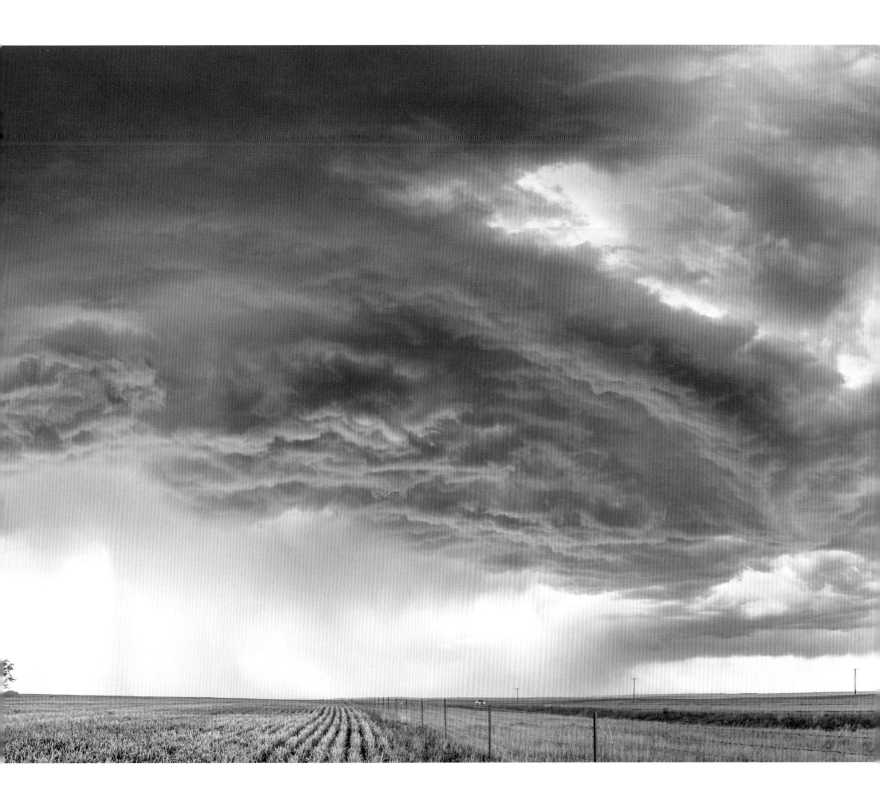

Will Eades (Australia)

Previous page: **Great Falls, Montana, United States of America.** We intercepted this storm from the rear, so to get the shot of the approaching front we had to drive right through the middle of it and out the other side. Half an hour later we were clear, having passed through flash floods and hail. Despite the thunder all around us it was the sound of a western rattlesnake at my feet that sent me jumping clear as I put down my tripod. The snake fled into the field in front of us, and I frantically tried to shoot a panorama of the storm that was now overhead.

Nikon D810 with 16-35mm f/4 lens at 16mm, ISO 64, 1/25sec at f/13, tripod

willeades.com

Alex Nail (United Kingdom)

Mnweni Cutback, Drakensberg, South Africa. Temperature inversions are a common occurrence in the Drakensberg. In the afternoon, the heat of the day energises the clouds below and – seemingly without warning – you are swallowed by the mist. On these afternoons it's always worth heading out with a camera. The mist can break as suddenly as it arrives and with a bit of luck you can witness stunning atmospheric effects. The Mnweni Pinnacles pictured are among the most dramatic features in the whole Drakensberg.

Canon EOS 5DS R with 70-200mm f/4 lens at 200mm, ISO 200, 1/500sec at f/8, handheld

alexnail.com

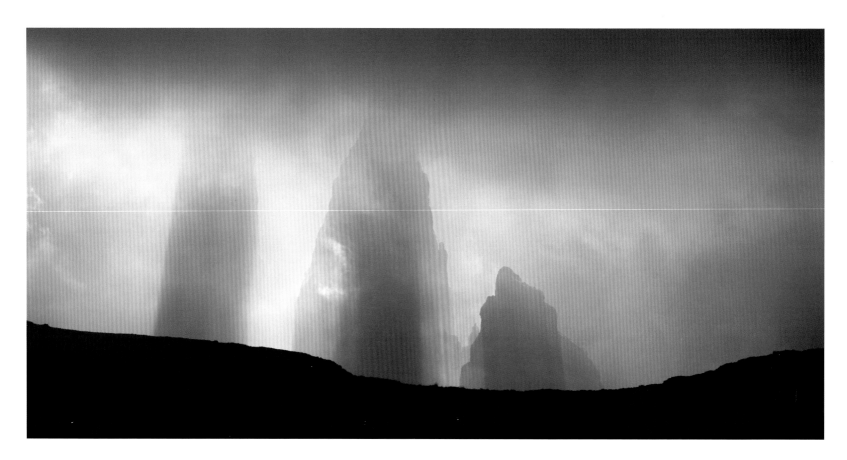

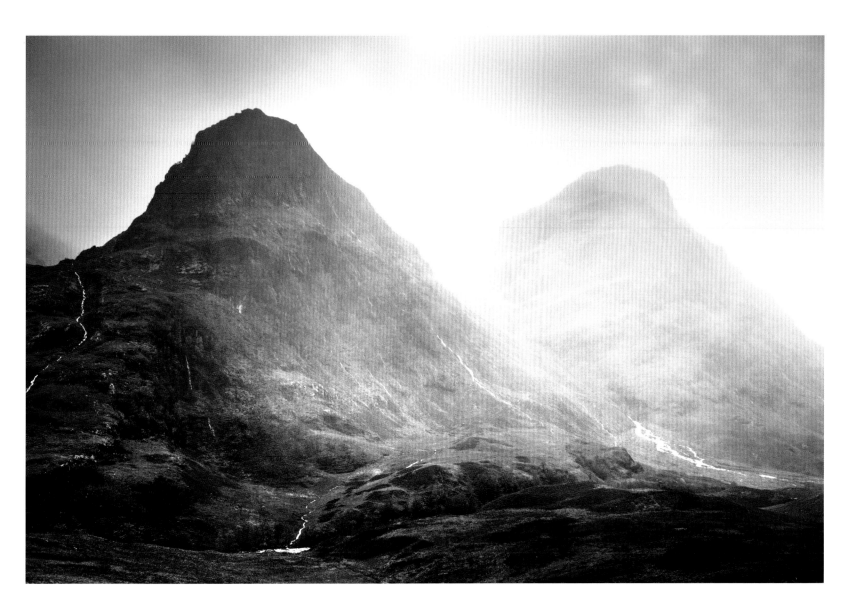

Damian Shields (United Kingdom)

Gearr Aonach and Aonach Dubh, Glencoe, Scotland. I was met by gloomy skies, cold gusts and incessant rain when I arrived at Glencoe, but I was determined to plough on in my quest for compositions. I spent a lot of time wiping my lens between shots and the constant rain showers began to saturate my clothing to the skin. However, there is something in the desolation of such a day in the glen that enhances its character, creating a mood that lingers in your mind.

Nikon D800 with 28-70mm f/2.8 lens at 35mm, ISO 800, 1/1000sec at f/8

damianshields.com

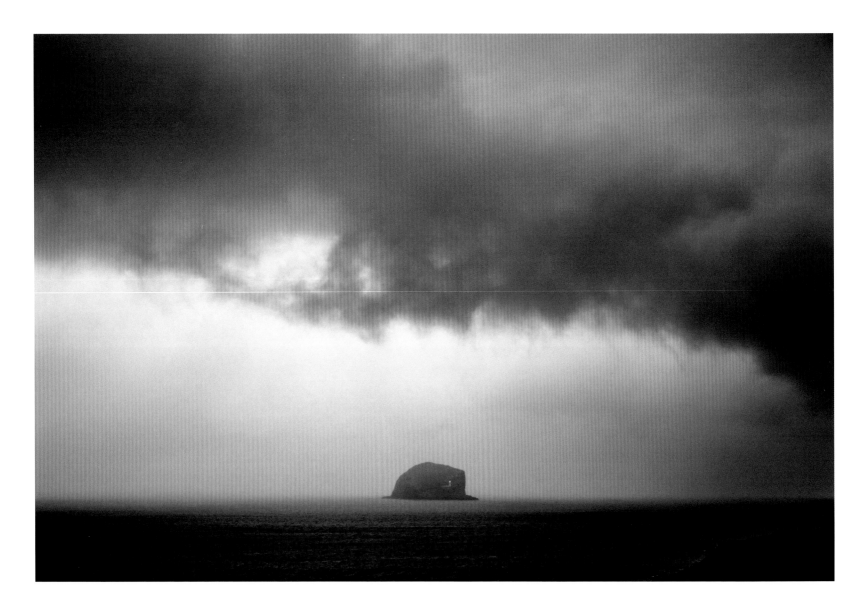

Graham Niven (United Kingdom)

The Bass Rock, Firth of Forth, Scotland. I was driving home from a failed mission to capture a sunset, when the storm clouds that had obscured the sun swept across the sea and began to envelop the Bass Rock. I pulled over hastily to capture the scene as it rapidly darkened and the squall hit. I had no time for a tripod or deliberation; I had to quickly compose the scene before the moment was gone. It was vital to time the photograph with the East Cove lighthouse flash, as the tiny light gives a sense of scale and – more importantly – presence.

Nikon D850 with 28-300mm f/3.5-5.6 lens at 36mm, ISO 400, 1/30sec at f/5, handheld

nivenphotography.com

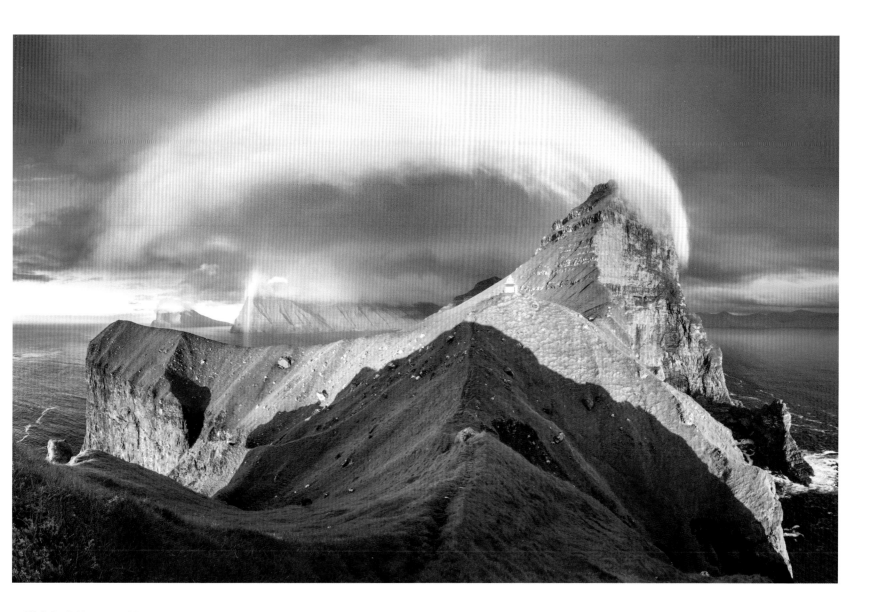

Wojciech Kruczynski (Poland)

Kallur lighthouse, Faroe Islands. The picture consists of nine frames arranged in a three-by-three grid, which is quite difficult to put together and requires a lot of work, but with this beautiful place it was worth the effort. Weather conditions like this do not often occur in the Faroe Islands – I had to wait for three days in a tent in the rain for them. The hardest thing, however, was getting to the location to start with. My journey involved an aeroplane, bus, ferry, another bus and then a long walk on foot. I had to walk through a tunnel that is close to one and a half miles long and then do roughly the same distance along a mountain sheep path; on the way I was attacked by arctic skua that were so aggressive I had to carry an open tripod over my head. It was worth overcoming these difficulties, though, because Kallur lighthouse is located in one of the most beautiful places on the planet. Because the cliff I was shooting from is very tall and vertical – and the wind blows hard – you definitely need a head for heights, and the rain will soak you again and again. You need to quickly take pictures and run away, again fighting with angry birds. The life of a landscape photographer is beautiful, isn't it?

Sony a7R with 16-35mm f/4 lens at 16mm, ISO 100, 4sec at f/10, tripod, nine frames stitched together

stroop.pl

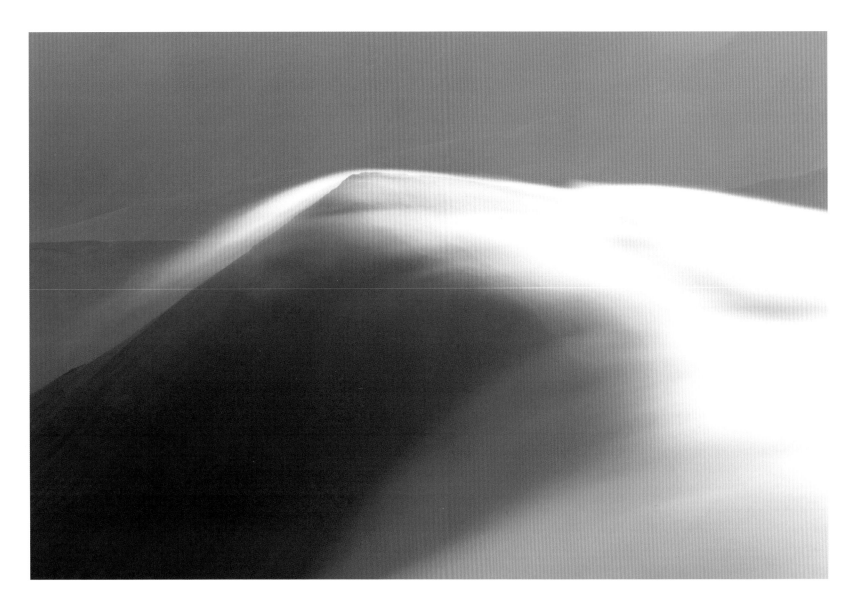

Thomas Roberts (United Kingdom)

Cribyn, Brecon Beacons, Wales. The 'Dragon's Breath' in the Brecon Beacons is a phenomenon that I have spent a great deal of time trying to predict and capture. As a result, I have witnessed countless sunrises from these summits, however, none has been quite like this. The low-lying mist filled the valley and crept slowly over the back of Cribyn before pouring over the summit. I used a 10-stop ND filter to extend the exposure to capture the flow and opted for a telephoto lens to focus on the intimate details of the backlit scene.

Canon EOS 6D with 70-200mm f/4 lens at 160mm, ISO 100, 8sec at f/16, 10-stop ND filter, tripod

thomasroberts.cymru

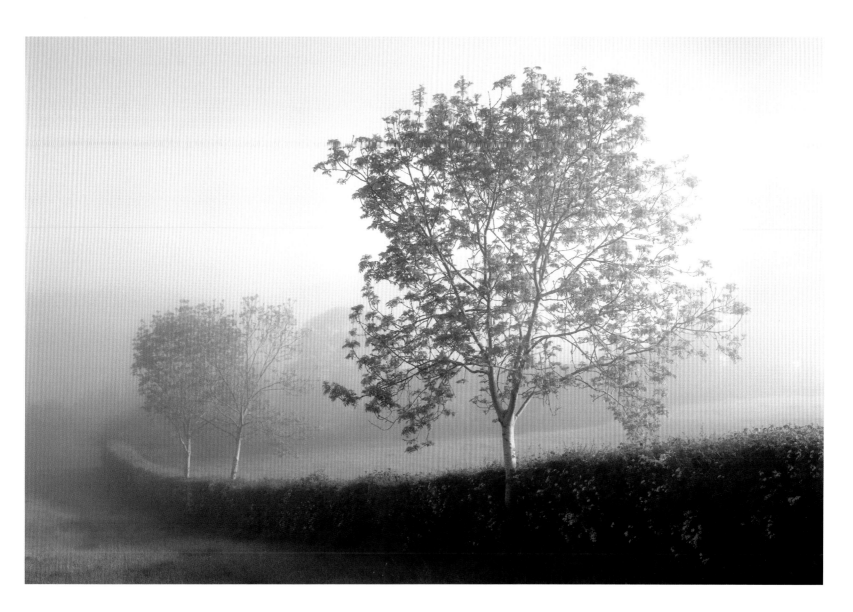

Stuart McGlennon (United Kingdom)

Nether Wasdale, Cumbria, England. This image was made during misty conditions in Wasdale, which is extremely rare, as the area has weather patterns all of its own. On this particular morning the heavy mist shifted gradually up the valley; I chased it from Wastwater up through the farmland to where this image was captured, peering over a wall at this nice curved hedgerow. I had no time to use a tripod as I was parked on a single-track road and didn't want to block any farm vehicles or incur a farmer's wrath.

Nikon D610 with 50mm f/1.8 lens, ISO 100, 1/640sec at f/6.3, handheld

lensdistrict.com

Chris Davis (United Kingdom)

Sgùrr Eilde Mòr, Highland, Scotland. This was taken on a winter camping trip with Alex Nail in the Glencoe region of the Scottish Highlands. I shot this little snow dune with Sgùrr Eilde Mòr in the background under different conditions with a variety of light. For this shot, I wanted to create a very high-key, minimalist image. In this instance the wind was the biggest challenge, as to get the central composition I needed to set up my camera in a slightly elevated, exposed position.

Canon EOS 5D MkIII with 16-35mm f/4 lens at 24mm, ISO 200, 1/400sec at f/13, two-stop soft ND grad filter, tripod

chrisdavis-photography.com

Jon Gibbs (United Kingdom)

Cheswick, Northumberland, England. Being a huge fan of dune beaches, I am always on the look out for interesting shapes and patterns in the marram grass, and a cold morning on the Northumberland coast ensured the grasses were slightly frosty. I was drawn to this particular scene because of the wonderful curves of the grasses. Rather than making a static image, I used a 10-stop ND filter to give me a long exposure and add a little movement to the image.

Nikon D800 with 35mm f/1.4 lens, ISO 100, 15sec at f/13, Lee Big Stopper (10-stop ND filter), tripod

jon-gibbs.co.uk

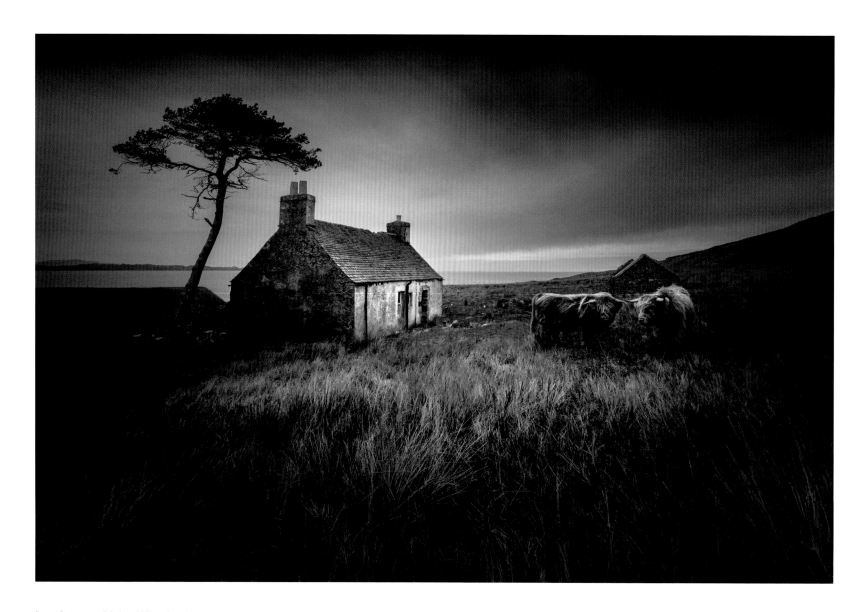

Lee Acaster (United Kingdom)

Applecross, Scotland. I was on a trip to Torridon with some other photographers when we passed this lovely little abandoned croft with a lone tree on the road near Applecross. Brakes were hastily applied and cameras set up. I'm always a little nervous around cattle, but luckily one of our party had decided to explore the inside of the croft, giving me the opportunity to get some shots of the exterior, safe in the knowledge I could use him as bait if necessary. The overcast weather lent itself to a monochrome treatment, which enhanced the mood.

Sony a7R with 18mm f/3.5 lens, ISO 200, 1/20sec at f/11, polariser, tripod

leeacaster.com

Karl Mortimer (United Kingdom)

Right: **Marchlyn Mawr reservoir, Snowdonia, Wales.** While descending from Carnedd y Filiast, half an hour or so before sunset, the curve of the reservoir's dam and the access road to it glinted provocatively in the late-evening light that raked across the landscape. It was this simple composition of curves that caught my eye and I made a few exposures, knowing that I'd be converting to black & white to emphasise the relationship between those bright, reflective curves and the darker tones of the mountainside.

Fuji X-Pro2 with 16-55mm f/2.8 lens at 55mm, ISO 200, 1.3sec at f/14, tripod

karlmortimer.com

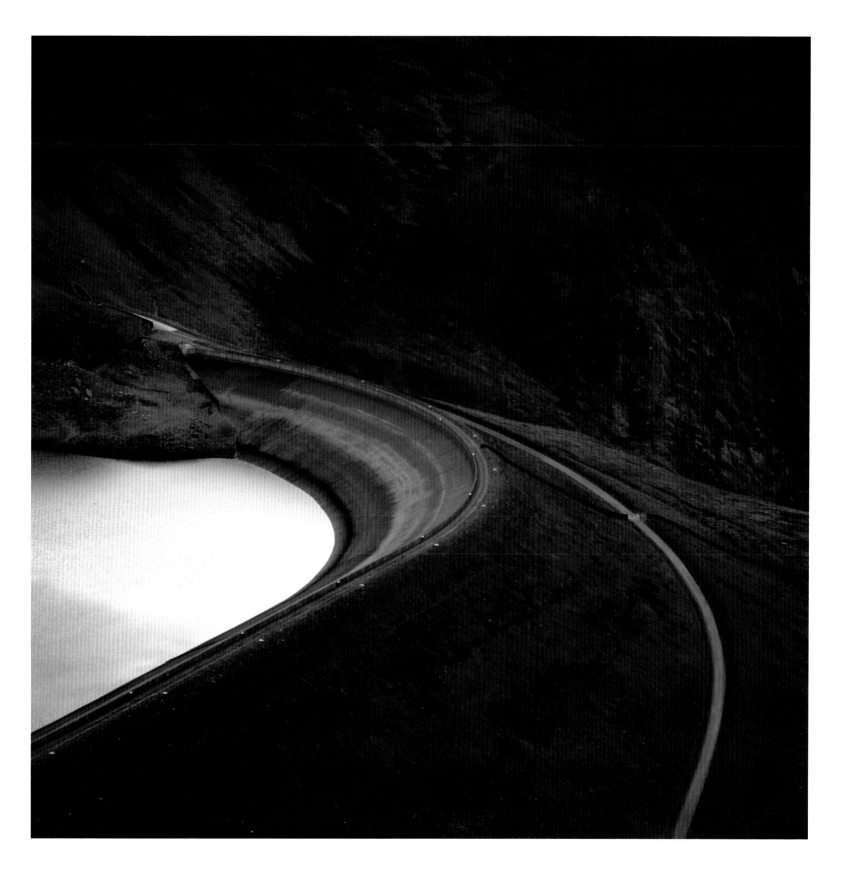

SMALL WORLD

Nature can be at its most amazing in the smallest forms. This category is for macro and close-up photographs of the plants and insects all around us that often go unnoticed.

SMALL WORLD – WINNER

William Mallett (United Kingdom)

Saffron Walden, Essex, England. The asparagus plant in my garden – which has become a bush and produced berries – is a haven for wildlife. I normally look for spiders in it to photograph, but on this particular evening, after a rain shower, it was covered in tiny snails. The light below is from a backlit asparagus berry; I always try to visit after a rain shower, as I find backlit droplets bring the images to life.

Olympus OM-D E-M10 MkII with 60mm f/2.8 macro lens, ISO 5000, 1/125sec at f/4, handheld

instagram.com/willmallett

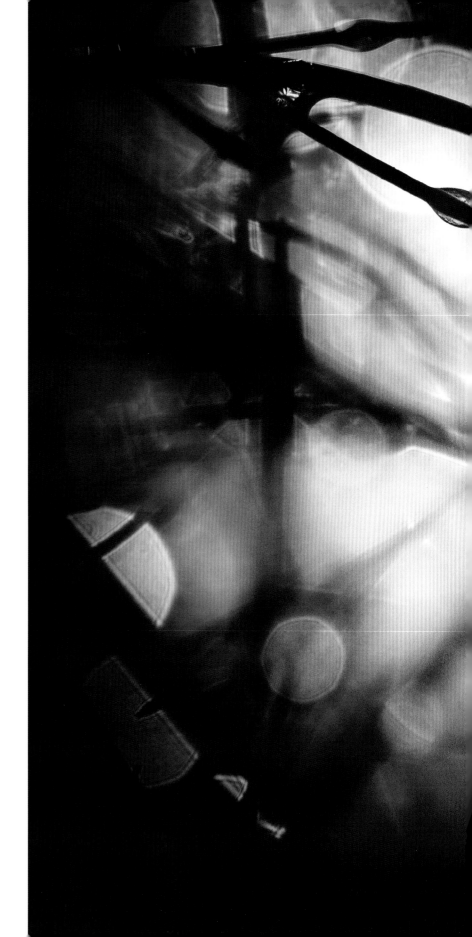

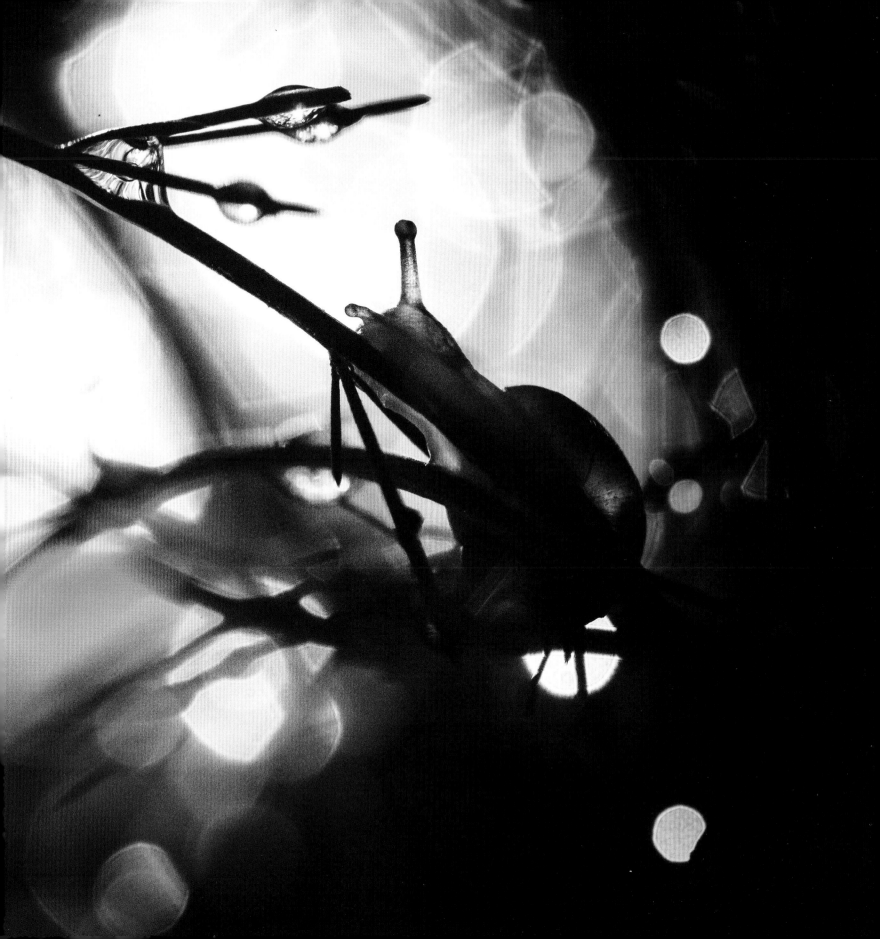

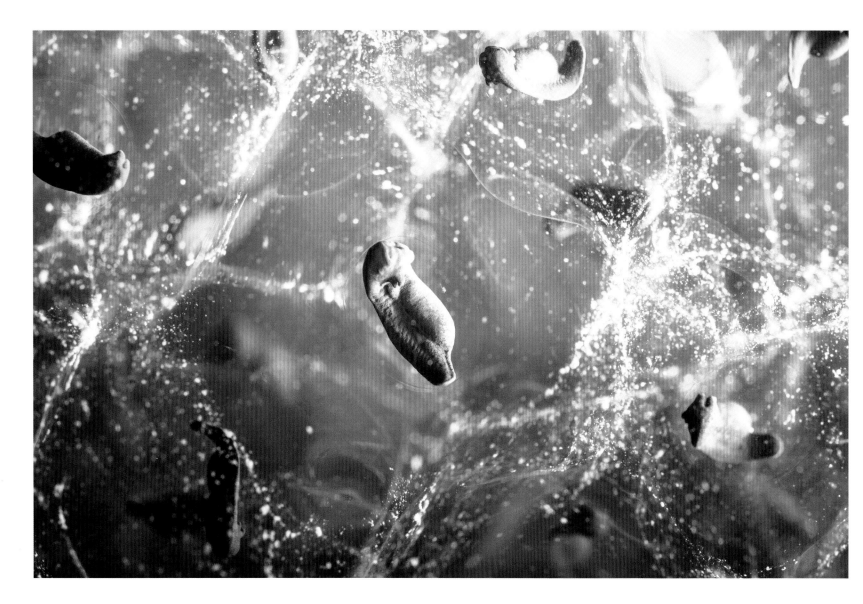

Amy Bateman (United Kingdom)

Kendal, Cumbria, England. This frogspawn had been spawned in a puddle that was drying up on our farm in Cumbria. We rescued it as a way to teach my children about wildlife conservation and ecology, keeping it on our patio in a fish tank. I photographed it regularly throughout its growth to show the incredible rapid morphological development. We released the fully grown froglets back to a site close to their spawn site.

Nikon D750 with 105mm f/2.8 lens, ISO 320, 1/3sec at f/22, polariser, tripod

amybatemanphotography.com

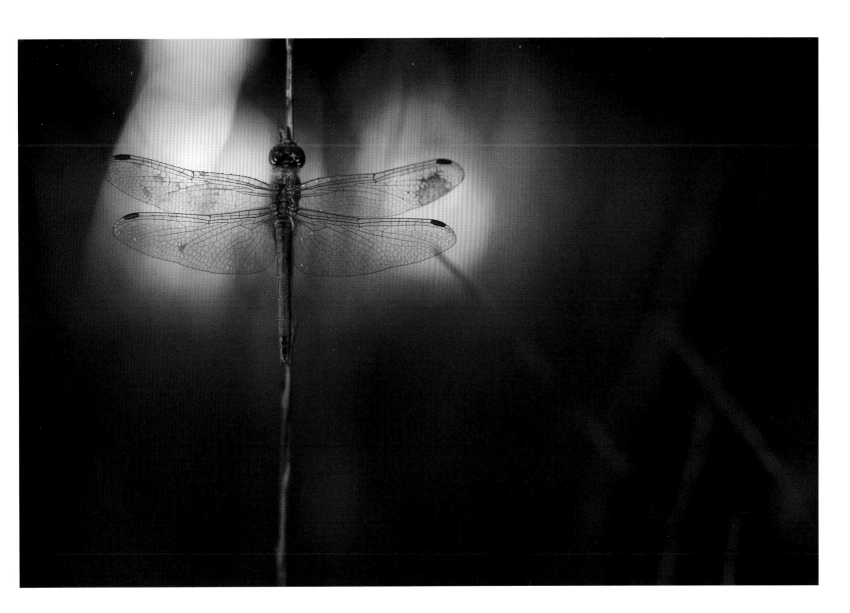

Simona Tedesco (Italy)

Red-veined darter, Pietrasanta, Tuscany, Italy. I spend a lot of time watching the lives of dragonflies and I'm especially fascinated by their behaviour after sunset. On summer nights I often go to look for them in the uncultivated fields close to my home. I found this specimen resting on a long grass stem; it was late and the wings were already covered with dew. To avoid disturbance, I lit the scene behind the dragonfly with a torch to get a warmer atmosphere, taking advantage of the dry grass stems that filled the image.

Canon EOS 1D MkIV with 100mm f/2.8 macro lens, ISO 1000, 0.4sec at f/4.5, tripod

facebook.com/simona.tedesco

Stefan Gerrits (Netherlands)

Female banded demoiselle, Lake Kvarnträsk, Espoo, Finland. It was the first day of my holiday and rather than rest, I decided to get up early with my camera. I found this female banded demoiselle spreading her wings to warm up in the early sunlight. The backlighting reveals how complex the structure of the wings is; it's almost like they're made of stained glass. The early morning light, the droplets on the damselfly, the position of the camera and the sun gave each image I took a different range of colours, from gold and silver to beautiful gemstone-like hues. This one was my favourite.

Canon EOS 5D MkIII with 100mm f/2.8 macro lens, ISO 100, 1/320sec at f/3.2, handheld

stefangerrits.com

Briana K Massie (United States of America)

San Francisco, California, United States of America. This image was captured approximately half an hour before sunset. I wanted to record the intricate play between light and dark within the leaves as the shadows danced among them, which was difficult given the rapidly changing light levels. I did not have enough time to set up a tripod, so I was also faced with the challenge of capturing the photograph handheld and in low light levels. I chose this composition because I wanted to emphasise how unpredictable nature is through an image that is nearly perfectly centred, yet contains no symmetry.

Canon EOS 5D MkIII with 70-200mm f/2.8 lens at 140mm, ISO 6400, 1/125sec at f/11, handheld

brianakphotography.com

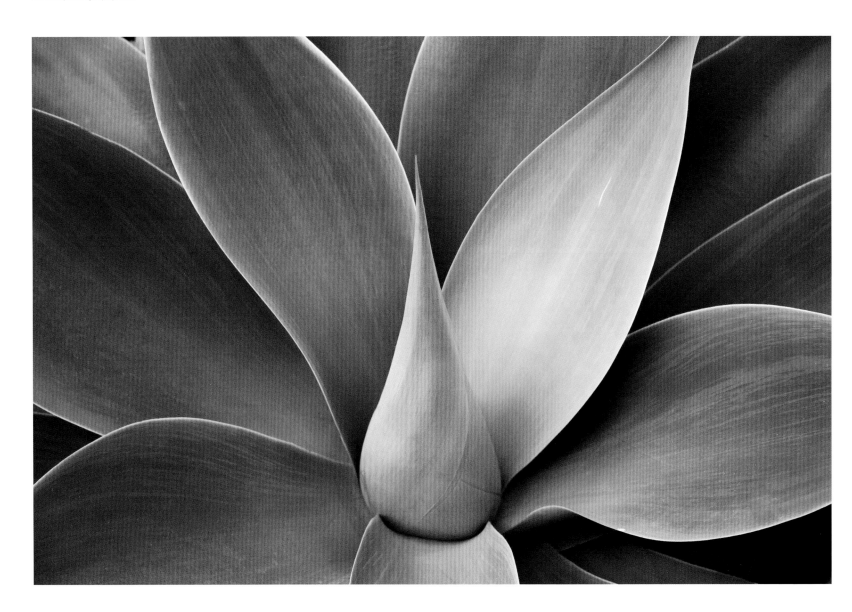

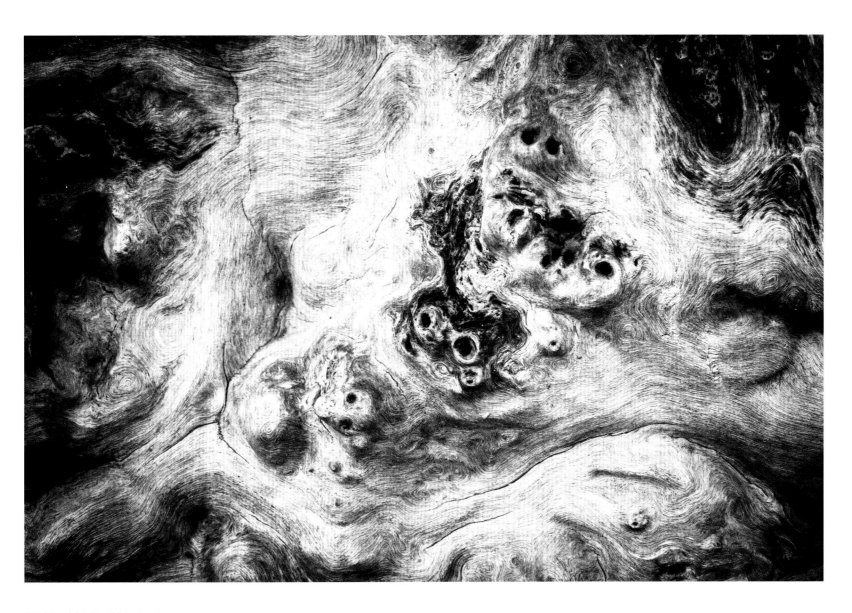

Bill Ward (United Kingdom)

Bristol, England. There is an old decaying log in our local park that my kids play on, and on close inspection I was surprised to see it houses all sorts of dark and unsettling worlds in miniature. This shot reminds me of an alien landscape seen from the air, so while it could technically be described as a macro photograph, I prefer to categorise it as micro landscape photography. That would definitely be a more accurate summary of my intention when composing the shot.

Pentax K-3 II with 35-105mm lens at 50mm, ISO 100, 0.3sec at f/16, tripod

billwardphotography.co.uk

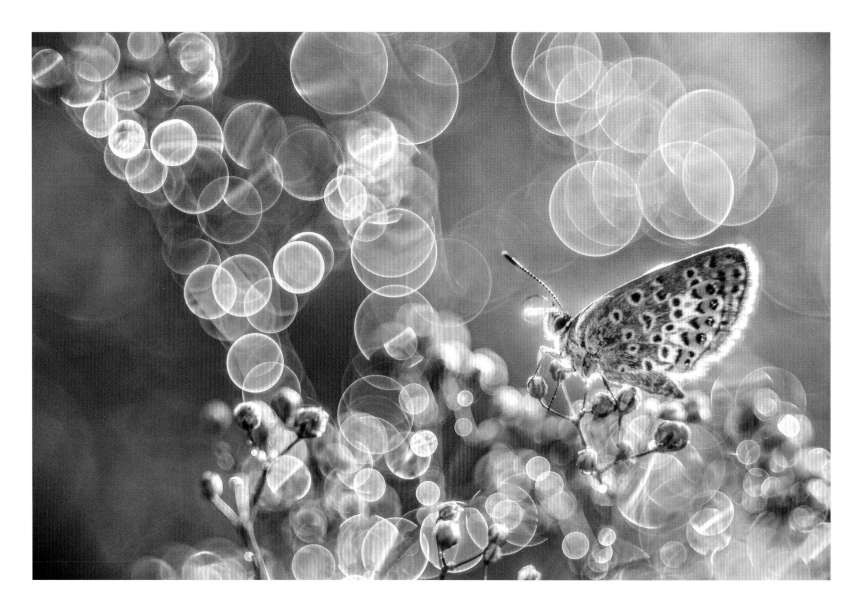

Peter Racz (Hungary)

Csömör, Hungary. It was sunrise when I found this butterfly resting in a bush. As it was only a few centimetres long I had to use a whole set of extension tubes, which limited the depth of field and meant a longer exposure time was needed. Combined with the slight breeze this gave me quite a challenge. The rings in the background are the bokeh caused by the morning dew; their unique shape is the result of my special Meyer Görlitz lens.

Canon EOS 5D MkIII with Meyer Görlitz Trioplan 100mm f/2.8 lens and 65mm extension tube, ISO 80, 1/2000sec at f/2.8

shamanphoto.com

Claire Carter (United Kingdom)

Shropshire, England. Vincent van Gogh said 'Great things are done by a series of small things brought together' and this image illuminates this quote. My garden often becomes my studio when I can't venture further, and it tends to be the simple things that catch my eye. Opening this feather emphasised both its fragility and strength, while getting close revealed the structure of the barbs and barbules.

Canon EOS 5D MkIII with 100mm f/2.8 macro lens, ISO 100, 6sec at f/14, tripod

carterart.co.uk

Henrik Spranz (Austria)

Southern Tuscany, Italy. During a trip to Tuscany in autumn I was eager to find a butterfly for a seasonal picture. Some withered fern and a little branch with leaves I had found gave the autumnal impression I was looking for: the technical challenge was to find the ideal location and a torpid butterfly before sunrise, then get him sharp using a wide aperture.

Canon EOS 5D MkIII with 180mm f/3.5 lens, ISO 320, 1/80sec at f/4.5, tripod

spranz.org

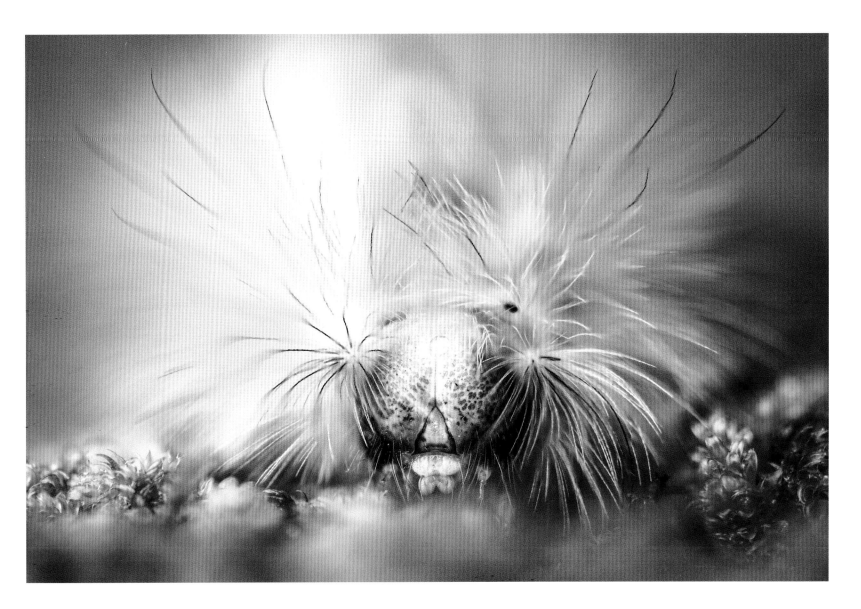

Geraint Radford (United Kingdom)

Pale tussock moth caterpillar, Swansea, Wales. This image was captured in the woods near my home, but having never seen one of these beautiful creatures before it was difficult at first to figure out which end was which. I placed my camera on the fallen tree where this caterpillar was walking – perhaps looking for somewhere to pupate – and waited until it paused for a moment. I then captured four frames for a focus stack, composing the image in a relatively abstract manner while hoping to showcase the amazing hair and colours of this wonderful caterpillar.

Nikon D5 with 105mm macro lens, ISO 635, 1/80sec at f/5.6, focus stacked

bewilder-photography.com

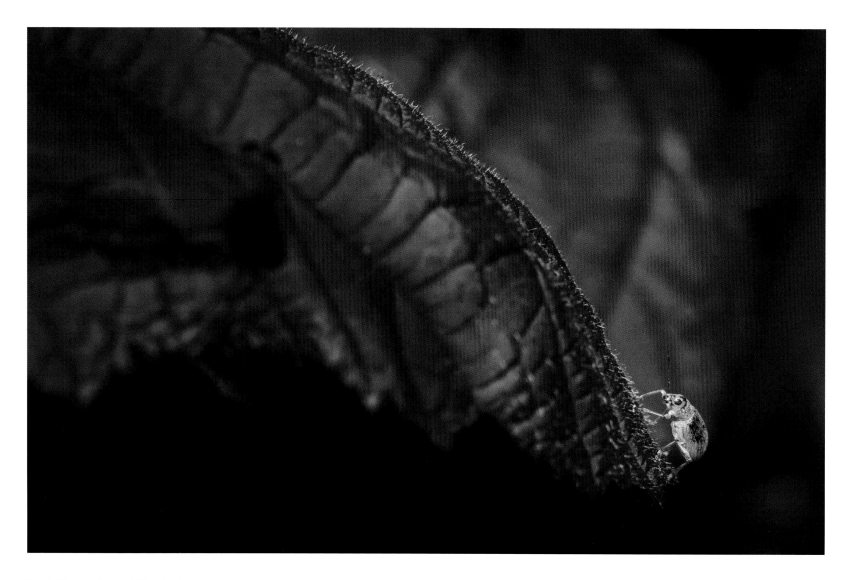

Mark Horton (United Kingdom)

Loseley Park, Godalming, Surrey, England. This shot was taken at Loseley Park, a wonderful old house in Surrey with astonishing gardens that I can spend hours bug-hunting in. I paid very close attention to this deep red foliage, hoping for a photo opportunity, and couldn't have got luckier than spotting a few of these amazing little green weevils – the colours contrasted so well. It is easy to lose concentration when faced with several potential subjects, so I picked one and followed it as it walked among the leaves. I took this shot as it moved to the tip of a leaf, turning when it reached this dead end.

Canon EOS 7D with 100mm f/2.8 macro lens, ISO 160, 1/200sec at f/7.1, diffused flash, handheld

markhortonphotography.co.uk

Carolyne Barber (United Kingdom)

Right: **Hackney, East London, England.** I was out in my garden early one morning when I saw this tiny snail on the greenhouse glass. The surrounding dewdrops made it sparkle so much that it looked like a tiny diamond. I quickly got my camera and macro lens and took its picture. It seemed to pose for the camera for a few seconds before it was gone. I had to be quick – they move faster than you think.

Nikon D7000 with 40mm f/2.8 macro lens, ISO 100, 1/500sec at f/4

carolynebarberphotography.org.uk

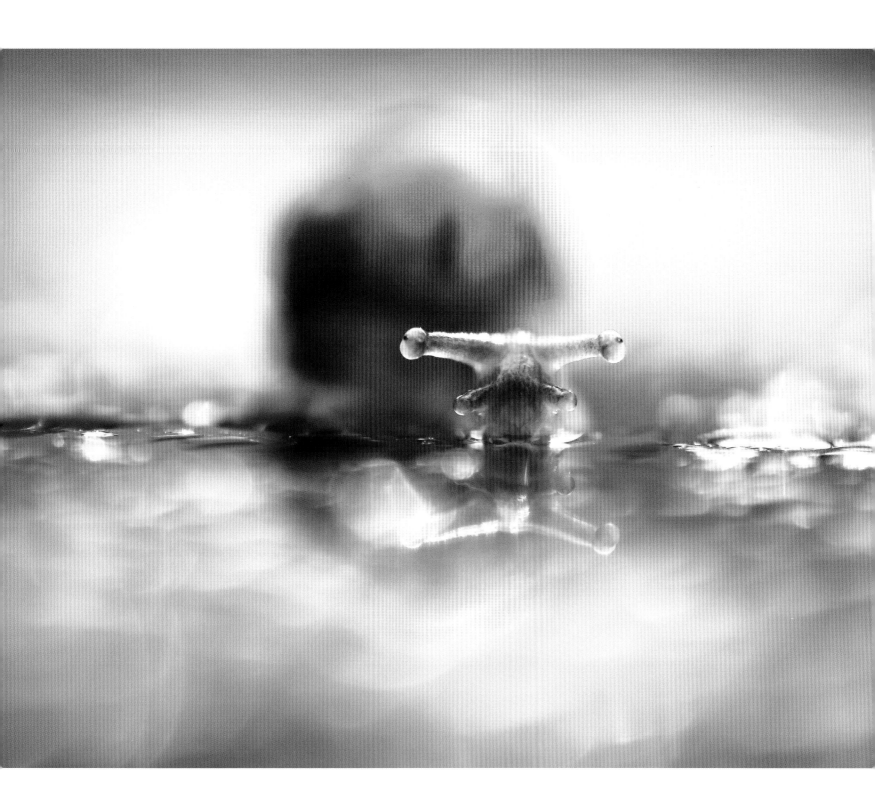

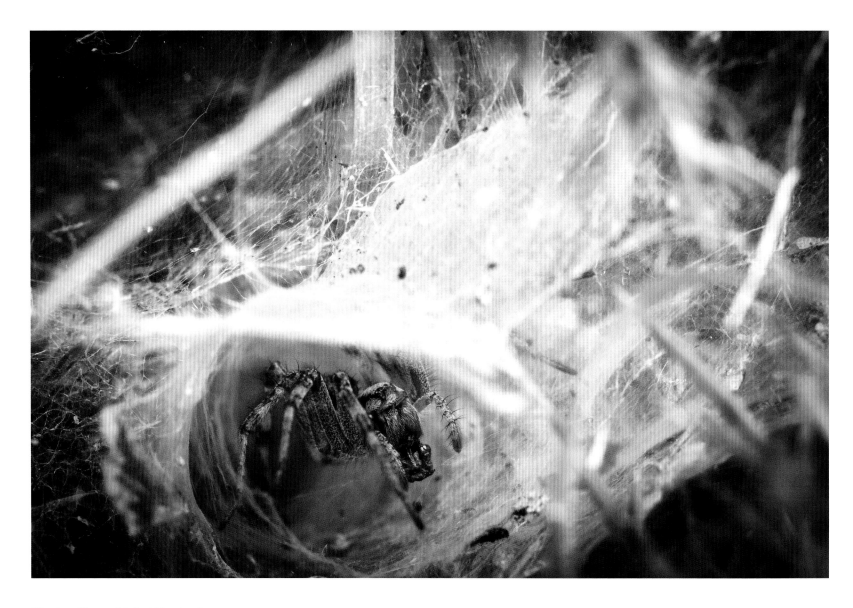

Stephen Young (United Kingdom)

Labyrinth spider, Heysham Nature Reserve, Lancashire, England. This image was taken while I was walking around Heysham Nature Reserve. Seeing this particular spider was a first for me and I wanted to capture it close up, with part of its habitat. I lined up my camera so I was looking into the labyrinth entrance and waited for the spider. The spider was quite active, appearing briefly at the entrance in various stances before disappearing back again, but it was several minutes before it appeared at the edge of the web looking in my direction. I quickly took the shot, which captures the spider, the complex structure of the labyrinth entrance and the surrounding gorse bush.

Nikon D300s with 105mm f/2.8 macro lens, ISO 800, 1/320sec at f/2.8, polariser, tripod

photostone.wixsite.com/espy-photography

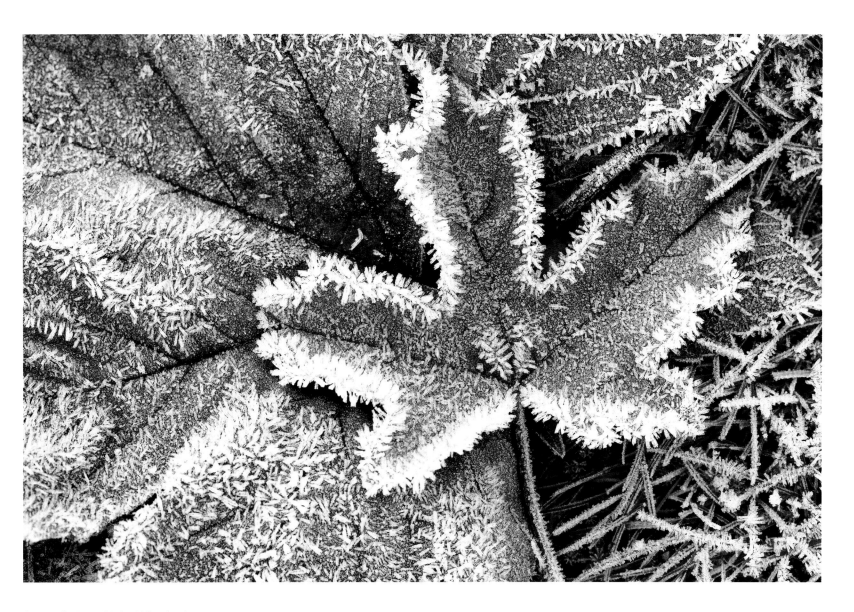

Simon Gakhar (United Kingdom)

Northumberland, England. Hard frosts are common where I live and always seem to produce exciting photo opportunities. One particular morning I was searching for an interesting composition when I came across this fallen sycamore leaf with a bold outline of ice crystals. It was resting on top of a larger leaf, which was also covered in crystals. I felt that positioning the smaller leaf to the right of the image and orientating it so it pointed slightly to the left, provided just the right compositional balance.

Canon EOS 5DS R with 100mm f/2.8 macro lens, ISO 100, 1/10sec at f/10, tripod

flickr.com/photos/simmyg

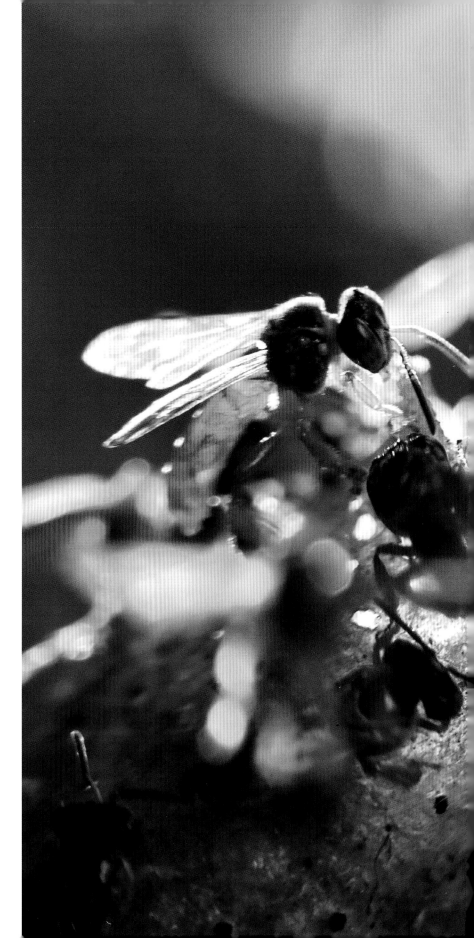

Bence Máté (Hungary)

Boca Tapada, Costa Rica. After spending a morning in a rainforest in Costa Rica I was heading to my hotel's dining room when I saw a huge number of small wasps flying in to holes burrowed in to the side of the lodge. I went back to fetch my camera and tried to catch the moment when the wasps – still in the air – arrived at their nest. The size of these tiny insects is slightly more than five millimetres.

Canon EOS 1D X with 100mm lens, ISO 1600, 1/250sec at f/7.1

matebence.hu

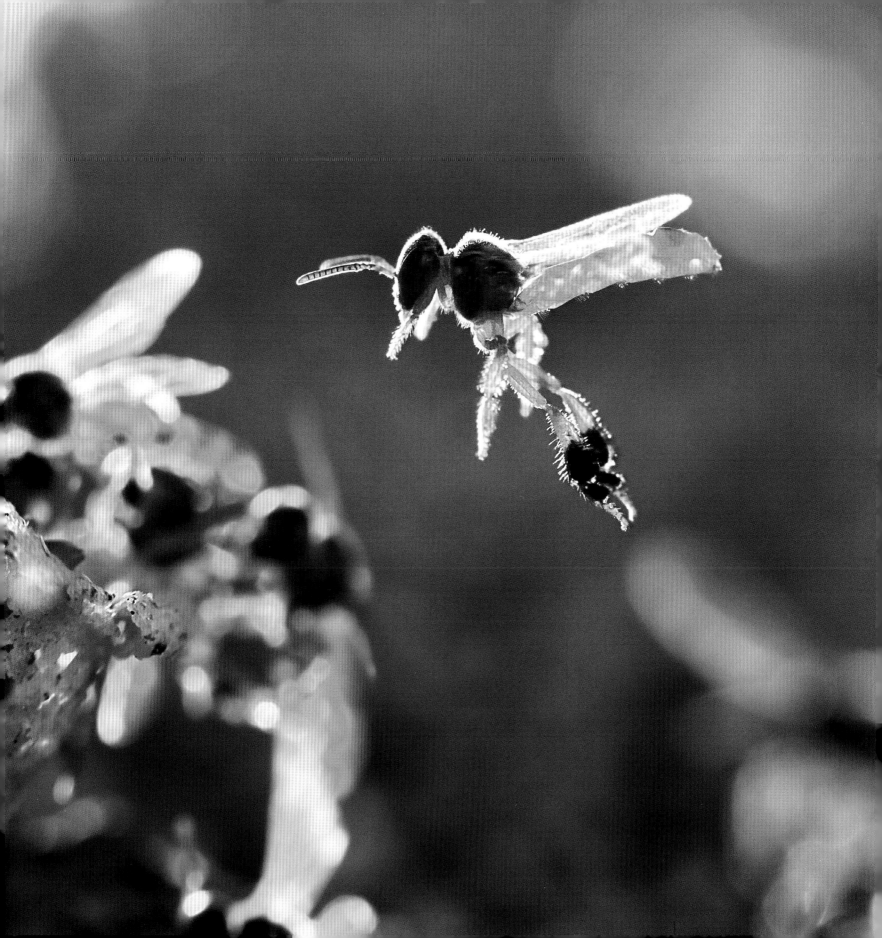

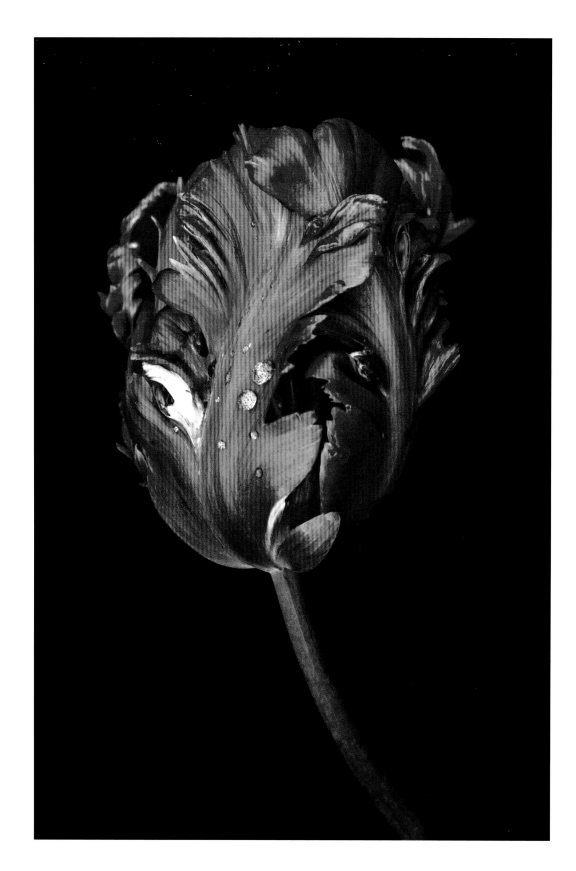

Tammy Marlar (United Kingdom)

Parrot tulip, Bedmond, Hertfordshire, England.
I took this photograph of a 'Rococo' parrot tulip
very early one morning in April. The light was soft,
but the sun gave out no warmth and some freezing
dew droplets still clung to the petals. The flower
resembled a human heart in size, colour, shape and
texture, and looked as if it was weeping. I used a
piece of black card as a backdrop to place maximum
emphasis on this beautiful flower.

*Canon EOS 5D MkIII with 180mm f/3.5 macro lens, ISO 1600,
1/320sec at f/11*

tammymarlar.com

Claire Carter (United Kingdom)

Right: **Bracken, Shropshire, England.** My garden is
happily wild and a source of inspiration. On the day
this was taken the weather was far from clement,
so I headed out with some card as a backdrop, my
macro lens and a handheld light. The card was
bright red; used as the red channel it gives plenty
of options when converting to black & white. My
light glanced off the bracken and natural light on
the card ensured it wasn't flat. The bracken itself
had a certain stance that made it stand out from
the crowd, but it had to be clamped in place.

*Canon EOS 5D MkIII with 100mm f/2.8 macro lens, ISO 200,
0.6sec at f/10, tripod*

carterart.co.uk

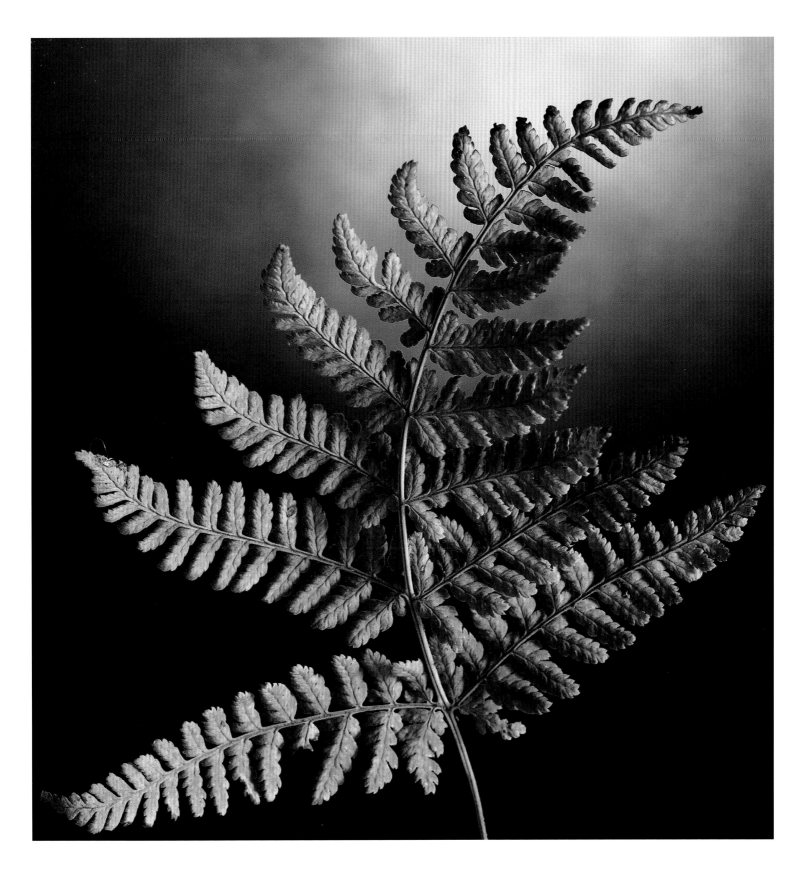

Peter Racz (Hungary)

Bükk Mountain, Hungary. On a hiking trip we spotted a tree that had been cut down and was covered in cobwebs. Up close it looked like an abandoned, sleeping metropolis. When I took this shot, I wanted to recreate the illusion, and make the small bits of wood look like huge skyscrapers.

Canon EOS 5D MkIII with 100mm f/2.8 macro lens, ISO 100, 1/400sec at f/2.8

shamanphoto.com

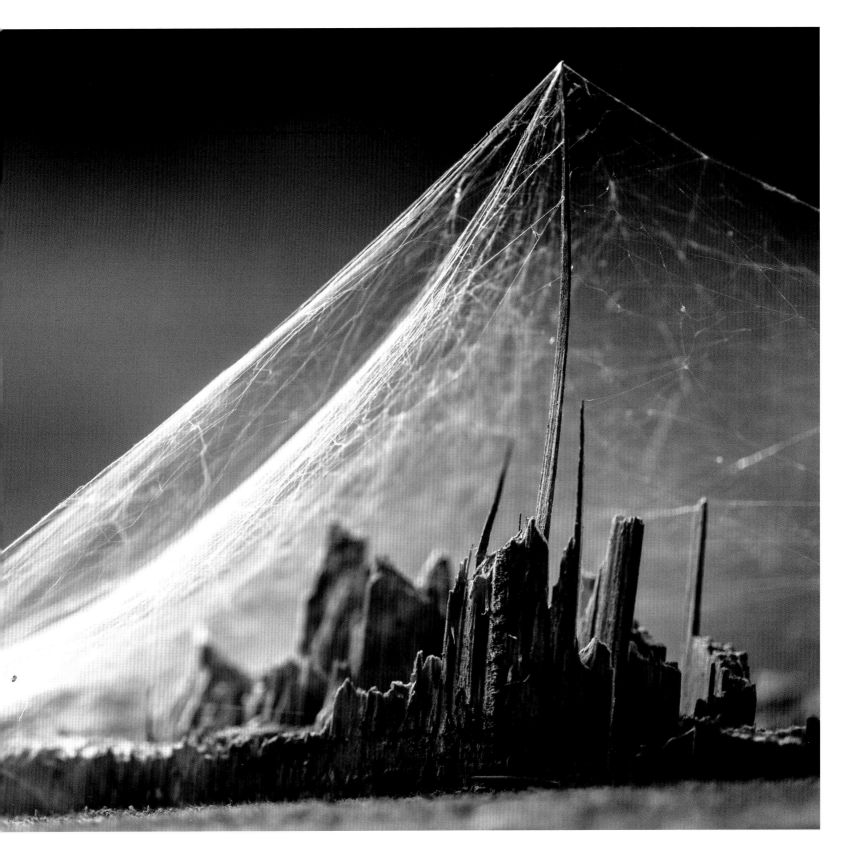

Alessandro Oggioni (Italy)

Parco Regionale di Montevecchia e della Valle del Curone, Montevecchia, Italy.
I went to Montevecchia Regional Park in the early morning to try photographing snails mating, when I found this interesting repeated texture created by this bryophyte. I needed a subject that would break the symmetry and add a little bit more to the picture, so I kept looking until I found this mushroom. I positioned the camera parallel to the ground and centred the mushroom in the frame. The soft morning light and cloudy sky reduced the contrast, enabling me to record this small pattern on the forest floor.

Nikon D7200 with 60mm f/2.8 lens, ISO 100, 1.6sec at f/14, tripod

alessandroggioniph.com

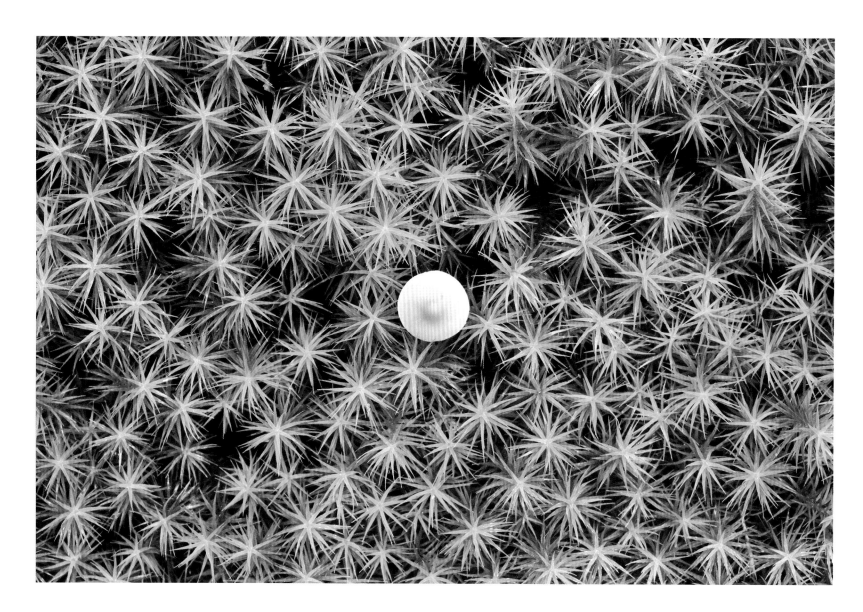

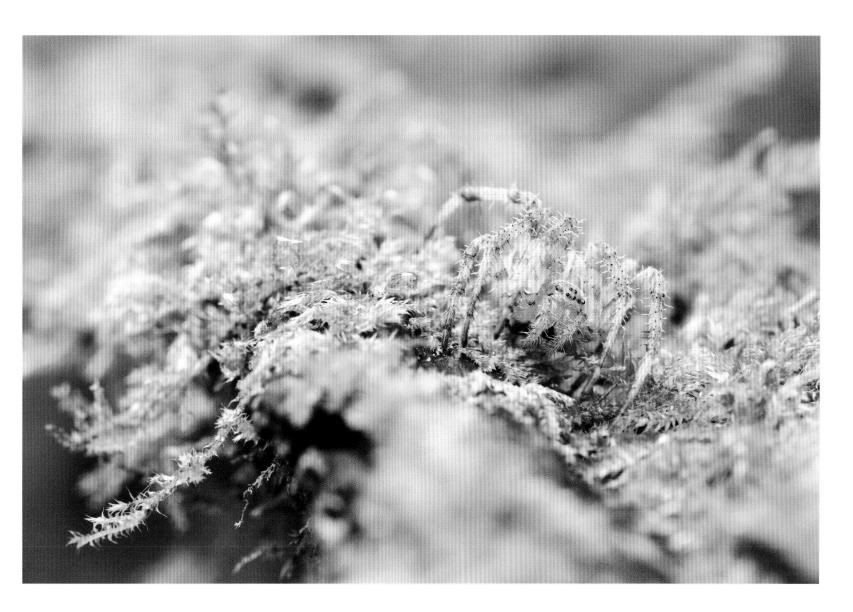

Stefano Coltelli (Italy)

San Miniato, Pisa, Italy. When the sun begins to rise on the hills of Tuscany, and all you can feel is the breeze on your skin, you will find a small world of bugs waiting for the sun. While I was taking some shots of the various insects, I noticed this spider on a moss-covered tree trunk.

Nikon D800E with 105mm f/2.8 macro lens and 2x teleconverter, ISO 800, 1/20sec at f/22, tripod

stefanocoltelli.com

Tammy Marlar (United Kingdom)

Skimmer dragonfly, Lagoa dos Salgados, Algarve, Portugal. The pools and reed beds at Lagoa dos Salgados teem with insect life. This magical moment was captured in August, and shows a dragonfly enjoying its breakfast of mosquitoes and other small flies. With its delicate wings backlit by the early morning light, it almost looks like a delicate piece of jewellery forged from gold.

Canon EOS 5D MkIII with 70-200mm f/2.8 lens and 1.4x teleconverter, ISO 500, 1/1600sec at f/5

tammymarlar.com

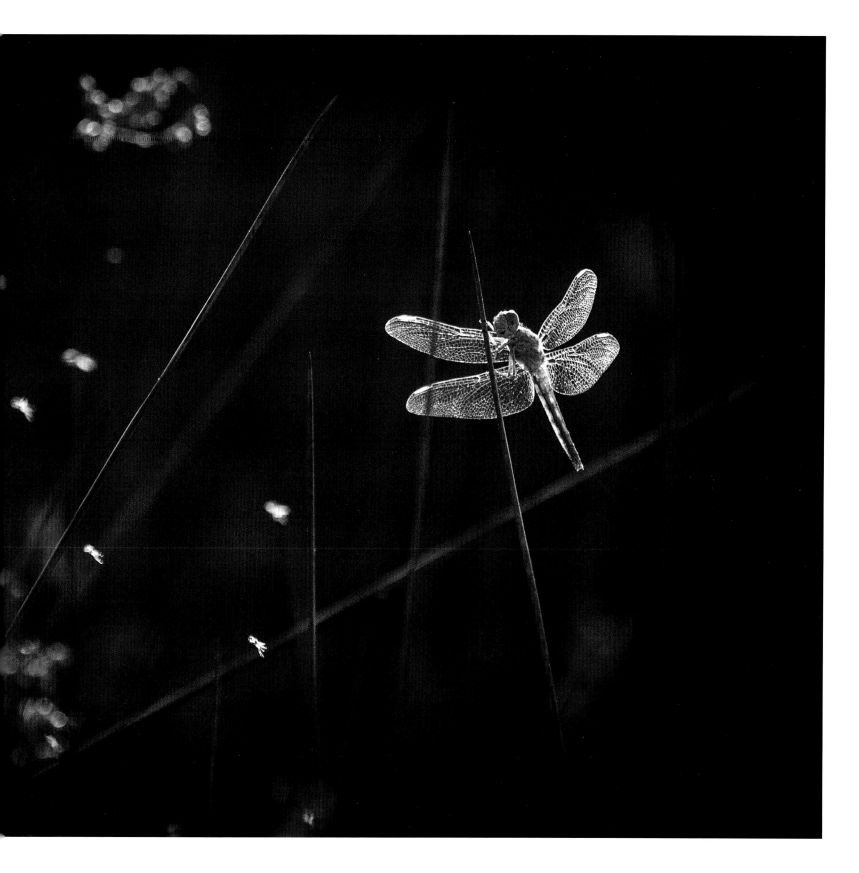

UNDER EXPOSED

A celebration of the breath-taking photographic work that is going on underwater. From seas and oceans to rivers and lakes, the judges were looking for images that showcase the remarkable world beneath the surface.

UNDER EXPOSED – WINNER

Saeed Rashid (United Kingdom)

Sohal surgeonfish, Fury Shoals, Red Sea, Egypt.
In the summer months, sohal surgeonfish tend to
mate and lay eggs on the top of the reefs in the Red
Sea. They fiercely defend their egg patch and rush
upon anything that invades that area. They will
often swipe their tail, which has a bony protrusion
sticking from it that can be as sharp as a surgeon's
scalpel, towards the intruder. Because of this you
need to make sure you don't get too close as a
photographer's hands make a very easy target
and often get cut.

*Canon EOS 7D with 10-17mm f/3.5-4.5 lens at 10mm, ISO 320,
1/100sec at f/11, Nauticam housing, two Inon Z-240 strobes*

focusvisuals.com

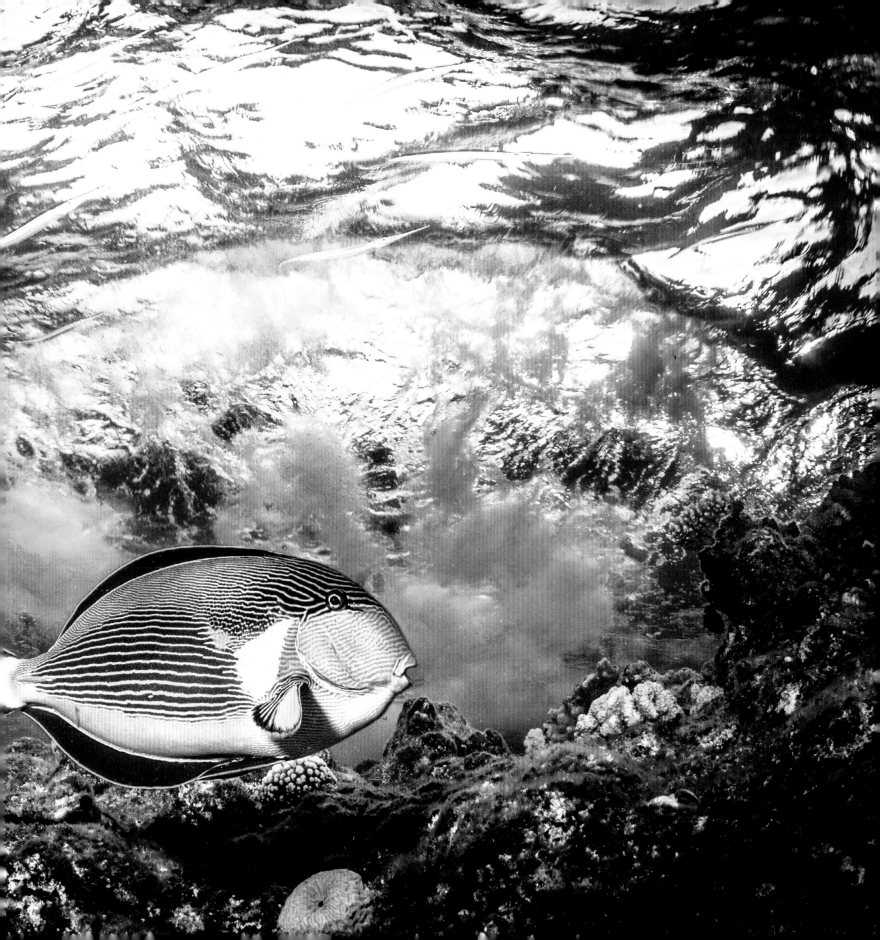

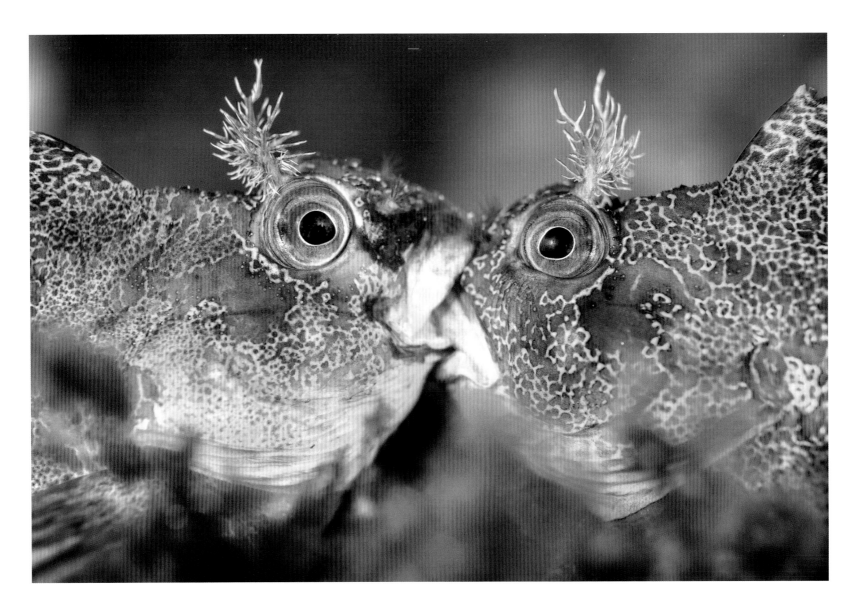

Henley Spiers (United Kingdom)

Tompot blennies, Swanage, Dorset, England. The British summer is mating season for tompot blennies and competition is fierce. I went diving in search of tompots and was delighted to encounter one with the ornate blue facial markings designed to attract a partner. To my surprise and wonder, he was soon joined by another male blenny and they started tussling in front of me. At one point the dust settled and they remained still just long enough for me to capture this image.

Nikon D7200 with 60mm f/2.8 lens, ISO 320, 1/125sec at f/4.5, Nauticam housing,
two Inon Z-240 strobes

henleyspiers.com

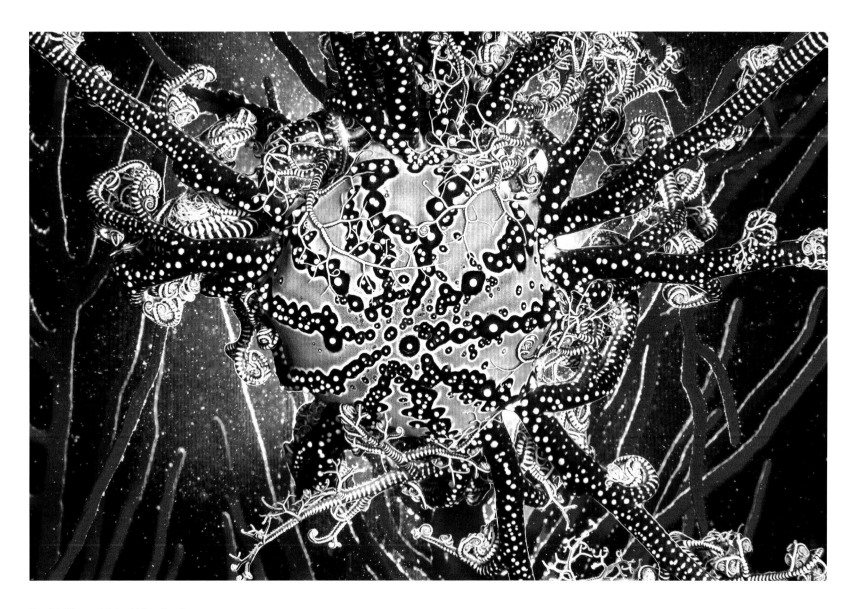

David Alpert (United Kingdom)

Basket star on a gorgonian fan, Partridge Point, False Bay, Cape Town, South Africa. We were diving in False Bay, looking specifically for basket stars. They are found deeper than one would normally dive on that reef and tend to open up at night (although this was late afternoon). As we descended through the low-visibility, green 'pea soup' we were extremely lucky to almost land right on top of this magnificent specimen. I decided to make use of the poor visibility to enhance the photograph, using off-camera lighting to create a starry night effect behind the starfish.

Canon EOS 5D MkIII with 100mm macro lens, ISO 800, 1/160sec at f/22, three Inon Z-240 strobes (on and off camera)

yourshot.nationalgeographic.com/profile/1304576

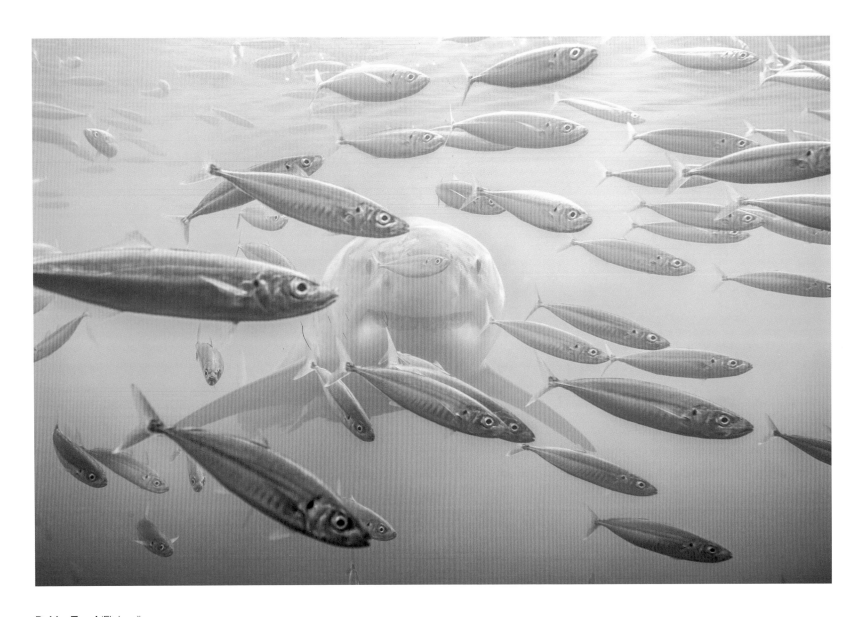

Pekka Tuuri (Finland)

Great white shark, Isla Guadalupe, Mexico. Isla Guadalupe is the world capital when it comes to observing great white sharks, but cage diving seriously limits the possibilities to take 'fresh' pictures. When I took this, the water close to the surface was quite milky, making photography very challenging. From out of the 'mist', I saw this great white shark lurking behind a school of fusiliers. I quickly focused on the shark and set a wide aperture to get focus blur on the fish, along with a fast shutter to avoid excessive motion blur. No flash was used and that was key to getting this picture.

Canon EOS 5D MkIII with 17-40mm f/4 lens at 40mm, ISO 500, 1/200sec at f/6.3, Subal housing

facebook.com/Vedenalainen-Suomi-240978516022608

Saeed Rashid (United Kingdom)

Flower cardinalfish, Tulamben, Bali, Indonesia.
Flower cardinalfish often school in small numbers
above shallow reefs in the Indo-Pacific seas.
Many fish yawn and this behaviour is sometimes
attributed to attracting a mate; or it is maybe used
to flush more water over their gills to clean them;
or they simply yawn to stretch their jaw muscles.
It was about 30 minutes before I saw an individual
yawn and luckily I managed to capture the moment.

*Canon EOS 7D with 60mm f/2.8 macro lens, ISO 800,
1/160sec at f/8, Nauticam housing, two Inon Z-240 strobes*

focusvisuals.com

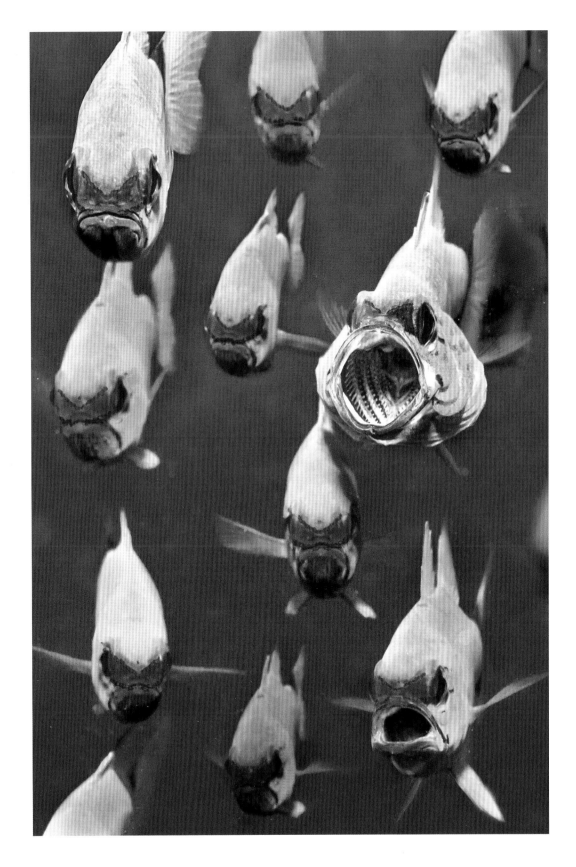

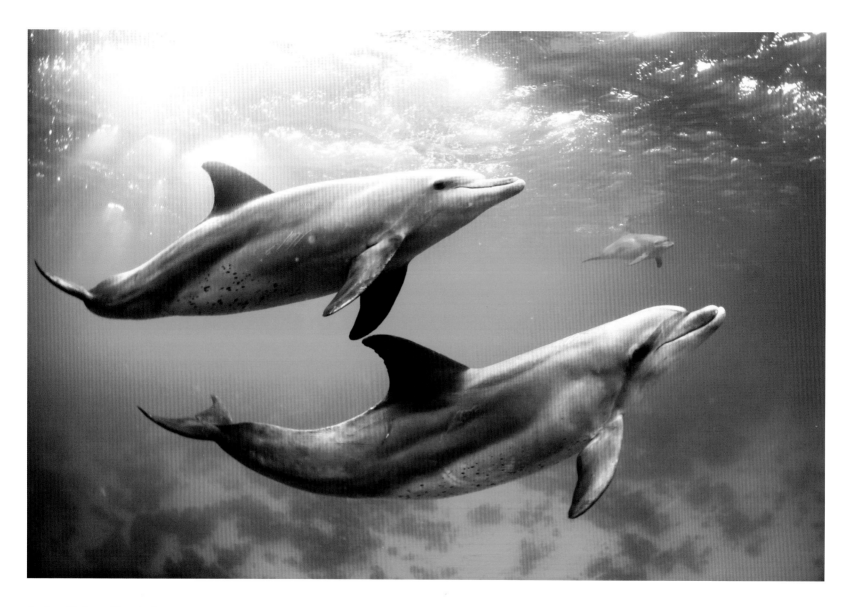

Anders Nyberg (Sweden)

Indo-Pacific bottlenose dolphin, Hurghada, Red Sea, Egypt. After the last dive of the day I came back to the boat to find everyone yelling 'dolphins'! I grabbed my camera and jumped back into the water, snorkelling and playing with these fantastic creatures. With this kind of image I find it is best not to use strobes, as it means I can move easily in the water. I think I played around with the dolphins for at least 30 minutes.

Nikon D800 with 10-17mm f/3.5-4.5 lens at 14mm, ISO 1000, 1/400sec at f/4.2

worldoceanphotography.com

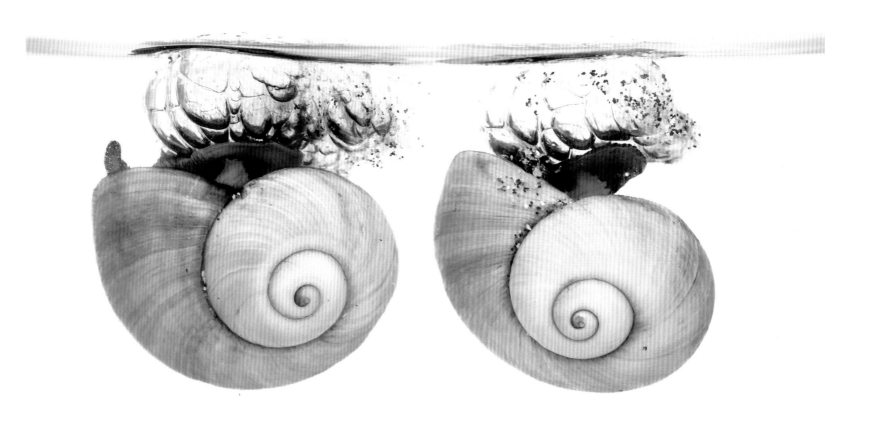

Andy Tibbetts (United Kingdom)

Violet sea snails, Isle of Eigg, Scotland. These amazing creatures spend their lives suspended under the sea's surface from a raft of bubbles. They occur mainly in the tropics, but can travel large distances on ocean currents. These individuals had possibly come several thousand miles to the somewhat cooler waters of the Hebrides, only to be washed up in Laig Bay on the Isle of Eigg, where they were found by one of the islanders. I put them in a pint glass of seawater and photographed them up against the white walls of the local teashop, before returning them to the sea.

Canon EOS 5D MkII with 100mm f/2.8 lens, ISO 800, 1/125sec at f/11

andydounephotography.co.uk

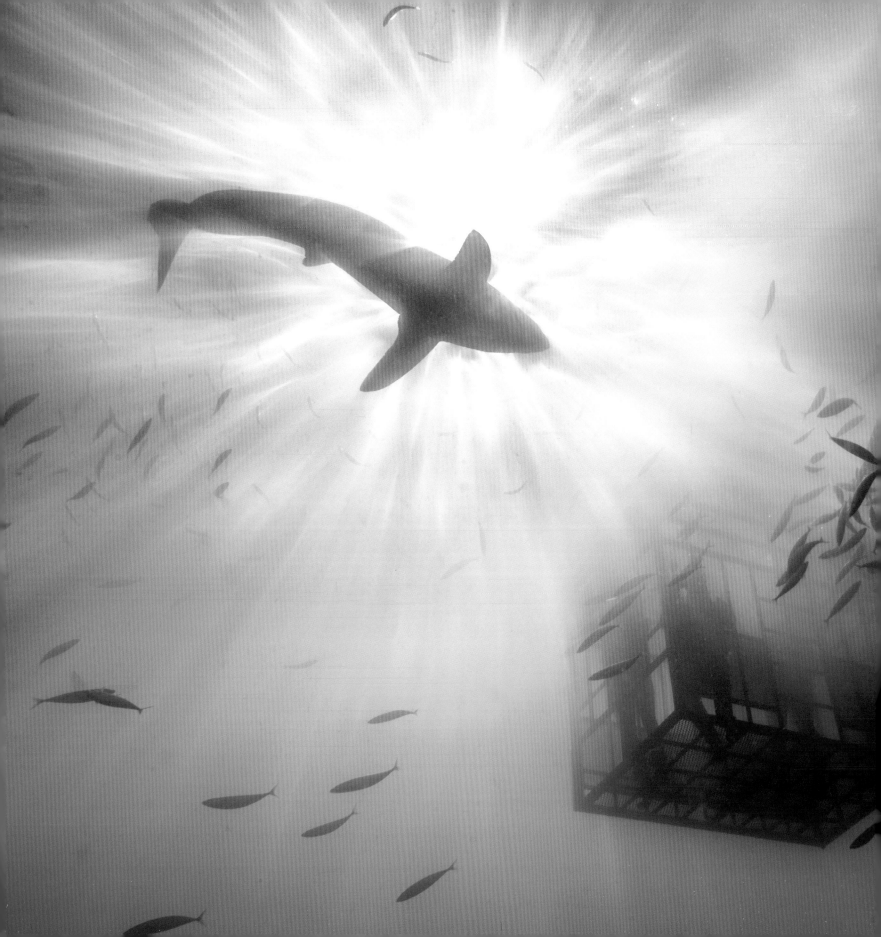

Pekka Tuuri (Finland)

Great white shark, Isla Guadalupe, Mexico. I took this from a cage that was lowered down to 7m, which meant I was able to shoot the great white sharks against the sun. Time underwater was limited, but I was lucky that one shark happened to swim right across the sun. The picture is a combination of two exposures, blended in Photoshop to allow both the sun and the cages to be clearly visible in a single picture.

Canon EOS 5D MkIII with 17-40mm f/4 lens at 26mm, ISO 100, 1/200sec and 1/640sec at f/13, Subal housing

facebook.com/Vedenalainen-Suomi-240978516022608

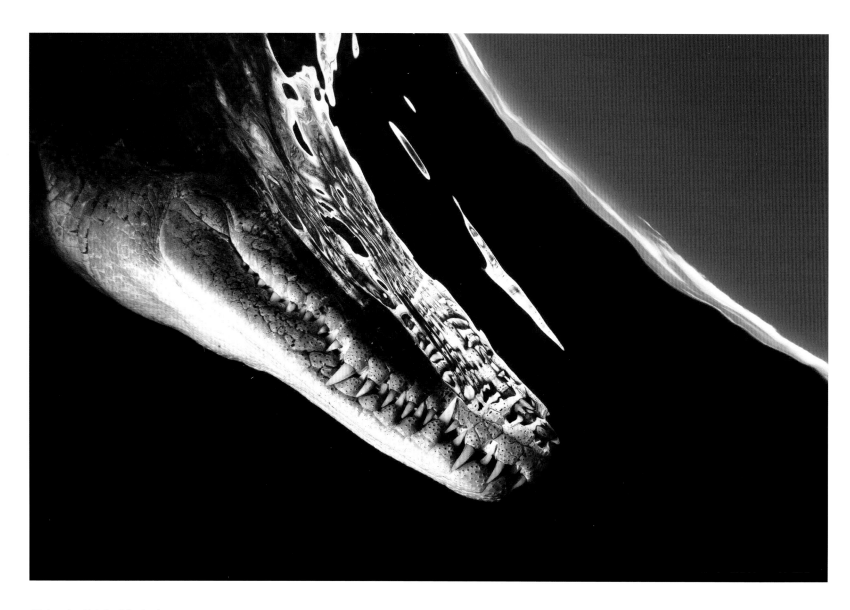

Alejandro Prieto (Mexico)

American crocodile, Jardines de la Reina, Cuba. Jardines de la Reina is a place where you can find American crocodiles in their natural environment. My first obstacle was to fight against my own fear, as these animals have a really bad reputation, but once I got in the water I started to feel comfortable around them. I have seen a lot of crocodile photographs in the past, but wanted to create a different kind of image, so I experimented with a number of different compositions. In the end I spent quite a lot of time with these animals and can say that they are not as bad as I first thought they would be; I respect them even more now.

Canon EOS 5D MkII with 15mm f/2.8 lens, ISO 200, 1/160sec at f/20, Subal housing, two Sea & Sea strobes

alejandroprietophotography.com

Pier A Mane (Italy/South Africa)

Ponta do Ouro, Mozambique. Capturing an image of a small school of bigeye or glasseye snapper was harder than I thought. If you get too close they break away, but if you shoot from a distance the details are lost and the composition suffers. They are also highly reflective, making it difficult to control the highlights from a strobe exposure. After many attempts I got this shot, which captures the red, silver and gold varieties.

Olympus OM-D E-M1 with 8mm f/3.5 lens, ISO 400, 1/320sec at f/16, two Subtronic Alpha strobes

piermane.com

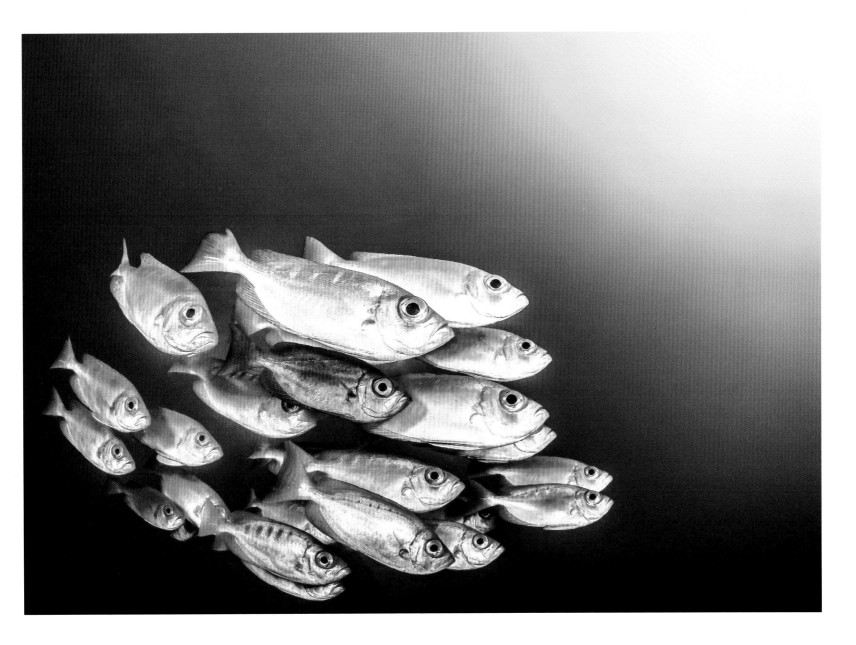

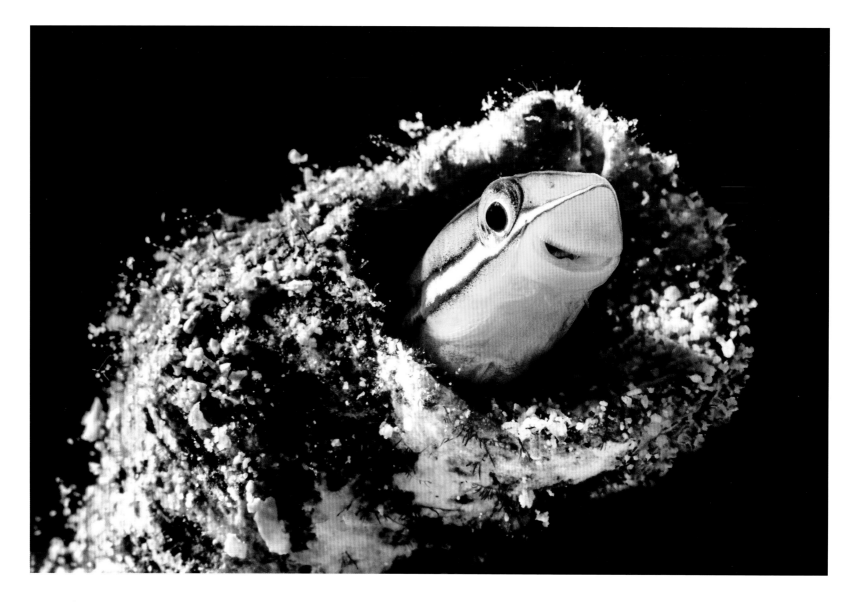

Dougie Souness (United Kingdom)

Blenny, south-east Sulawasi, Indonesia. I had done more than 20 dives during a trip to Indonesia, and this image was captured during the safety stop at the end of my final dive. This tiny blenny kept swimming in and out of a piece of coral, but it took a few attempts to get a shot with a pleasing composition, as there was quite a bit of surge – it is as if he is looking at me and laughing.

Nikon D810 with 105mm f/2.8 lens, ISO 200, 1/320sec at f/22, Nauticam housing, two Inon strobes

nohalfmeasuresphotography.com

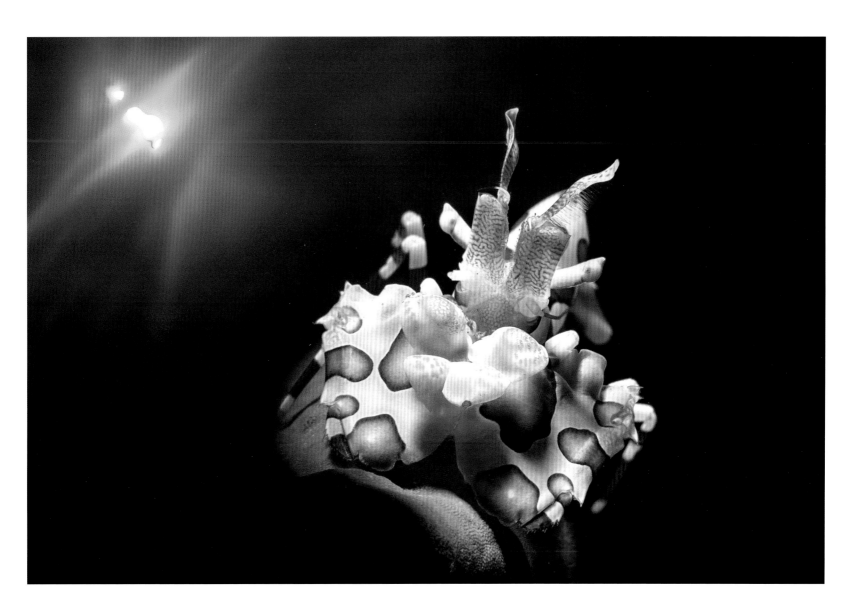

Massimo Giorgetta (Italy)

Harlequin shrimp, Lembeh Strait, Sulawesi, Indonesia. This image was captured at a depth of about 12m during a diving trip in the Lembeh Strait in Indonesia. The photograph is a double exposure: one exposure was made shooting upwards, in the direction of the surface to record the backlight, and a second exposure was made for the subject.

Nikon D800E with 105mm f/2.8 lens, Seacam housing, Subtronic 160 Pro strobe with Retra UWT Light Shaping Device
Backlight exposure: ISO 100, 1/3200sec at f/25, no flash
Subject exposure: ISO 100, 1/160sec at f/29, with flash

maxgiorgetta.it

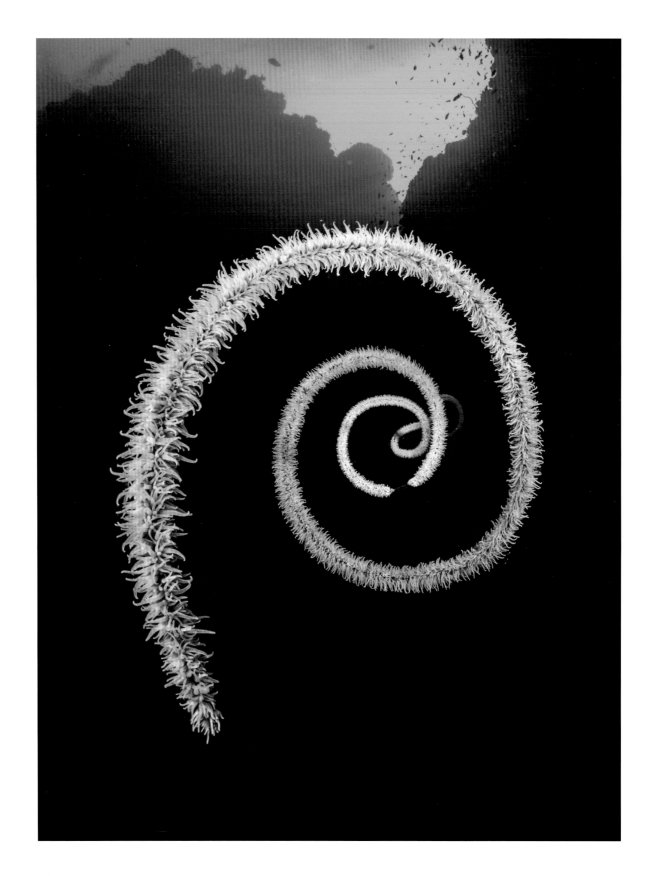

Pier A Mane (Italy/South Africa)

Left: **Port Sudan, Sudan**. I found this single stem coral branch sitting all by itself – it had grown so long that it appeared as a beautiful spiral when seen directly from the front. I positioned my strobes facing inward and used a fast shutter speed to isolate it against a black background.

Olympus OM-D E-M1 with 8mm f/3.5 lens, ISO 200, 1/320sec at f/13, two Subtronic Alpha strobes

piermane.com

Nicolas Cimiterra (France)

Giant oarfish, Mediterranean Sea. I planned a dive with a group of friends in April, just after the phytoplankton bloom, as this is the best time to observe this extraordinary fish. During the day the water was very clear, but it gradually became loaded with macroplankton such as jellyfish and ctenophores. The first sighting of the oarfish occurred at dusk (it was probably following the vertical migration of plankton), but this image was taken at night. This individual was observed several times for a few seconds or tens of seconds at a time, before moving away or disappearing into the depths and then reappearing a few metres further away. I was able to take several shots of this beautiful and exceptional fish, but he disappeared again into the darkness all too soon. It was an amazing human and naturalist experience.

Canon Powershot G15, ISO 100, 1/250sec at f/1.8, Inon D-2000 strobe

flickr.com/photos/130857402@N08

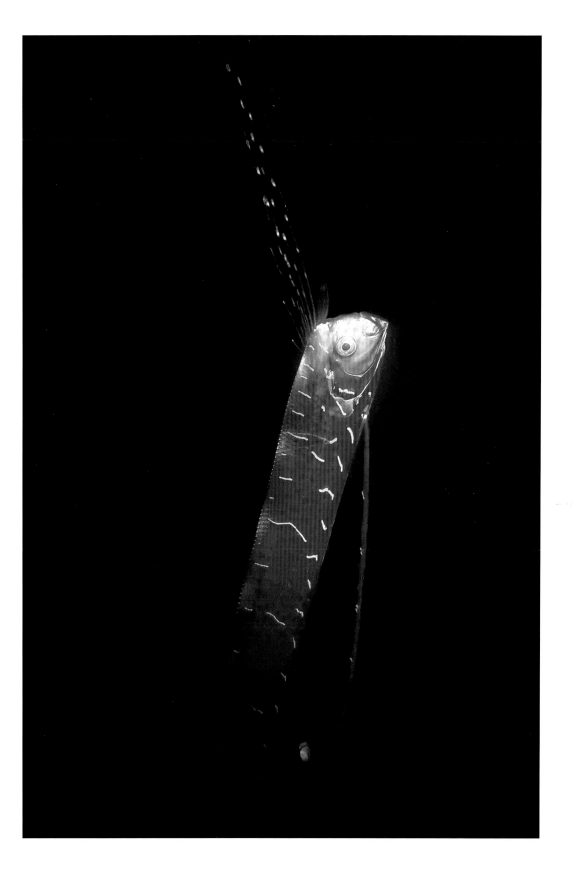

Ibrahim Roushdi (United Kingdom)

Whale shark, Isla Mujeres, Mexico. Every year, whale sharks congregate off the coast of Isla Mujeres in Mexico to feed on bonito spawn. On a remarkably calm day the sun's rays were forming beautiful spotlights and it was a case of waiting for a whale shark to come up towards the surface ready to 'bottle' and then getting into a position so it was framed by the light.

Nikon D800 with 15mm f/2.8 lens, ISO 1600, 1/250sec at f/8, Nauticam housing

SPIRIT OF TRAVEL

Cultures, people, places and festivals of the world; Spirit of Travel presents some of the most compelling and freshest images that capture the spirit of journeys around the planet.

Andy Holliman (United Kingdom)

Kangerlussuaq airport, Greenland. Kangerlussuaq airport is the largest airport in Greenland, so it is not only a busy hub for domestic flights, but also the main arrival point for international travellers. Air Greenland has a near monopoly on flights, so almost everything is in the company's bright red colours. It was the simple colour palette of this scene that appealed to me, including the signposts that are apparently directing the planes to their destinations. My departure had been delayed by three days due to bad weather on the coast, so seeing the arrival of the plane that would return me to Copenhagen was welcome. It may not look that way, but the end of winter was near and within weeks the snow would have cleared

Nikon D700 with 28-300mm f/3.5-5.6 lens at 34mm, ISO 200, 1/320sec at f/11

allthisuselessbeauty.co.uk

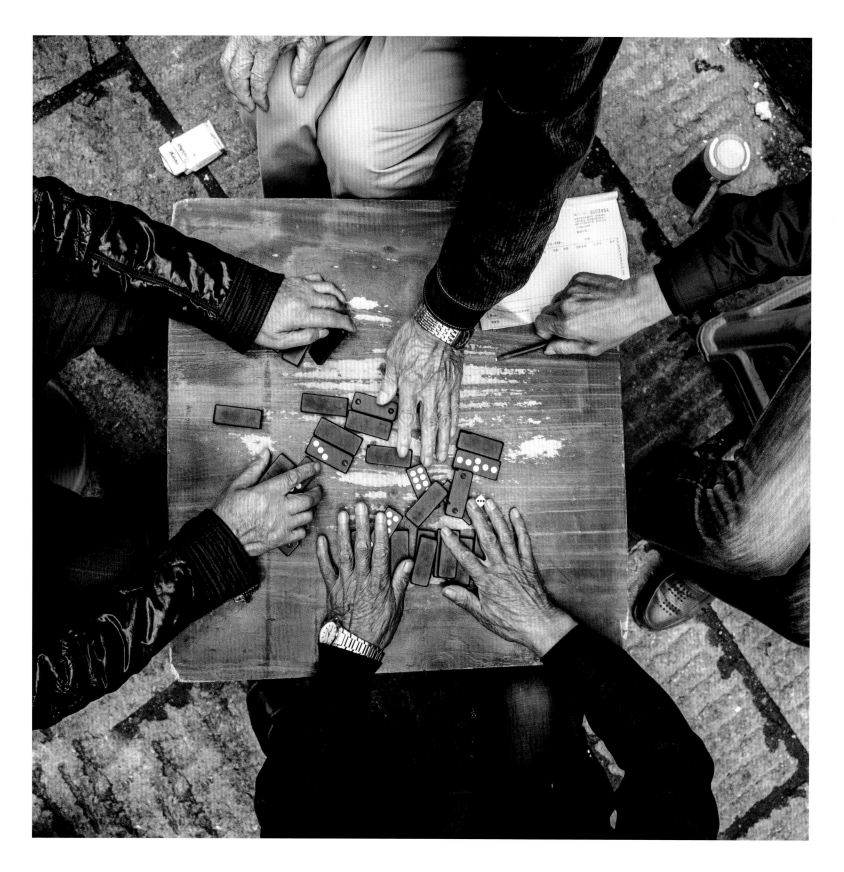

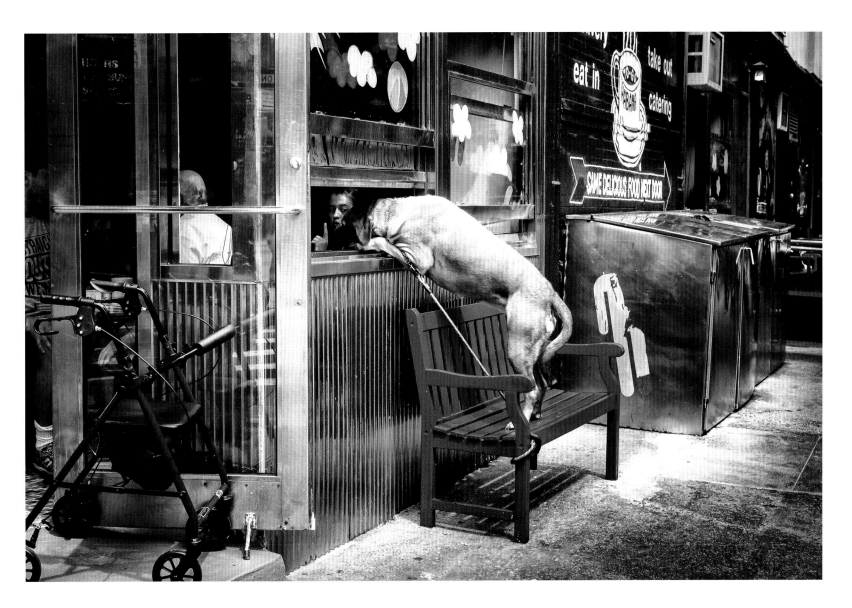

Chaitanya Deshpande (United Kingdom)

Left: **Changsha, Hunan Province, China.** I took this image in one of the small, quiet lanes beside a busy street food market in Changsha, China. I knew that if I waited long enough I would find a group of elderly men playing Chinese dominoes (*Tien Gow*). I was interested in watching the game itself, so as time went by the men became familiar with me being around and allowed me to take this wideangle image from above – it wasn't easy given the angle, but luckily I had more than one chance to get my image.

Canon EOS 5DS with 16-35mm f/4 lens at 21mm, ISO 400, 1/200sec at f/4, handheld

flickr.com/photos/chaitanyadphotography

John White (United Kingdom)

Café Habana, corner of Elizabeth and Prince in Lower Manhattan, United States of America. With one day spare on a three-week work trip to New York I decided to hit the streets. I covered bridges, buildings, trains, cars, sports and more, but the one thing that struck me was how amazing, diverse and fascinating the people are. On my way back from the Williamsburg Bridge, I popped on my 50mm lens and went looking for lunch. The dog in this photo was desperate for some scraps, and just as I fired the shutter his owner turned into the light to tell him what a naughty boy he was. Just a magic moment to capture.

Nikon D750 with 50mm lens, ISO 100, 1/60sec at f/8, handheld

john.media

Andrew Robertson (United Kingdom)

Manikarnika Ghat, Varanasi, Uttar Pradesh, India. This image was taken from a boat on the river Ganges, looking towards the Manikarnika Ghat in the holy city of Varanasi. The light was low and a tripod wasn't an option, so I had to open up the aperture and increase the ISO to capture a clean shot. My aim was to produce an image that captured the energy and mystical aura of Varanasi. The flames you can see are funeral pyres, and in post-processing I made the image punchier and brought out the warm glow of the fires against the soft haze that envelops the city.

Canon EOS 5D MkIV with 85mm f/1.2 lens, ISO 800, 1/60sec at f/2.5, handheld

andrewrobertsonphoto.com

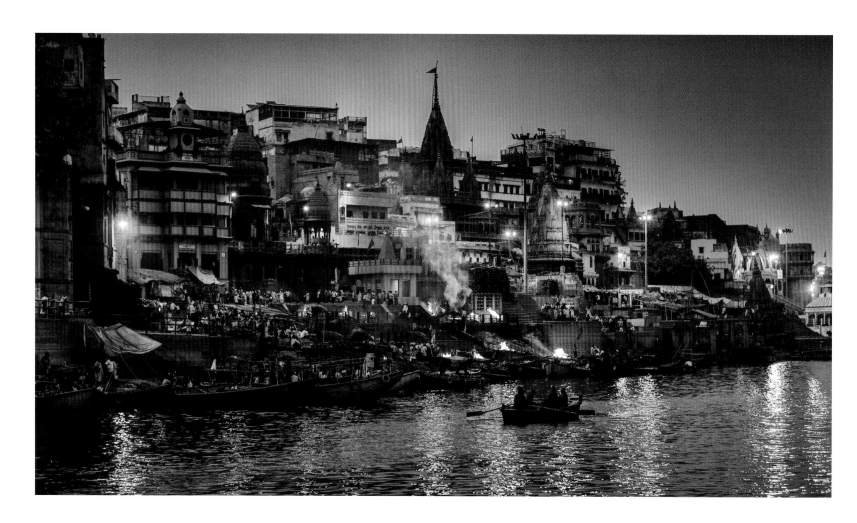

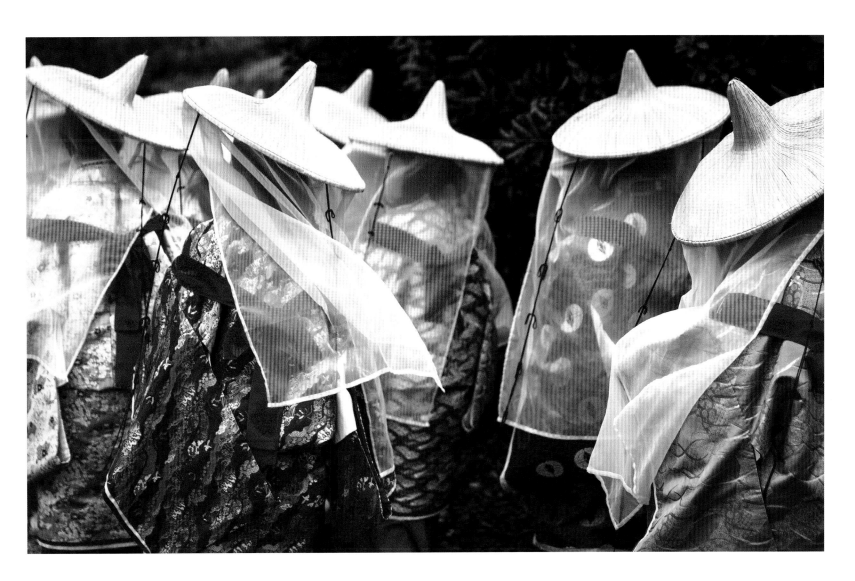

Hidetoshi Ogata (Japan)

Kumano Kodo, Nakahechi, Tanabe-City, Wakayama Prefecture, Japan.
The Kumano Kodo is a series of ancient pilgrimage routes in Japan that have been officially recognised as a World Heritage site. The routes date back to the Heian period, when the Imperial household went on a pilgrimage to Kumano 'in search of heaven on earth', resulting in the creation of three grand shrines and a temple. The pilgrimage subsequently became popular with everyone from noblemen to commoners and samurai warriors. Today, the Kumano Kodo Picture Scroll Procession is held in Wakayama, Japan, on November 3 every year. Here, you can witness participants wearing Heian period costume – including women wearing traditional kimonos – walking a narrow mountain trail as they re-enact the first Imperial pilgrimage.

Canon EOS 5D MkIII with 24-70mm f/2.8 lens at 70mm, ISO 100, 1/1250sec at f/2.8, handheld

facebook.com/hidetoshiogataphotography

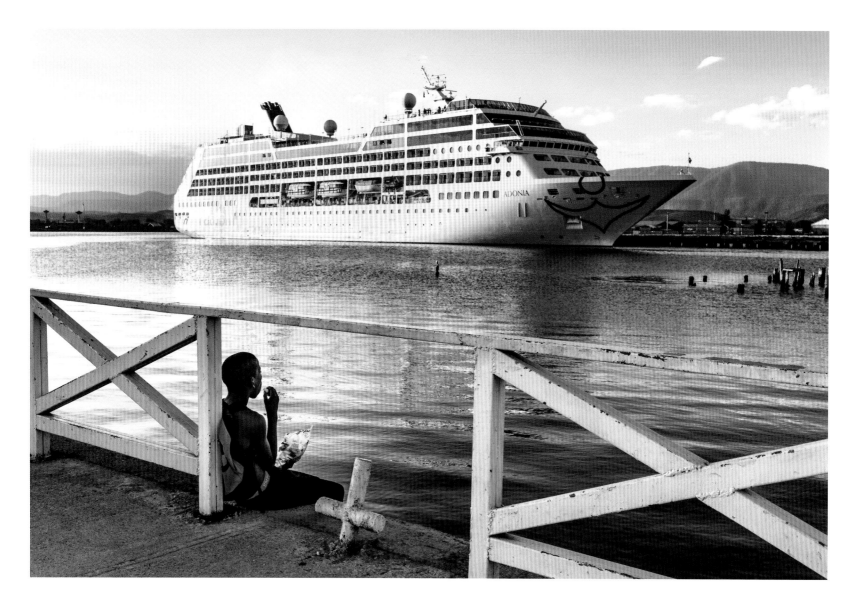

Dougie Souness (United Kingdom)

Santiago de Cuba, Cuba. A Cuban boy watches as an American cruise ship departs the port of Santiago de Cuba. This was taken one evening while walking near the port. Given the off-on-off political situation between Cuba and the United States of America, I wonder what was going through the boy's mind as he enjoyed his snack?

Nikon D810 with 24-70mm f/2.8 lens at 38mm, ISO 100, 1/160sec at f/8, handheld

nohalfmeasuresphotography.com

Tim Mannakee (France)

Havana, Cuba. While walking around old Havana after some heavy rain, I came across this old facade, which is typical of the fading, colonial architecture that can still be found in the old town. I waited in front of the building, hoping for something to happen, and after a few minutes this man arrived. He started singing in the hope that this would attract the young resident to the window. His serenading worked, and a girl soon appeared, although she didn't look overly impressed by his efforts.

Canon EOS 5D MkIV with 24-70mm f/4 lens at 30mm, ISO 1000, 1/250sec at f/5, handheld

timmannakee.com

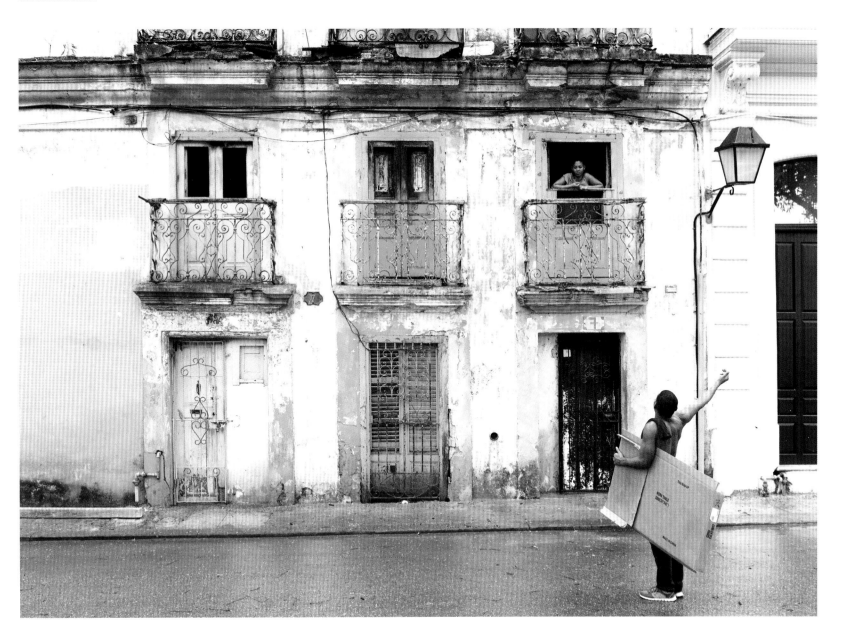

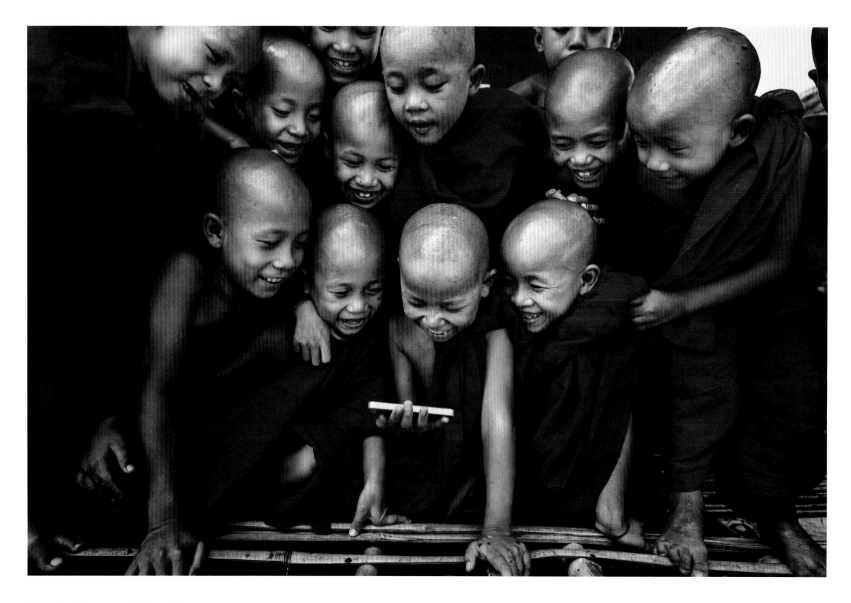

Gunarto Gunawan (Indonesia)

Shwe Gu monastery, Bagan, Myanmar. I took this photograph when I visited Shwe Gu monastery, which cares for orphans and trains them to be Buddhist monks. The orphans were gathering and playing, and I showed them a funny video on my iPhone – I did not expect them to be so excited! In the end, they were all scrambling to watch the video. Seeing them laugh, I immediately took my camera and photographed this magical moment.

Canon EOS 5D MkIII with 16-35mm f/2.8 lens at 25mm, ISO 320, 1/80sec at f/7

facebook.com/gunarto.song.3

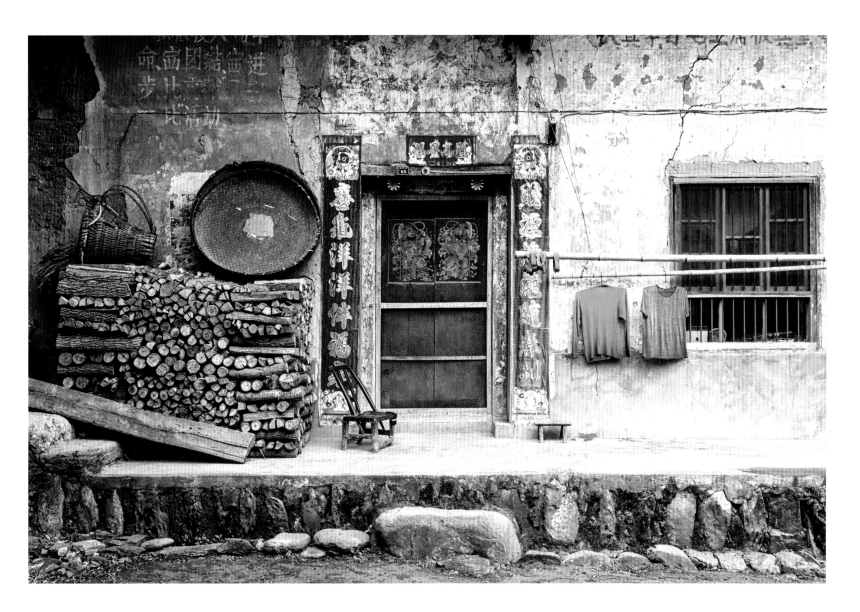

Yi Sun (United Kingdom)

Shaanxi, China. Shaanxi province, in the west of China, is traditionally associated with drought and poverty. However, some small agricultural villages within the Qinling mountains are rich and vibrant. My father and grandfather were raised in mountain mud houses very similar to the ones in this image. The front door decoration gives a sense of the happiness and satisfaction the owners feel for what a hard working life has given them.

Canon EOS 7D with 24-70mm f/2.8 lens at 24mm, ISO 640, 1/50sec at f/7.1

yisunphotography.com

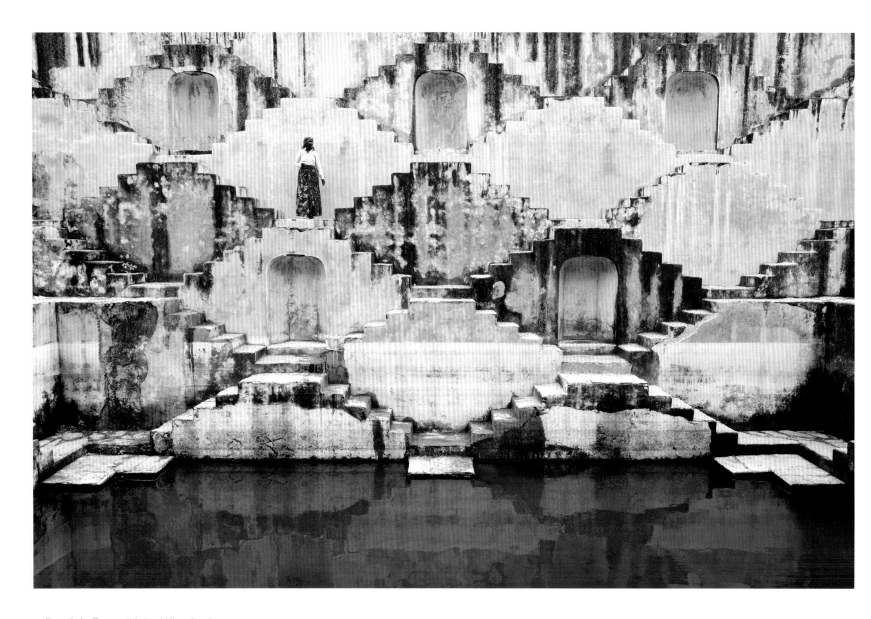

Dominic Byrne (United Kingdom)

Amber stepwell near Jaipur, Rajasthan, India. I had visited this stepwell about
five years previously and made some really nice architectural studies, but I knew
that in order to elevate the image it would need a human element. Upon my
return I was lucky enough to see a woman cleaning some of the steps. I waited
for quite a while and eventually she walked down towards the water, allowing
me to capture this moment. For me, it was definitely worth the wait.

Leica Q with 28mm f/1.7 lens, ISO 100, 1/60sec at f/10, handheld

dominicbyrne.com

Mark Boyd (United Kingdom)

Mandalay, Myanmar. I've never been one for guided tours, and visiting Myanmar would be no different. I woke early, ate on the street and began exploring. It wasn't long before I wandered into the 'real' Mandalay, where the only thing in abundance was poverty and the daily struggle for life. I walked. I sat. I watched. One thing I have noticed in emerging countries is that amid the poverty and daily struggle, smartphones provide entertainment, communication and even childcare. I noticed the smiling woman in the poster at the foot of the platform and it made me wonder if the dad was bringing up his son alone? Had he lost his wife? I walked on...and I continued to wonder.

Olympus OM-D E-M5 MkII with 60mm f/2.8 lens, ISO 250, 1/80sec at f/5, handheld

mbimagery.co.uk

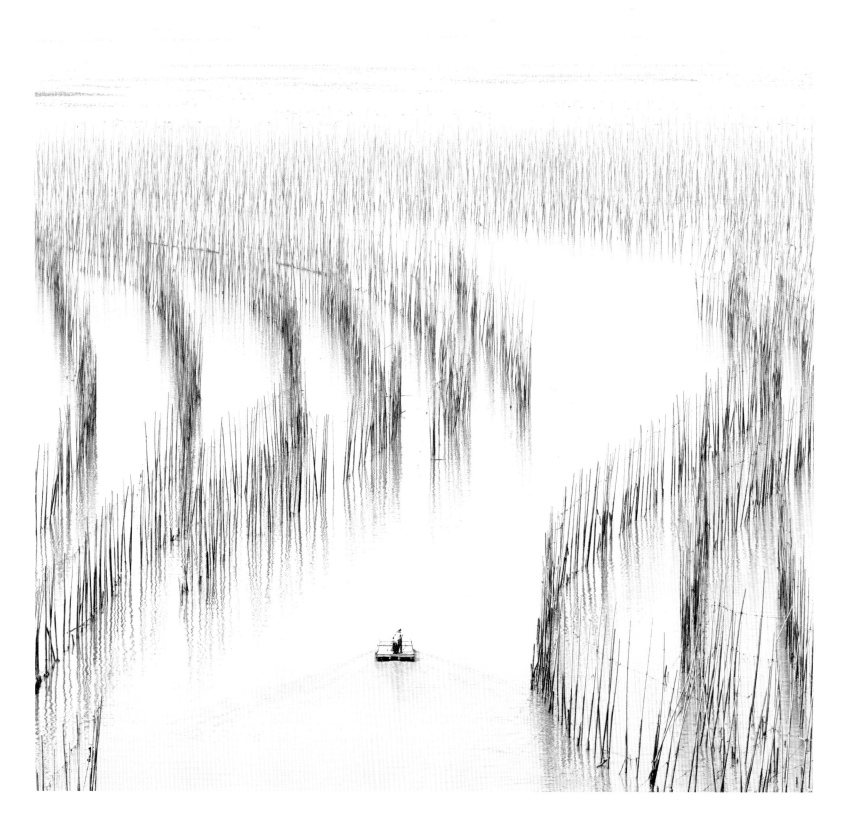

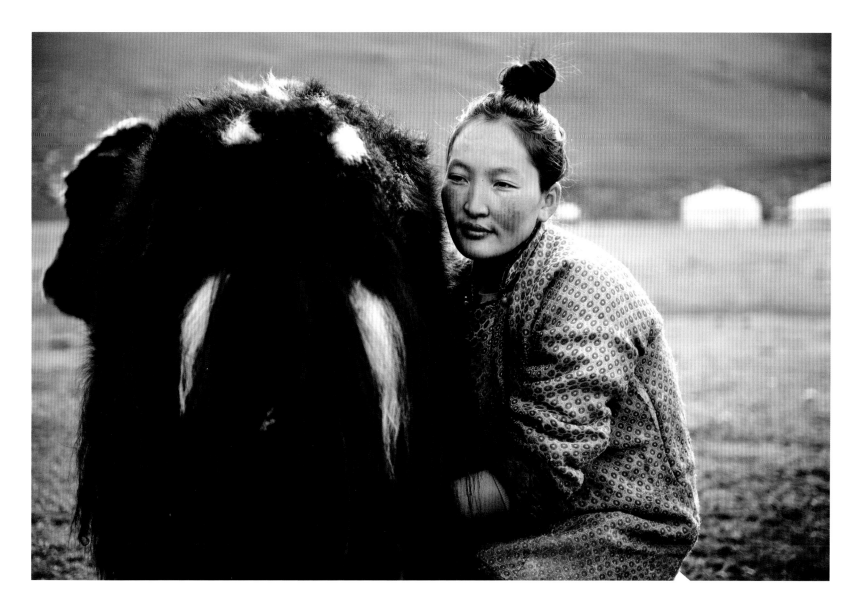

Stephen King (Hong Kong)

Left: **Xiapu, Fujian province, China.** This image was recorded early one grey and rainy morning, as local fishermen made their daily journey through a path in the seaweed nets to the ocean. I climbed to the rooftop of a half-completed building in order to get a high enough vantage point to get the right angle for the shot. I opted for a square crop in order to eliminate the distraction of the sky and to focus on the geometry of the scene.

Canon EOS 5DS R with 100-400mm f/4.5-5.6 lens at 135mm, ISO 100, 1/250sec at f/14, polariser

stephenking.photo

Jon Chater (United Kingdom)

Orkhon Valley, Mongolia. Odonchimeg Galbaatar, 20, milks a yak from the family herd early in the morning. She is wearing a *deel*, a traditional Mongolian garment made by her mother. The highlight of my trip to Mongolia was experiencing the life of nomadic herder families such as this one. I only stayed with this family for two days, but their warmth and kindness made it feel much longer. They drew us into their family unit and showed us their culture, customs and routines of daily life. You feel so much like a part of the family that it's actually quite painful when you leave.

Nikon D610 with 24-70mm f/2.8 lens at 62mm, ISO 250, 1/500sec at f/2.8, handheld

jonchater.com

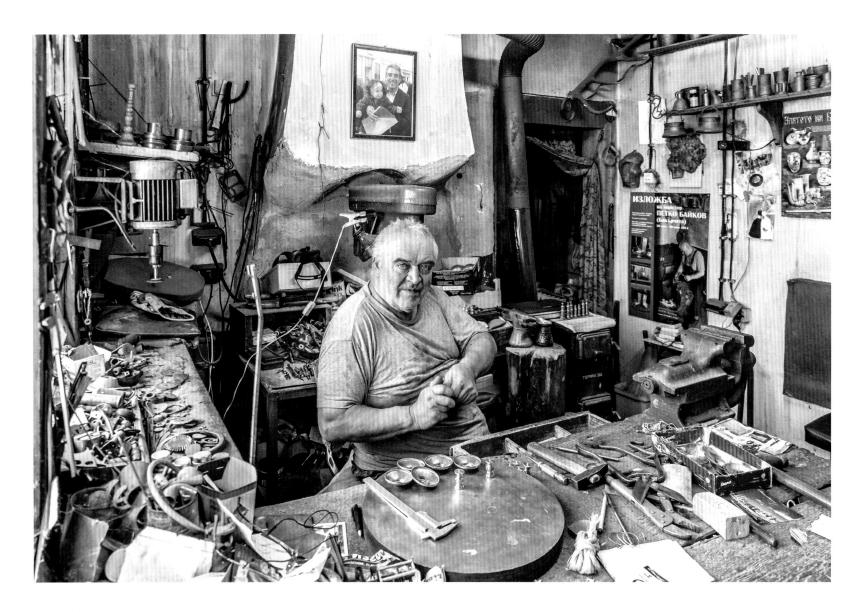

Todor Tilev (Ireland)

Kazanlak, Bulgaria. I was on my way to a church when I noticed this messy looking room. I went inside and asked this man if I could take a picture of him in his working environment. He gave me permission and I took a few pictures. A few months later a friend of mine saw the picture and thought that my subject might also be the person on the poster at the right of the frame. I checked online and discovered that his name is Petar Baikov, whose handmade copper masterpieces have been exhibited in more than 100 countries around the world.

Fuji X-T10 with 16-50mm f/3.5-5.6 lens at 16mm, ISO 800, 1/55sec at f/3.5, handheld

yourshot.nationalgeographic.com/profile/1435770

Gunarto Gunawan (Indonesia)

Bagan, Myanmar. More than 10,000 Buddhist temples were built on the Bagan plains, and more than 2,200 of these still remain today. With this photograph I wanted to revive the atmosphere of one of the ancient temples: the difficulties were the very hot atmosphere and rather dark lighting.

*Canon EOS 5D MkIII with 17mm f/4 lens, ISO 400,
1/2sec at f/5, tripod*

facebook.com/gunarto.song.3

VIEW FROM ABOVE

Whether shot from a drone, helicopter or aeroplane, this category – new for 2017 – was looking for the most inspiring images of our planet's landscapes taken from the skies.

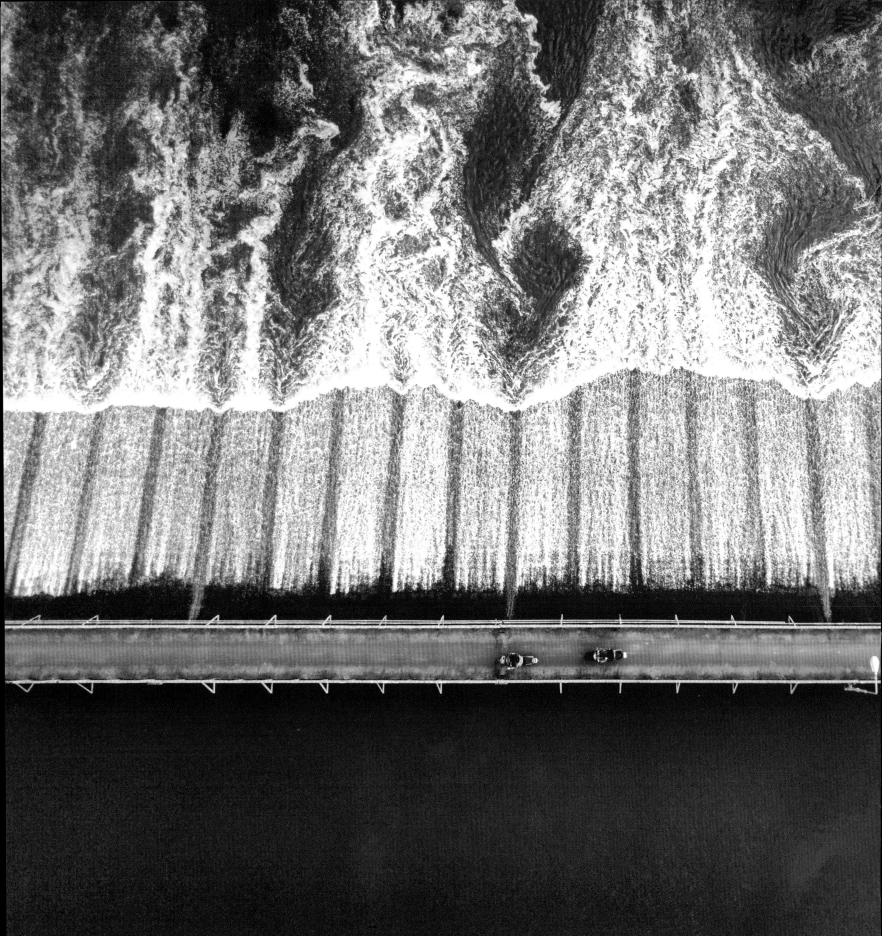

VIEW FROM ABOVE – WINNER

Tom Sweetman (United Kingdom)

Chiang Mai, Thailand. It was just before sunset in Chiang Mai and I decided to ride my scooter alongside the famous Ping River. As I was approaching a bridge I stopped to take a break and noticed that it was a motorbike bridge for locals, connecting two villages. I took this aerial photograph with my drone to document the incredible patterns in the river and the locals crossing the bridge on their scooters. Some days you just capture the moment.

DJI Mavic Pro with 28mm equivalent lens, ISO 100, 1/320sec at f/2.2

tominspires.com

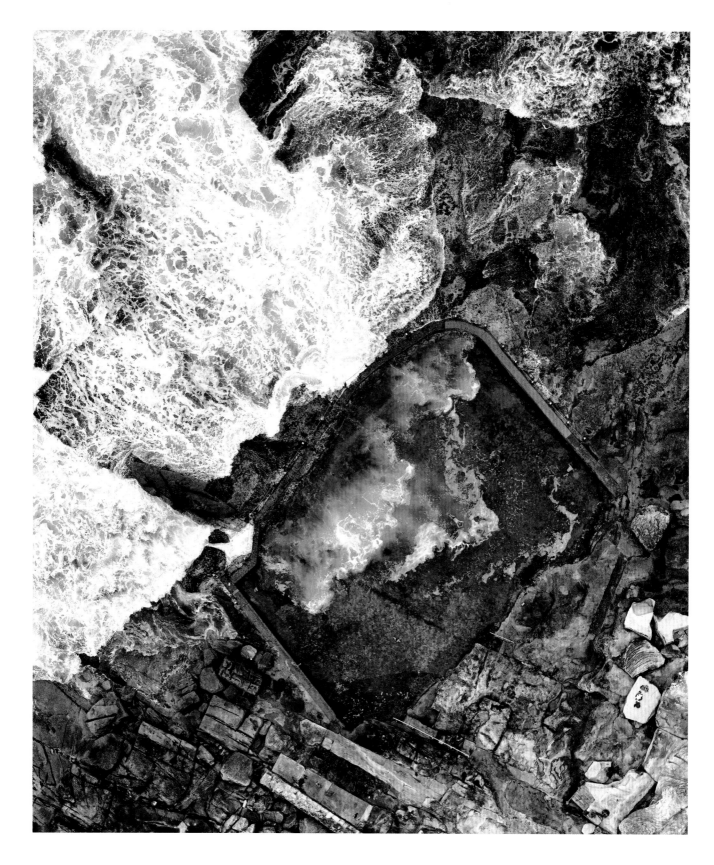

Stuart Chape (Samoa)

Left: **Sydney, Australia.** This image was taken from a helicopter early in the morning while photographing Sydney Harbour. The Sydney coastline has a number of swimming pools that have been carved into the sandstone cliffs, where swimmers can have both the pool experience and be exposed to the wash of ocean waves.

Sony a7R with 24-70mm lens at 70mm, ISO 400, 1/1250sec at f/6.3, handheld

bluethumb.com.au/photography/artists/stuart-chape

Stephen King (Hong Kong)

Right: **Iceland.** This image was shot from a helicopter while hovering over glacial meltwater flowing across the lava sands between Mýrdalsjökull and Vatnajökull in southern Iceland. It was shot on my third trip back to these river deltas and I was immediately drawn to the pendant shape of this large rock surrounded by the patterns formed by the meltwater; the smaller rocks looked almost like baby tadpoles following their larger leader. I had the helicopter circle a few times in order to ensure that I got the composition that I wanted, using a polarising filter to cut the glare off the water.

Sony a7R II with 24-70mm f/2.8 lens at 70mm, ISO 640, 1/800sec at f/3.2, polariser, handheld

stephenking.photo

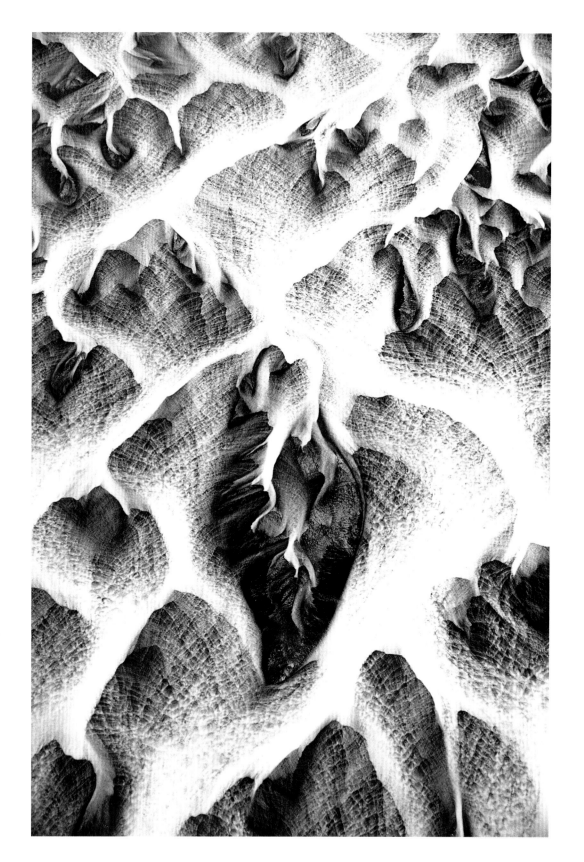

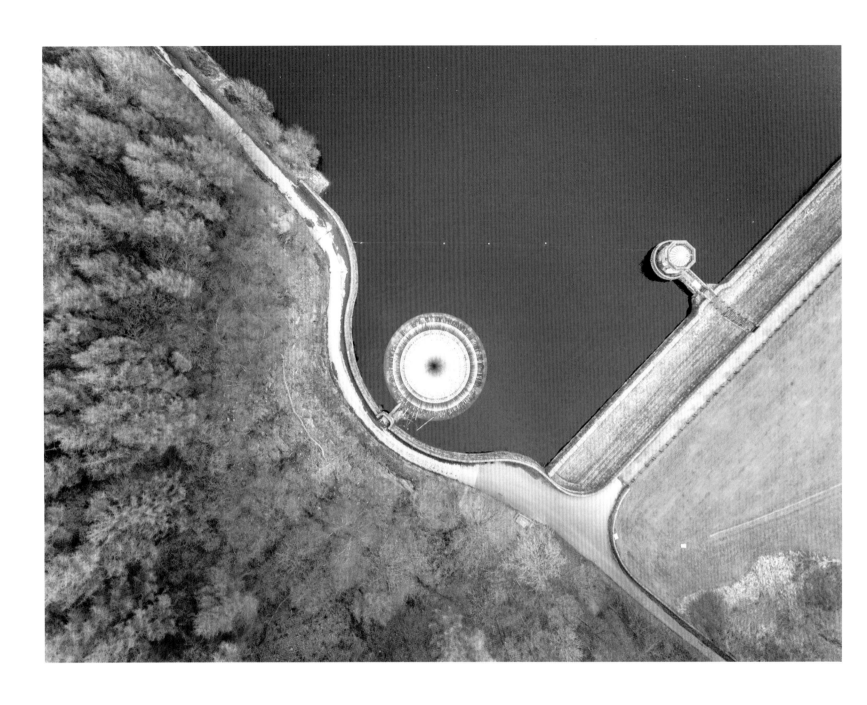

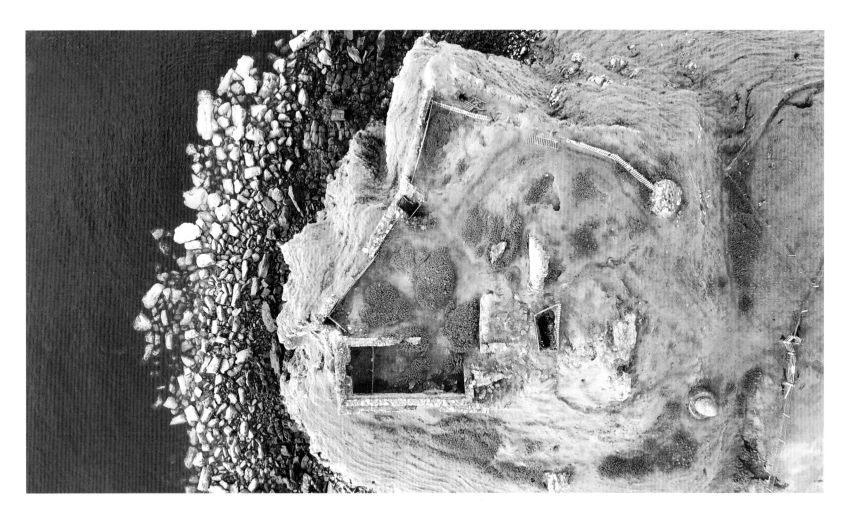

James Grant (United Kingdom)

Left: **Ladybower reservoir, Bamford, Derbyshire, England.** The Ladybower plugholes are an iconic sight in the Peak District and often overflow in the mid-winter months once the reservoir is high enough. I had just got a drone and one of my first missions was to capture them directly from above. I flew the drone from a safe distance, and slowly took it over the plughole; it was just a case of making sure the hole was roughly centred and then turning the drone to change the angle of the dam for some diagonal dynamism. I was fortunate to get this shot because there are now 'no drone flying' signs up around the reservoir.

DJI Phantom 4 with 24mm equivalent f/2.8 lens, ISO 100, 1/50sec at f/2.8

jamesgphotography.co.uk

Laura Daly (United Kingdom)

Duntulm, Isle of Skye, Scotland. On our last night on the Isle of Skye, we ventured just five minutes from our accommodation to Duntulm Castle at sunset. Sharing the hillside with the midges and the sheep, we launched the drone, knowing the ruins were best seen from above. I chose to include the bright blue water of the ocean as it perfectly complemented the lush green grass, especially with the soft sunset light catching the walls of the castle. The view from above captures the beauty and lure of Skye, both natural and man-made.

DJI Mavic Pro with 28mm equivalent lens, ISO 101, 1/25sec at f/2.2

lauradalyphoto.com

Alistair Horne (United Kingdom)

Sermilik, Greenland. I was on a three-day kayaking trip on the Sermilik fjord as part of a commission for the tourist board in Greenland and had the chance to put up my drone above our kayaks and the massive icebergs that moved around us. This specific iceberg was one of the largest we came across and I really wanted to get a sense of its scale by having a kayak beside it. Seeing them from above also completely changes the perspective and shows you just how much ice is above and below the water.

DJI Mavic Pro with 28mm equivalent lens, ISO 100, 1/2000sec at f/2.2

alihorne.com

David Hopley (United Kingdom)

Boulmer, Northumberland, England. A trip to Northumberland allowed me to spend some time exploring this beautiful part of the coastline from above. It is often difficult to find compositions at ground level, so I typically arrive at a location and launch the drone to find abstracts and patterns in the landscape. On this occasion there did not appear to be anything of significant interest, but in the distance I could see a fishing boat heading back to shore. After a quick change of batteries, I flew over to the boat just in time to capture it being retrieved by the tractor.

DJI Spark with 25mm equivalent f/2.6 lens, ISO 100, 1/60sec at f/2.6

drawswithlight.co.uk

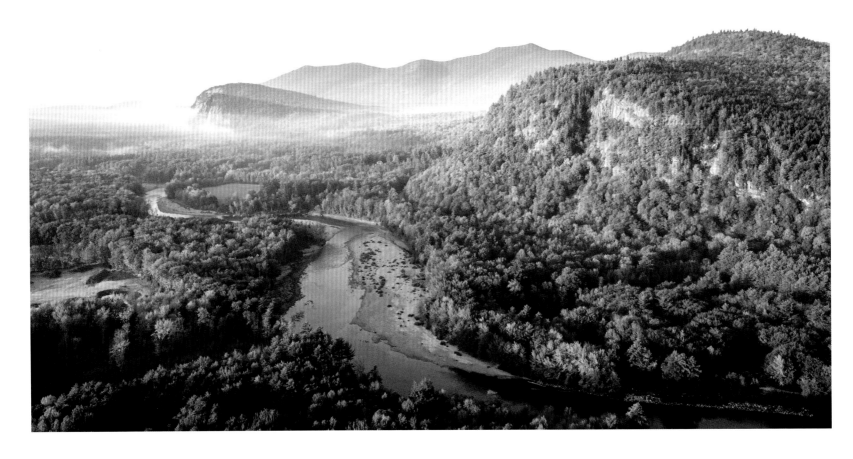

Paul Gath (United Kingdom)

North Conway, New Hampshire, United States of America. This was the third morning that I had taken my drone out at sunrise at North Conway and it was the last day I was going to be in the area. The conditions were perfect, with the sun lighting the tops of the trees and mist clinging to the sides of Cathedral Ledge and White Horse Ledge, in Echo Lake State Park in the distance. The Saco River was calm, but the autumn colours had been delayed because of the hurricanes in 2017; the touches of orange and red add more interest.

DJI Mavic Pro with 28mm equivalent lens, ISO 135, 1/100sec at f/2.2,
two-stop ND filter, polariser

paulgath.co.uk

Edward Felton (United Kingdom)

Portbury Wharf, Avon, England. Portbury Wharf has some excellent mud flats, which are great for wading birds. I originally planned to photograph their footprints from above at low tide, but after gaining height the landscape opened up beneath me, showing off its incredible beauty. This became the focus of the flight: looking for patterns and details where the sea meets the land. The setting sun gave some nice three-dimensional light, which helped give the scene its strong contrast.

DJI Phantom 4 PRO with 24mm f/2.8 lens, ISO 100, 1/400sec at f/4

skypixel.com/user/edwardj

Lisa Mardell (United Kingdom)

Hawaii Volcanoes National Park, Hawaii, United States of America. It had been my dream for many years to see the lava flow from Kīlauea in Hawaii, and then finally I got to fly over it in a helicopter. I was initially terrified, but my nerves were soon overcome when I saw the first red glow of the lava. Our pilot swooped low and circled, enabling me to photograph the patterns and textures, although they were a challenge to frame, as we were constantly moving. This is my favourite image from that day; the curves remind me of old, frayed rope.

Canon EOS 7D MkII with 70-200mm f/2.8 lens and 1.4x teleconverter, ISO 3200, 1/1000sec at f/5, handheld

photographybylisamardell.co.uk

YOUNG OPOTY

Nature is my world: for outdoor photographers
aged 18 or under to share the landscapes, nature
or wildlife subjects that matter most to them.

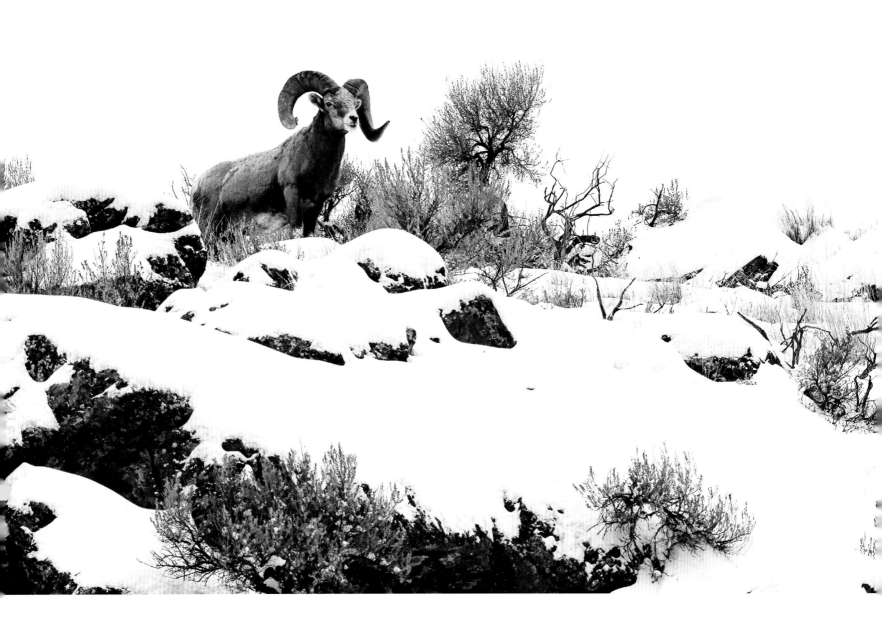

Josiah Launstein (Canada)

Sierra Nevada bighorn sheep, near Kamloops, British Columbia, Canada. I love bighorns, and Sierra Nevada bighorn sheep are extra special because they are an endangered species. We had a harder time finding rams during our visit to their area this winter, but just as the light was beginning to fade I spotted this ram standing majestically on a high ridge. Photographing at -25°C is always a challenge and I was afraid I wouldn't have time to get my camera on my tripod before the ram disappeared from view. Instead, I leaned my camera against a solid support as I framed up my shot. I loved all the snow and sagebrush and knew immediately that I wanted it to be black & white.

Nikon D7100 with 200-500mm f/5.6 lens at 460mm, ISO 500, 1/250sec at f/10, handheld

launsteinimagery.com

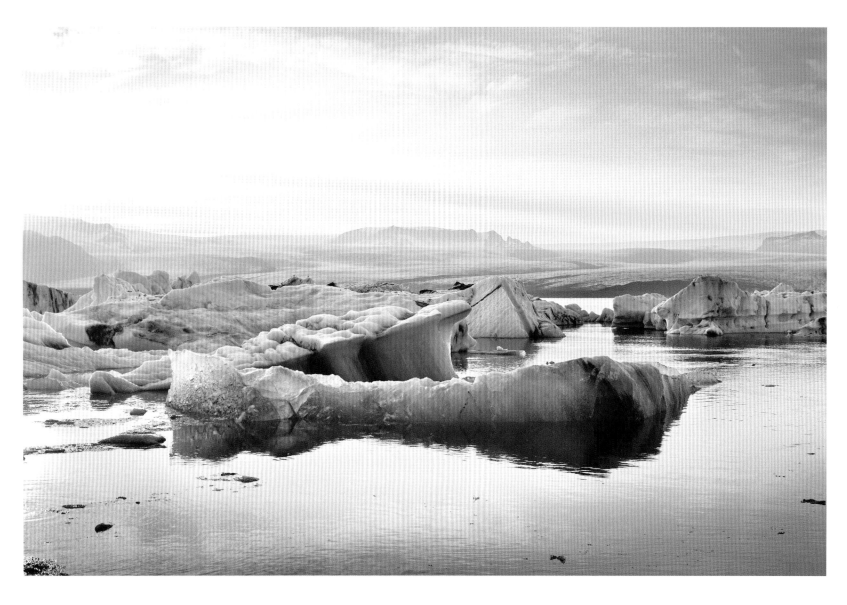

Julen Sanchez (Spain)

Jökulsárlón, Iceland. I will never forget the moment I arrived at this location; it was the first time I had seen a glacier in my life. Photographers often have to struggle to get the perfect light, but that wasn't the case here. I set up my camera on the shore and waited for a block of ice to settle in front of me, amazed by the colours and brightness.

Nikon D300 with 35mm f/1.8 lens, ISO 200,1/2000sec at f/4, tripod

instagram.com/julentto

Fergus Brown (United Kingdom)

Right: **Fairy Pools, Isle of Skye, Scotland.** I took this picture while on a walk with my family at the Fairy Pools on the Isle of Skye. On the way down, this scene captivated me, as you could see the raging river as well as the moody sky over the mountain. I decided to use an ND grad filter to create an atmospheric feel and a plain ND filter to enhance the movement of the crystal, turquoise water.

Olympus OM-D E-M1 with 12-40mm f/2.8 lens at 12mm, ISO 200, 1sec at f/22, two-stop medium ND grad filter, two-stop ND filter, tripod

fergusbrownphotography.co.uk

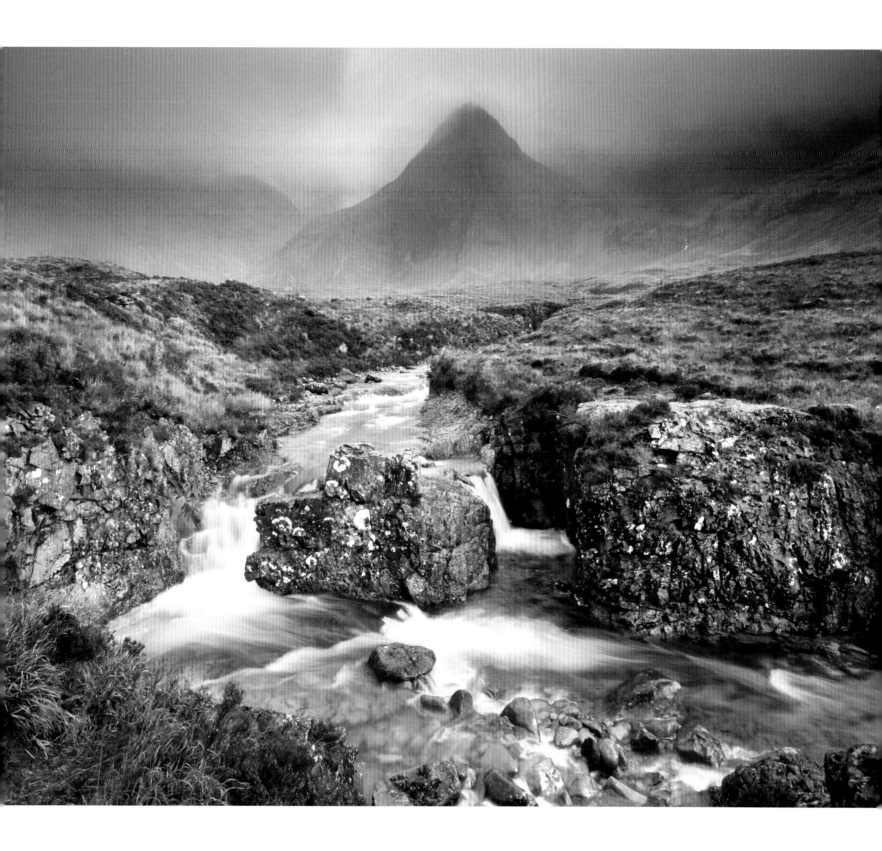

Nicholas Hess
(United States of America)

Portland Japanese Gardens, Oregon, United States of America. I walked across a footbridge in the Portland Japanese Gardens and noticed the water was covered with these water striders. The way they covered the surface of the water was very serene and it was an irresistible shot to take. I wanted to have the entire image sharp so I chose a relatively small aperture and took the shot from a bird's-eye view. I didn't want the water striders to be too small in the shot, but I also wanted to give an idea of how many there were. I like the mysterious aspect of the shot and how they almost look like they are falling through the air.

Olympus OM-D E-M1 with 100-300mm f/4-5.6 lens at 100mm, ISO 640, 1/100sec at f/8, handheld

nicholashessphotography.com

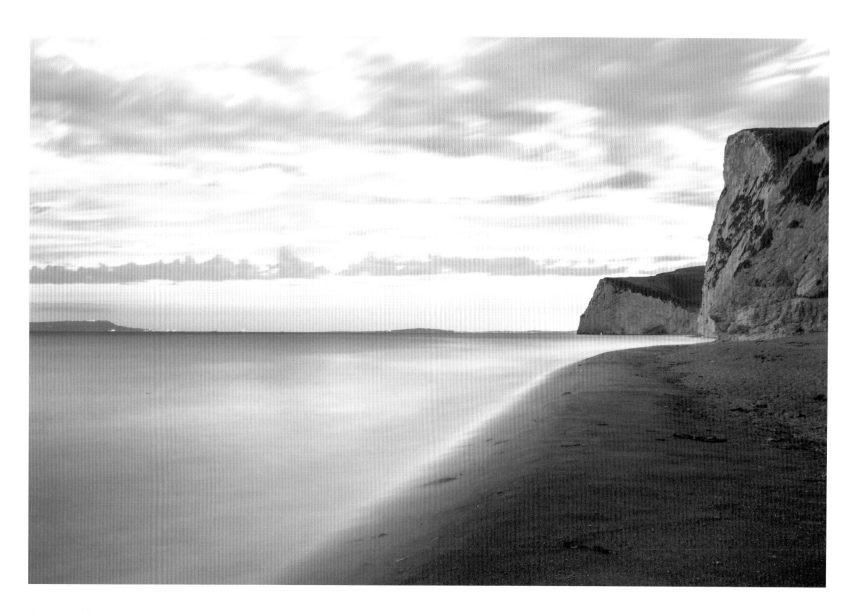

James Oakley (United Kingdom)

Durdle Door, Dorset, England. This was my first time at Durdle Door and I was overwhelmed by the landscape that I saw before me. I was firing off shots one by one, capturing the moment as it went by, trying to get some great images. I was fighting against time, as the sun went down behind a huge band of clouds near the horizon; there was only a brief moment when the light was at its best. One problem I found at this location was the number of people that were on the beach – it was very hard to get a good composition without getting anyone in the shot.

Canon EOS 700D with 18-55mm lens at 24mm, ISO 100, 55sec at f/14, ND filter, tripod

jamesophotos.com

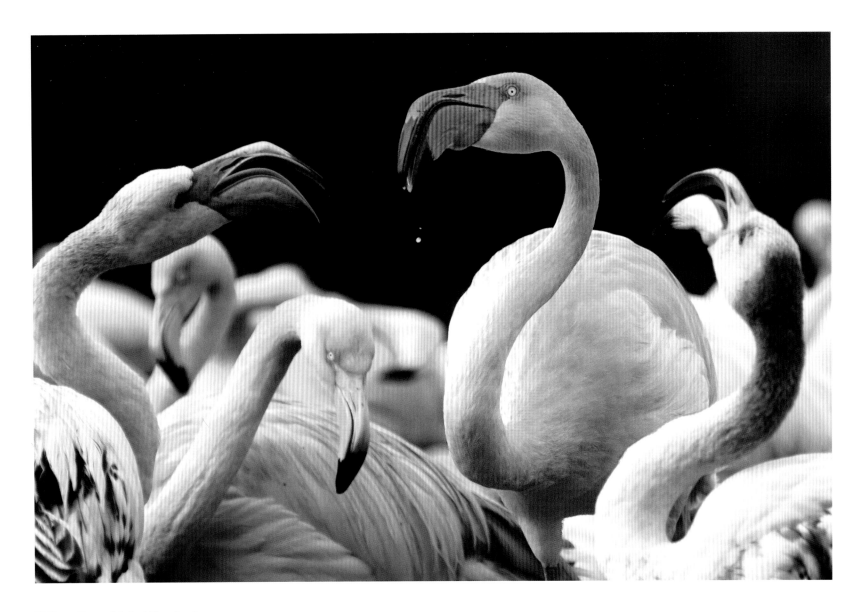

William Evans (United Kingdom)

Greater flamingos, Slimbridge Wetland Centre, Gloucester, England. Flamingos are commonplace in zoos up and down the country, but it is quite common for people to pay attention solely to the glorious pink feathers or their bizarre balancing act, rather than appreciating the unseen beauty of these birds. I learned from my brief encounter at Slimbridge just how sociable flamingos really are and I wanted to portray this characteristic the only way I knew how.

Steering clear of portraits, I searched the flock for an image portraying the true nature of flamingos. Creeping slowly in front of a willow tree, an adult inched into my frame, staring straight into my lens, with two juveniles at its side. At that moment the cloud-ridden sky granted me a shaft of light and I could quickly flick from ISO 1600 to 400, throwing the background into darkness and emphasising the perfect plumage of the central bird. During post processing I made adjustments to exposure, contrast, saturation, sharpness and noise.

Canon EOS 600D with 100-400mm f/4.5-5.6 lens at 160mm, ISO 400, 1/1000sec at f/5, handheld

inthewildphotography.co.uk

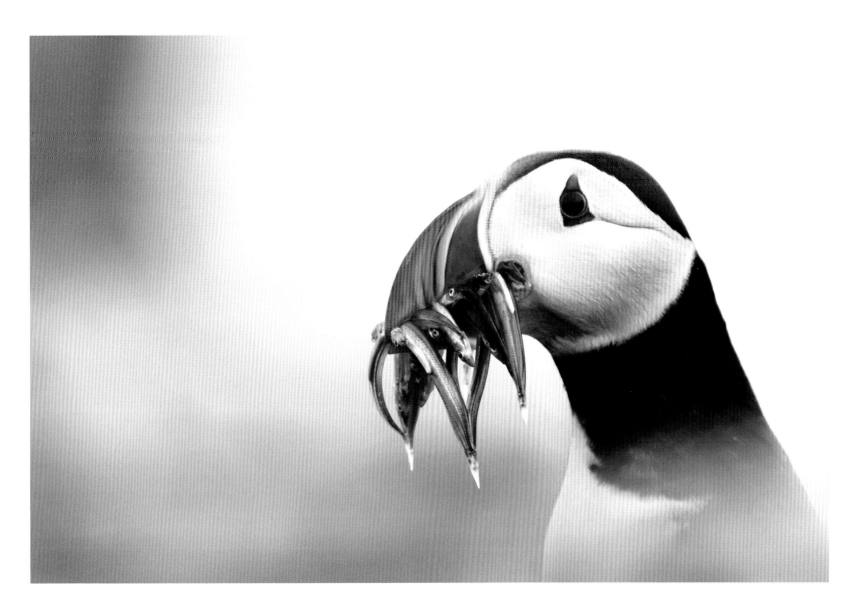

Alicia Hayden (United Kingdom)

Puffin, Isle of May, Scotland. The misty grey background and subtle yellow lichens were the perfect background for the beautiful colours of this puffin's bright, breeding-season beak. I chose a close-up shot to show as much detail as possible, including the internal structure of the sand eels and the puffin's bill. I waited behind a rock for the perfect moment to arise when this puffin returned to land. Due to the low light and misty conditions, I used a wide aperture to deliver a sharp, yet atmospheric, portrait.

Canon EOS 60D with 70-300mm f/4-5.6 lens at 282mm, ISO 200, 1/1000sec at f/5.6

OPOTY.CO.UK

To find out more about the competition and
see previous winners, please visit our website.

AMMONITE
PRESS

ammonitepress.com